C000117639

# moving in time

images of life in a democratic south africa

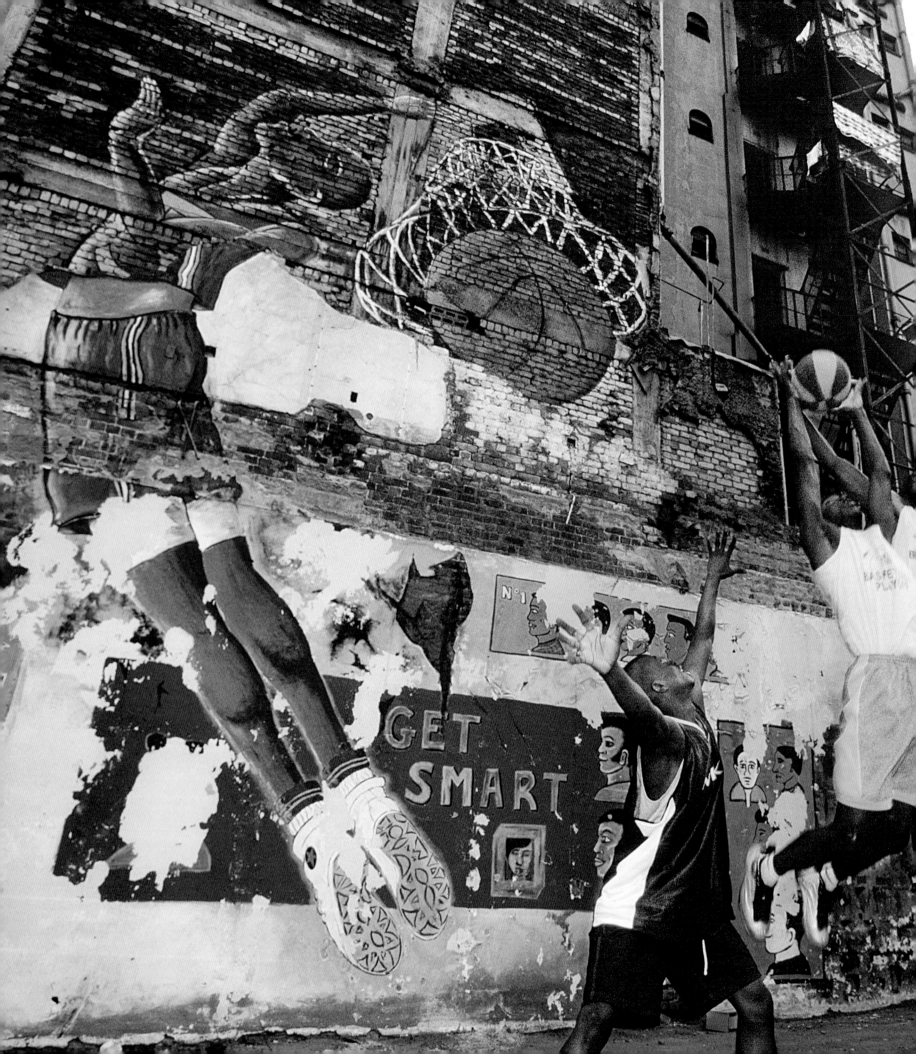

Wembley Tigers basketball team, Johannesburg, 1999.  [ **Caroline** Suzman ]

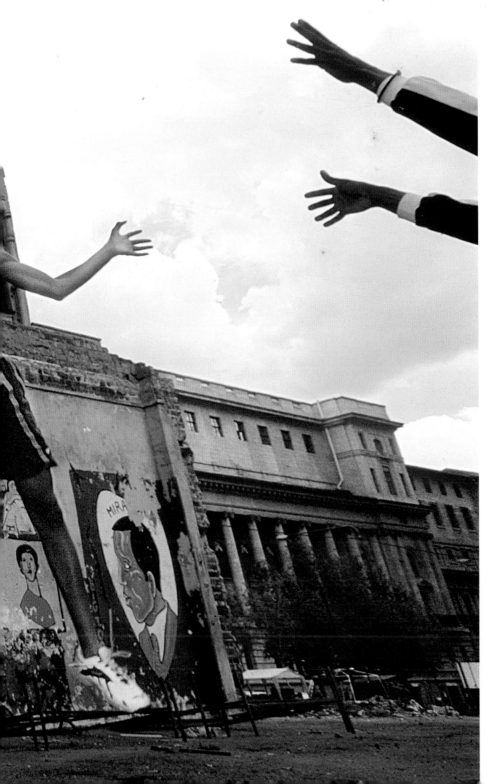

# moving in time

images of life in a
democratic south africa

photographs edited by **george hallett**
introduction by **mandla langa**

Published in 2004 by:

KMM Review Publishing Company (Pty) Ltd

P O Box 782114, Sandton 2146

Distributed by:

The University of KwaZulu-Natal Press

Private Bag X01, Scottsville 3209, South Africa

books@ukzn.ac.za

www.ukznpress.co.za

Tel (033) 260-5226

Fax (033) 260-5801

ISBN 0-620-32027-3

Managing editor: Riaan de Villiers

Designer: Francois Smit

Reproduction: Andrew Meintjes and Andile Komanisi

Printed by Colorpress, Johannesburg

# contents

We wish to thank the following concerns for generously supporting this project:

Telkom

The MTN Foundation

House of Motani

House of Motani

# foreword: 1994 and all that jazz

Moeletsi Mbeki, chairman of KMM Review Publishing Company, and I met at the North Sea Jazz Festival in 2003. Instead of spending the night listening to music and meeting old friends between concerts, we ended up talking about a book of photographs he wanted to put together to celebrate ten years of democracy in South Africa.

We agreed that much had changed since the first elections in 1994. Most South Africans, irrespective of class, race or creed, had undergone profound psychological changes. A new spirit of hope, generosity, and creativity had developed. However, many problems – such as HIV/AIDS, poverty, crime, and unemployment remained. Could we create a book of photographs that truly reflected the current mood of the country without sinking into either naïve adulation or self-pity and morbidity?

Discussions continued, and the project began. In the months that followed, I pored over hundreds of photographs submitted by more than 50 photographers countrywide; slowly, the book began to take shape.

Notably, a new generation of photographers made themselves felt in the selection process. They were technically in full control of their medium, and committed to developing their youthful vision of the world around them. They came to meetings with laptops to display their portfolios. However, more established photographers also provided outstanding work.

We engaged in stimulating debates about the photographs, and I was deeply moved by their work and their support for our project. We all felt that a representative publication of this nature was long overdue.

Therefore, this book is a testimony to the creativity of South African photographers, young and old. May our lives continue to be enriched by their work.

I would like to thank South Photographs for generously allowing me to work from their offices in Melville, Johannesburg; Andrew Meintjies and Andile Komanisi for their meticulous scanning and correction of the images; Francois Smit, for his superb design work; and, especially, Riaan de Villiers, for keeping the whole project together.

George Hallett

March 2004

# introduction: emerging from a storm

## mandla langa

One day someone arrives and opens the gate.
The sun explodes its fire
Spreading its flames over the earth
Touching the spring of mankind.

– **Mazisi** Kunene

ON 6 July 1996, addressing thousands of mourners packed into an Umtata community hall during the funeral service for Mzwandile Piliso, a stalwart of the African National Congress, the then deputy president, Thabo Mbeki – who has always reserved some of his most eloquent moments for the burial of the dead – observed that what had brought everyone to that charged Eastern Cape hall was 'this thing'. Simultaneously sombre and celebratory in fine traditional garb and stylish western gear the colour of fingerprint ink, the assembled multitude gazed deep inside themselves in order to discover the meaning of 'this thing'; eventually, by the time the last song had been sung, and the mourners were dispersing on one of the coldest days in living memory, everyone knew what Mbeki had meant. Simply put, 'this thing' is that quintessential element characterising societies that have braved the storm, that have elected to wait out a cold night in the knowledge that a new dawn would certainly come. He had spoken of the spirit, the soul, of South Africans, young and old, black and white, the lame and the halt.

This soul has wrestled with itself since the historical rendezvous of our reluctant ancestors, the restless whites and resistant blacks. More than five centuries and many litres of blood later, the combatants have slowly come of age, their final steps resembling a *pas de deux* rather than a sword dance. Central to this process has been a consciousness as old as time, which drives sane people to refuse to continue indulging in activities whose aftermath will mean their eternal condemnation.

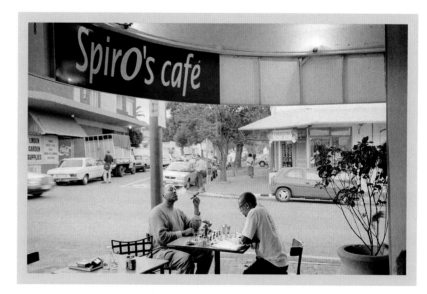

First encounter, April 1994. [ **George** Hallett / South Photographs ]

A decade ago – ten years encompassing three leap years, a bounty for numerologists and shamans – South Africans sculpted a history informed by a singular need to redress the blasphemed past, and chart a course towards a future in which their youth would thrive and join the royal fellowship of world humanity.

Not all South Africans, however, were imbued with the sense of making sense. In all societies, there are throwbacks hell-bent on recreating the past in their own image; in this country, there were people still cast in the apartheid mould. Some, like the embarrassing khaki-clad and swastika-wielding adherents to

Hendrik Verwoerd's credo that blacks were brought on to this earth to provide ease and comfort for white people, embarked on acts of sabotage which did more to underscore their ineptitude than anything else. More sophisticated worshippers at the neo-apartheid shrine strove, by word or precept, to undermine anything done in the name of progress. Here they were, foaming at the mouth, playing the politics aptly conveyed by the Yiddishe concept of *dafke*: a bloody-minded commitment to oppose anything proposed by one's adversary – in this instance, the democratic government – and an iron obligation to support anything it opposes, little realising how ineluctably they were consigning themselves to the realm of irrelevance. Because, it must be borne in mind, white people (and black people for that matter) are not oblivious to mellifluous words and meretricious goods that seek to excommunicate them from the world community.

One of the unintended consequences of the South African transition from oppression to democracy has been the evolution of an openness that has brought into the public domain the warts that have been hidden since recorded time. The victory of the ANC in the first non-racial election in April 1994, Nelson Mandela's inauguration as president, and the formation of the government of national unity set in motion processes as inexorable as a river in flood. Firstly, sanctions which had isolated the apartheid regime were lifted, and South Africans began to travel without fearing the stigma of their national passport, bitterly christened the 'Green Mamba'. This was accompanied by the collapse of the 'Bantustans', those laughable territories run by tin-pot dictators who had set up repressive administrations based on ethnicity, and served as cats' paws of apartheid. With South Africa's isolation ended, it joined the Organisation of African Unity, now the African Union, the United Nations, and the Commonwealth, and began, domestically, to dismantle apartheid structures and institutions.

One of the most important developments of 1995 was the inauguration of the Constitutional Court. Its landmark decision to abolish capital punishment received a mixed response. The majority – men and women whose kith and kin had lived under the shadow of the rope brandished so recklessly by the apartheid state, resulting in innocent people going to the gallows, some singing – welcomed the decision. Others – some of whom had fallen victim to violent crime, or were close to victims – continued to support capital punishment on the grounds that it acted as a deterrent, even though research and analysis based on best international practice suggested otherwise. The anguished cry of this section of our society has been grist to the mill of outright proponents of the death penalty.

The media – especially broadcasting – became a mirror in which the people of the country could see themselves, thus helping them to express the stirrings of their collective soul. It is in this arena that the two worlds – the one that seeks to restore the fractured soul of the past, and the other that aims to eradicate uncomfortable memories, and instil national amnesia – clash, with both sides validating the mordant dictum that it is the future that is certain, and the past that is unpredictable.

It was this need to come to terms with apartheid's legacy, and, simultaneously, prepare the ground for the future – a Janus-like accommodation of past, present, and future – that led to the establishment of the Truth and Reconciliation Commission. The TRC went against the grain of the lobby that trumpeted the existence of an unproblematic and amnesiac 'rainbow nation' – a notion that would result in historical revisionism. It was here that South Africa's most enduring drama would play itself out, beamed into every corner of the country via television and radio. Here, the country looked deep into itself – examined

'this thing', and what it had endured – and struggled, painfully, to make sense of what had been done in the name of the people. The evidence before the TRC revealed the depths to which the previous administration had sunk in its efforts to contain resistance to apartheid. Much later, during amnesty hearings, it would be the quality of mercy of the victims and their relatives that would astound and move the world. Many of those who had been wronged sought symbolic reparations, measures that would help them and others to heal their shattered past with dignity.

It is in sports, the arts, popular culture, and literature that South Africans were able to tell their story or, more precisely, the tale that apartheid had told through stammering symbols of silence. This being a country of pioneers and warriors, physical sports – which attract the lion's share of national sponsorship and ad spend – held society captive and, as it were, walking in step. Rugby, which had been regarded as a white man's pastime, played a role in nation-building, not so much through the Springboks' trouncing of the All Blacks and seizing the World Cup in 1995 as Mandela's donning of skipper Francois Pienaar's number six jersey, in full view of millions of television viewers worldwide.

In the public imagination, this singular event eclipsed the inauguration of the Commission for the Restitution of Land Rights, the heightening violence in KwaZulu-Natal ahead of local government elections, and the widespread disturbances at universities related to issues of access and curricula. In that moment of glory, gone was the impulse mourned by Chinua Achebe in his memorable analysis of racism displayed in Joseph Conrad's *Heart of Darkness*, when he wrote that standing between black and white was a 'chasm of engineered ignorance, misunderstanding, division, illusion, and hostility. It highlights the national tragedy of people who have lived long together, but could do no better than acknowledge only their differences. They have done so with such passion as would suggest that perhaps they sensed something in common between them, which neither of them was prepared to acknowledge.'

That victory on an emerald-green Ellis Park set off an avalanche of expectations which – unlike the doctrine familiar to patients recovering from substance abuse, who are eternally exhorted to regard expectations as premeditated resentments – opened the sporting world to all sorts of possibilities. Voices clamoured for the inclusion of black players in the national team, now recognising the absurdity of taking for granted that rugby existed solely for the participation in and delectation of whites. Sports personalities from all walks of life, some returning from abroad, became more serious about the development of sports among the historically disadvantaged.

In theatre, which had seemed to run out of themes with the demise of apartheid, a new energy began to manifest itself. The Market Theatre in downtown Johannesburg, known as a venue for anti-apartheid plays, was re-energised with the return of musicals and serious theatre with relevant, if acerbic, social commentary. Some of the old names, such as Gibson Kente, Mbongeni Ngema, and others, continued to appear in theatre that was now more informed by today's imperatives than the terrors of the past. The scourge of HIV/AIDS became a prominent theme; this sought to give voice to the victims, and supply text where there was silence, given the government's somewhat plodding attempts to articulate its programmes and their efficacy.

In music, a new buzz began with the advent of kwaito, a home-grown mélange of rap, R&B, and township sass. Complementing this was the licensing of more community and commercial radio stations that

introduced greater diversity to this sector, and widened listeners' choice. Television channels and advertisers responded to this new energy, and more programmes catering for the youth were flighted. New players, with pre-pubescent facial fuzz and exotic first names followed by a letter of the alphabet – Chuck D, Jazzy B – graced the tabloids, and thrust microphones into the faces of suburban TV viewers who wondered despairingly what the world was coming to.

What the world was coming to was a realisation that mainstream media coverage of this new generation – for whom June 16, apartheid, and 'the struggle' were as remote as the Bambatha Rebellion or the Anglo-Boer War for the rest of us – had been a study in caricature. Where is the youth of today? This question, typically asked by fifty-somethings who survived June 16, 1976, some of whom went into exile, possibly saw action at Malanje in Angola against UNITA, and experienced unspeakable loneliness, misses the central point of the need to sustain rather than mock the youth, or rob them of their voices. Because, in their own way, however awkward or cryptic the lyrics booming out of Yfm or Kaya FM may be, young people are striving to express their take on 'this thing', their collective soul, and their particular anxieties.

But the anxieties of the youth are not that dissimilar to the anxieties of women, or any other people in this country. Their central preoccupation is the performance of the economy. Underlying this is the need for South Africans to ask themselves, on the face of the evidence before them, how this decade-long journey has impacted on the quality of their lives.

Nay-sayers aside, the government can boast certain successes, among them ensuring macroeconomic stability, despite the paucity of the country's skills base, and the volatility of the interest and exchange rates. There are concerns, however, over the cost of transport and telecommunications, which, in the words of the government's own ten-year review, 'are key factors in an economy at such great distance from major world markets'. Telkom, the country's monopolist telecommunications utility, has recently been upbraided for anti-competitive activity; this has been warmly welcomed by consumers as well as public and private institutions in the light of the conventional wisdom that lower telecoms costs will ensure higher rates of investment. In the midst of all this, however, growth happens apace in the telecoms sector, with the three cellular operators, Vodacom, MTN, and Cell C, presenting to the world ingenious mechanisms to capture new markets, at home and elsewhere in Africa. Reflexive communicators, South Africans have outdone themselves in providing access to various means of communication, with the result that, by 2001, more than 32 percent of households had access to cellular phones, 42 percent to land lines, 73 percent to radios, and 54 per cent to television.

There is so much that needs to be done. There is a need to stimulate job creation, and stem the tide of unemployment. It is important to note that the latter is not necessarily a state remit, but has implications for the coherence of the public and private sectors.

In the meantime, the state has introduced various initiatives and programmes to push back the frontiers of poverty. Social grants have been equalised and extended, with beneficiaries increasing from 2,6 million in 1994 to more than 7 million today. Government expenditure on grants has gone up from R10 billion in 1994 to more than R35 billion in 2003. Access to electricity, water, and sanitation has been improved. Moreover, dramatic footage of people left homeless by fires raging through informal settlements sometimes obscures the fact that, through the land and housing programmes, more than R50 billion-worth of assets

have been transferred to the poor since 1994. These are initiatives the world community sometimes takes for granted, but which are the life blood of, and make the difference between survival and perdition for, the poor.

It is hardly surprising that this sports-mad country is on tenterhooks as FIFA decides who will host the soccer World Cup in 2010. Every South African is convinced that there is much in the country's infrastructure to clinch the deal. The country has hosted major conferences and events, from UNCTAD to the Non-Aligned Movement, the Commonwealth of Heads of Government Meeting, the Worlds Aids Conference, the African Union Summit, the UN World Conference Against Racism, the World Summit on Sustainable Development, the African Ministers of Finance and Economic Development, the Rugby World Cup, the African Cup of Nations, the Athletics World Cup, the All Africa Games, and the Cricket World Cup.

At the time of writing, South Africa was in the throes of an election. Formerly pristine white political parties were making forays into the black townships. Every night, television programmes were reflecting just how far people had travelled in the decade under review. Pomp and ceremony upstaged substance, clichés and slogans were rolling off politicians' lips like cataracts, and townships and villages were reverberating with the smacking sound of babies being kissed. The people, their faces either inscrutable or ecstatic, looked on, possibly wondering how long it would take for the first promise to be fulfilled or broken. Mbeki, in the persona of a postman, was delivering letters to a clientele which, a decade ago, would have let loose its dogs on him and people of his ilk. Now, they welcomed him, and addressed him in the language of their ancestors. Snap polls were being conducted after party-political broadcasts, the respondents required to vote nay or yea via the short messaging services on their mobile phones; these instant plebiscites resounded on radio talk shows, where sponsored broadcasts proclaimed the virtues of the interlocutors while trashing their opponents.

The democratic process was unfolding daily on the box and radio, in much the same way that the whole world experienced the Gulf War and the O J Simpson trial on television. This means that many thousands of people are kept informed about the kinds of choices open to them. They are also entertained by soap operas, from the usual American pabulum such as 'The Bold and the Beautiful' and 'All My Children' to local offerings such as 'Isidingo', 'Generations', 'Zero Tolerance', 'Muvhango', and 'Yizo Yizo' on SABC channels, and 'Backstage' on e-TV, the free-to-air commercial station licensed in 1998.

However, some real-life dramas have been beamed out on television and radio, notably the goings-on at the Hefer Commission hearings in Bloemfontein, where spy allegations against a leader of a crime-busting institution were tested against the testimonies of former comrades-in-arms, and found wanting.

If the broadcast environment were to be used as an analogy for South Africa's progress from the darkness of the bunker to the revealing light essential for any functioning democracy, a tension exists between homogenising the country's social and cultural impulse and a celebration of its diversity. Given the language mandate – South Africa has 11 official languages – and, under the provisions of the act establishing the Independent Communications Authority of South Africa (ICASA), which is responsible for regulating the airwaves – the public broadcaster has had to satisfy the programming needs of the vast majority while trying to make a profit in a competitive environment. Complex formulas have been evolved to cater for the needs of disparate sectors. News is broadcast at different times in different languages; the advertisers, who look for possibilities to capture well-heeled audiences, prefer to pour their money into the English-language news.

This rankles with those with a fetishist attitude to their languages, and has endowed the emotive language debate with more heat than light. Afrikaans, previously one of two official languages, has been relegated to equality with the other ten. Likewise with local drama and domestic programme genres: irrespective of the strength of their audience ratings, they are invariably pipped to the revenue post by imports, no matter how trashy or mediocre. Since the media buyers are usually young and white, an ongoing complaint is that their race and class preclude their empathy with the product in hand, leading one wit to speculate on the possibility of enlisting Tom Cruise to anchor a Zulu news bulletin. But then, Cruise would be unable to bear the weight of the enduring South African dialectic of light and darkness, love and hatred, reconciliation and conflict, hope and despair, and exhumation and reburial.

Indeed, the whole gamut of human experience seems to find expression in broadcasting. The harrowing drama of the TRC, played out on television screens nationwide, ensured that no South African could claim to have been untouched by the events of the past. Here, perpetrator and victim bared their souls to the nation, and tried to exorcise the demons involved in apartheid's crimes against humanity. The leaders of traditionally white political parties impugned the commission, thus depriving many of their youths who had gone to war in defence of an obscenity of a chance to redeem themselves. Others tried to pretend that they had not benefited from the past abuses, and that the slaughter had not been in their name. Hope lay in sections of the white youth, who kicked against the orthodoxy of passive denial and enjoined their elders to come forward and 'fess up. At first, it was a simple case of black and white, with blacks the victims and whites the perpetrators. As time passed, however, the unflattering mirror was held up for blacks to look at themselves, and what they saw convinced them that the colour of evil was the colour of our nightmares.

This confusion also lies at the heart of our patriotic hysteria, when we strive to appropriate symbols that define our cohesion. In this respect, we are a nation of schizophrenics. The transition from apartheid to democracy has also divested us of a crutch. Apartheid sharpened our understanding of the enemy, delineating everything in black and white. Without it, many of us were doomed to discover that the enemy was actually in our neighbourhoods, in our houses, inside the family. In certain instances, it stared back at us whenever we looked in the mirror. For many black people, there is the reprise of the observation made by James Baldwin that, even though all our brothers are black, not all blacks are our brothers. In the timeless conflict staged in this country, the majority of perpetrators – and casualties – are black. Apartheid devalued black life, and some psychologists, in the mould of Franz Fanon, might interpret the murders and rapes that fill our headlines as less of a reflection of the killers' savagery than of their visceral compulsion to eradicate from their midst that which they find so execrable, but which bears such an uncanny resemblance to themselves. In the meantime, whites, weaned on the udder of privilege, regard themselves as victims, excommunicated from their Eden.

Where things have fallen apart, the centre has somehow held. This is part of the miraculous self-generative powers of the crazy quilt that constitutes our society. On numerous occasions, it has seemed as if the country would tear itself apart, but every time it has stopped at the edge of the abyss. Shrewd political observers have ascribed this refusal to self-destruct to the shared history of this country's historically divided people. While it is only since the 1994 democratic elections that we have become a united nation, whites and blacks have in fact lived in proximity, however fraught, for over five centuries. With those

elections, the sabre-rattling of Afrikaner extremists, who had promised Armageddon, was exposed as pure bluster. Similarly, the campaigns of recusant black movements rallying against negotiations were stopped dead in their tracks.

Some will attribute the survival instincts of this country – 'this thing' – to Nelson Mandela and others, including Archbishop Desmond Tutu, for whom the 'rainbow nation' is not just romantic rhetoric but a heart-felt reality. Despite the ebb and flow of transition, it is Mandela's moment at the Rugby World Cup in 1995 that the country continues to remember with fond nostalgia – or the moment when Tutu broke down on television as he listened to a particularly harrowing account during a session of the TRC. It could be in the gestures of depthless generosity, when women who witnessed the slaughter of their entire families reached out and touched the hands of penitent killers. Or it could be the moment – after Cape Town had made an impassioned case – when the whole country held its breath as the countdown began in Lausanne to the announcement of the city that would host the Olympics in 2004.

What, then, will it mean to be a South African in the next decade? Following the 1999 elections, Mbeki, who embodies a no-nonsense, let's-get-to work ethic, became president of the republic. Not a believer in miracles, but an adherent of the philosophy that people can work miracles, he confronts the imponderables that were perhaps subsumed under the honeymoon lassitude of the Mandela era. His preoccupation with healing the entire Africa simply calls upon the people of South Africa to contribute towards the stability of their own continent. We need to remember that the transition to democracy by South Africa in 1994 coincided with the continent's bleakest moment: the massacres in Rwanda. And, yes, the economy has to be cranked up to work.

The next ten years won't be an artificially happy space. It will call on all the energies of legislators, broadcasters, regulators, business people, workers, community representatives, and creative people in all their formations to put a collective shoulder to the wheel and steer the country forward. The energy is already there, with television beginning to show daring images that challenge society, along the lines of Brazil's *telenovelas*, or new-style soap operas, in which the grittiness of life is portrayed without sentimentality, in a manner that lets audiences feel that their real stories are finally being told.

A packaged story of a society might possibly omit the minutiae that are the sum parts of the narrative whole, but could still explore those aspects that move us to laughter or tears, rage or exultation. It could also help the world to understand 'this thing' – and the craziness of a people who have come out of a storm. ■

[

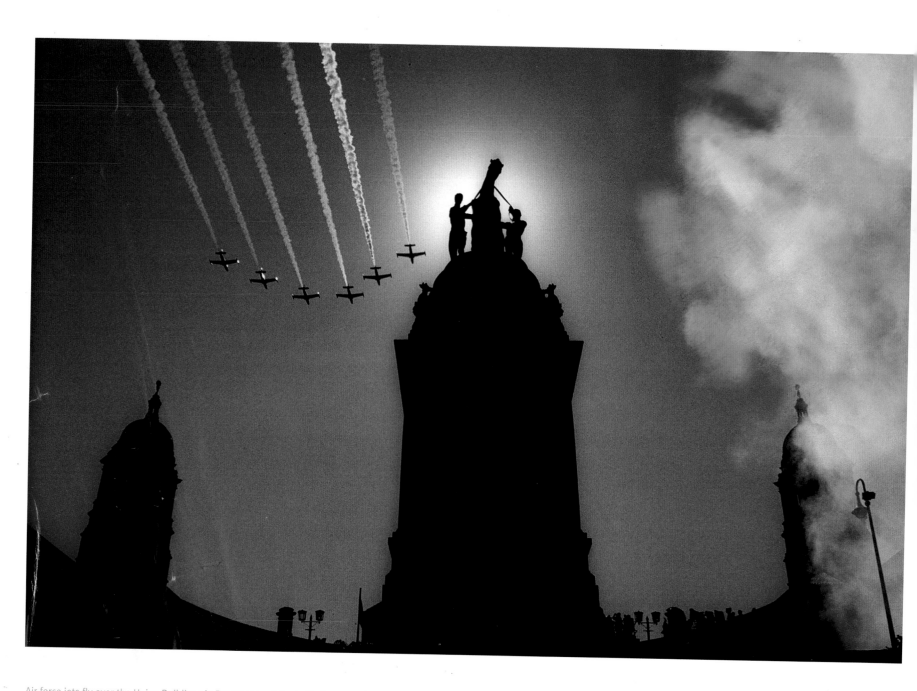

Air force jets fly over the Union Buildings in Pretoria to celebrate the inauguration of president Thabo Mbeki. June 1999. [ **Steve** Lawrence / Independent Newspapers ]

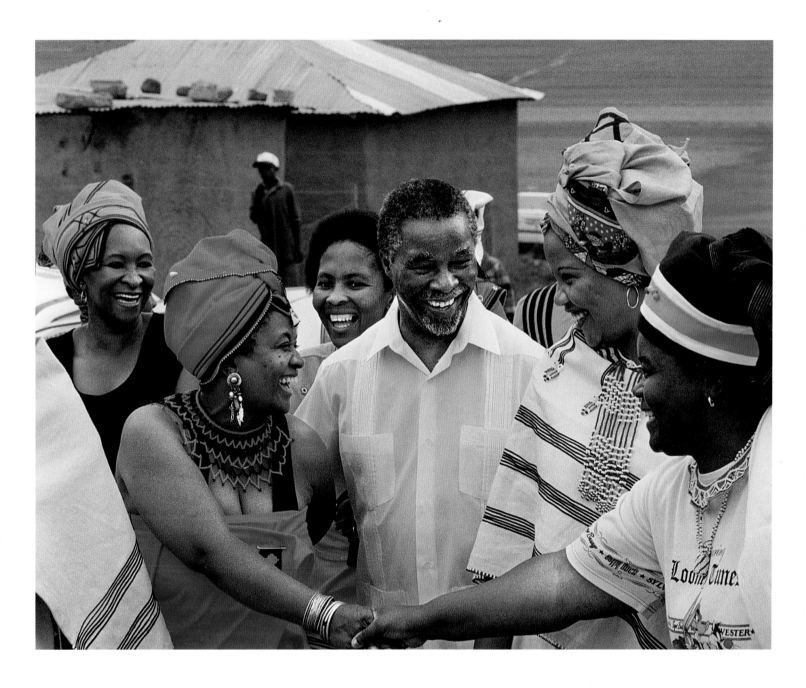

Thabo Mbeki among relatives and friends, Idutywa, Eastern Cape, December 1999. [ **Benny** Gool ]

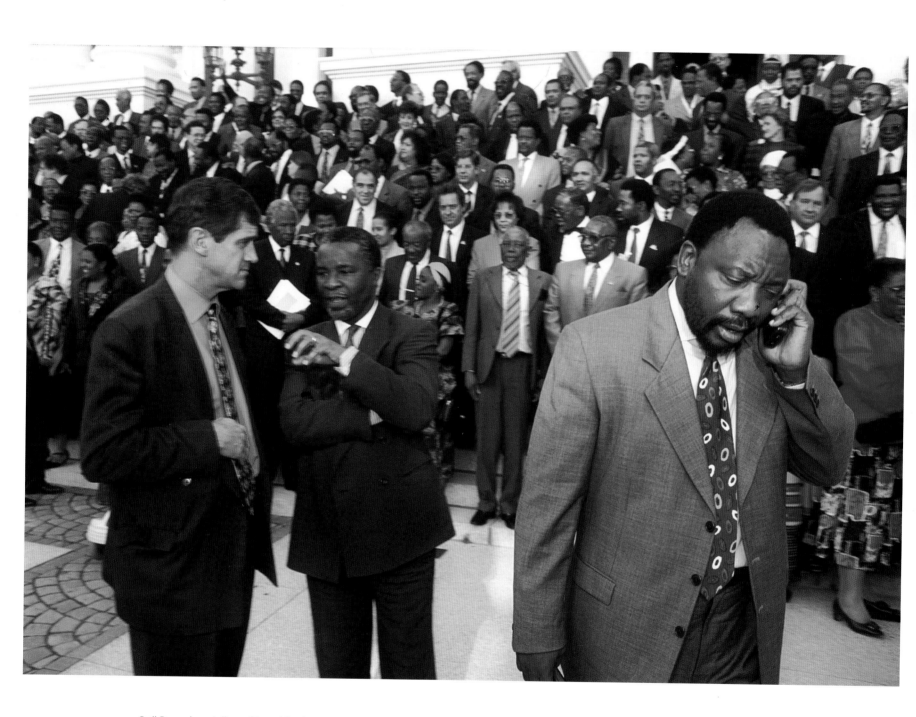

Cyril Ramaphosa talks on his mobile phone before a photo shoot outside parliament to commemorate the conclusion of the work of the constitutional assembly, which drew up South Africa's new constitution. The assembly was chaired by Ramaphosa and Roelf Meyer, far left. With Meyer is then deputy president Thabo Mbeki. 1997. [ **Rodger** Bosch ]

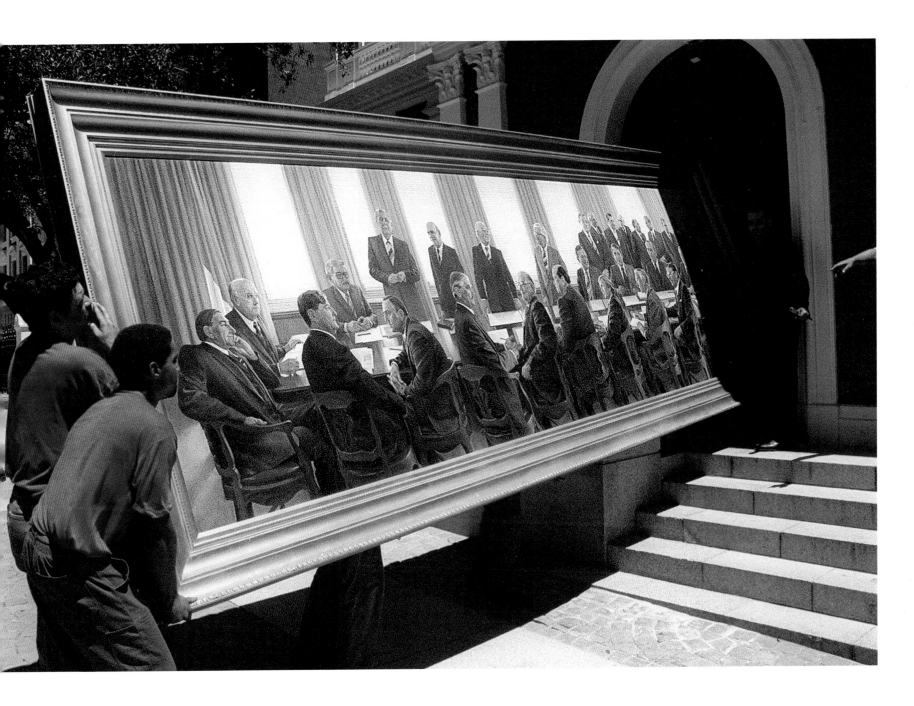

A painting of a National Party cabinet under P W Botha is removed from parliament. [ **Brenton** Geach / Independent Newspapers ]

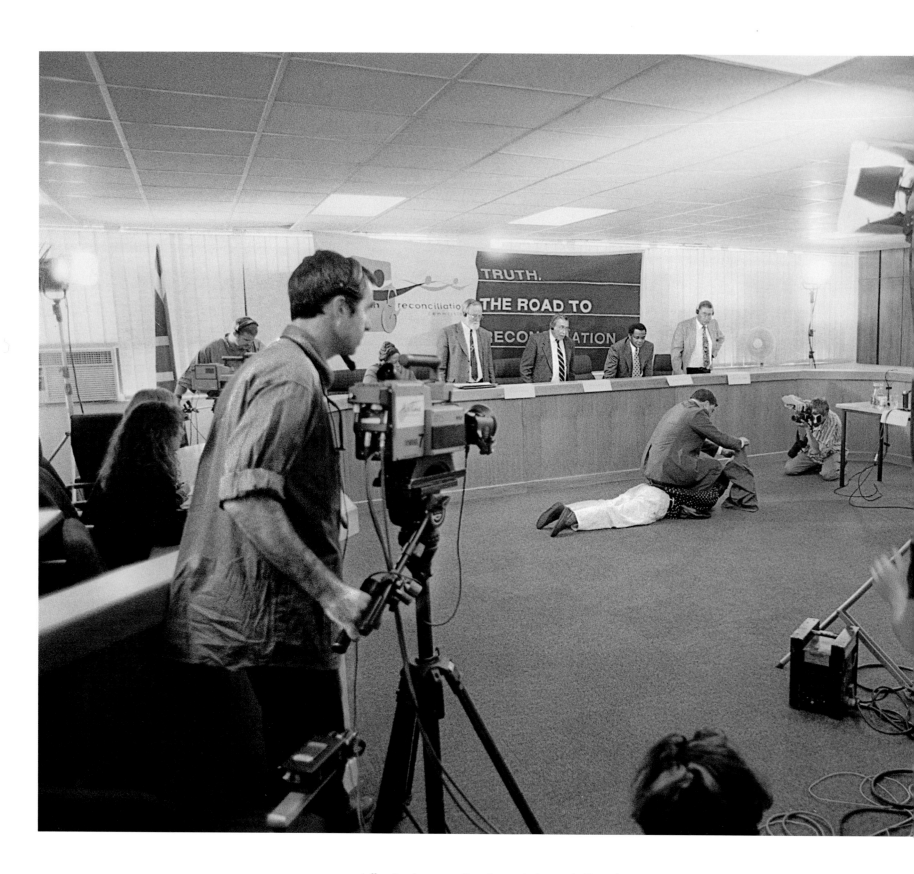

Jeffrey Benzien, a security policeman in the apartheid era, demonstrates his 'wet bag' technique for extracting information from detainees to the Truth and Reconcilliation Commission, Cape Town, 1997. [ **George** Hallett / South Photographs ]

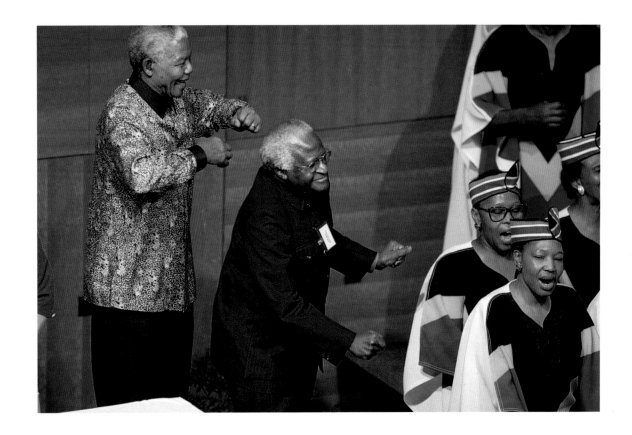

Nelson Mandela and Desmond Tutu celebrate the release of the final report of the Trust and Reconciliation Commission, Pretoria, March 2003. [ **Andreas** Vlachakis / South Photographs ]

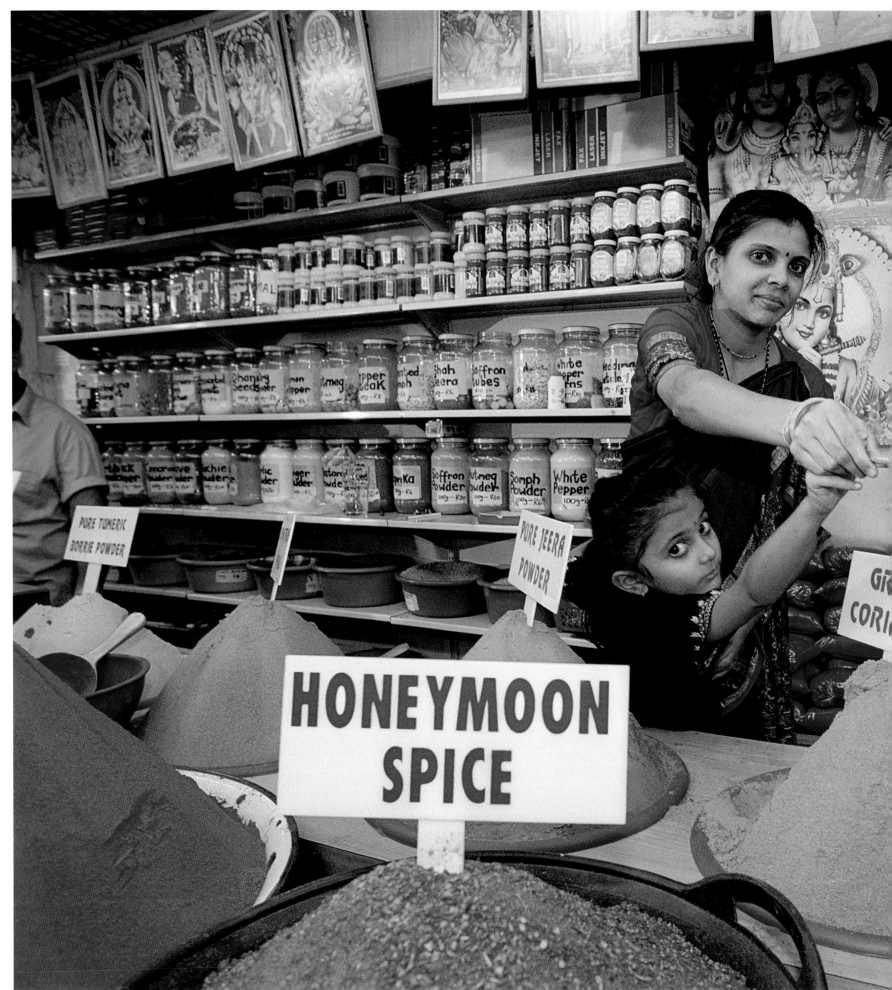

**HONEYMOON SPICE**

Spice seller, Grey Street Market, Durban, 2001.

# caroline **suzman**
[after the gold rush]

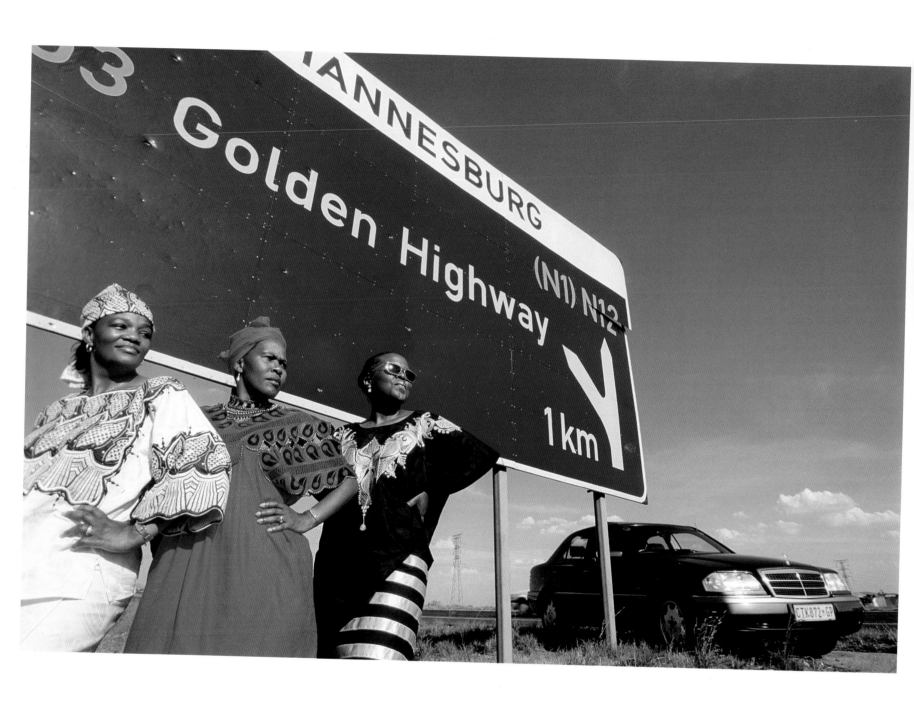

'WaBenzi', Soweto, 1999.

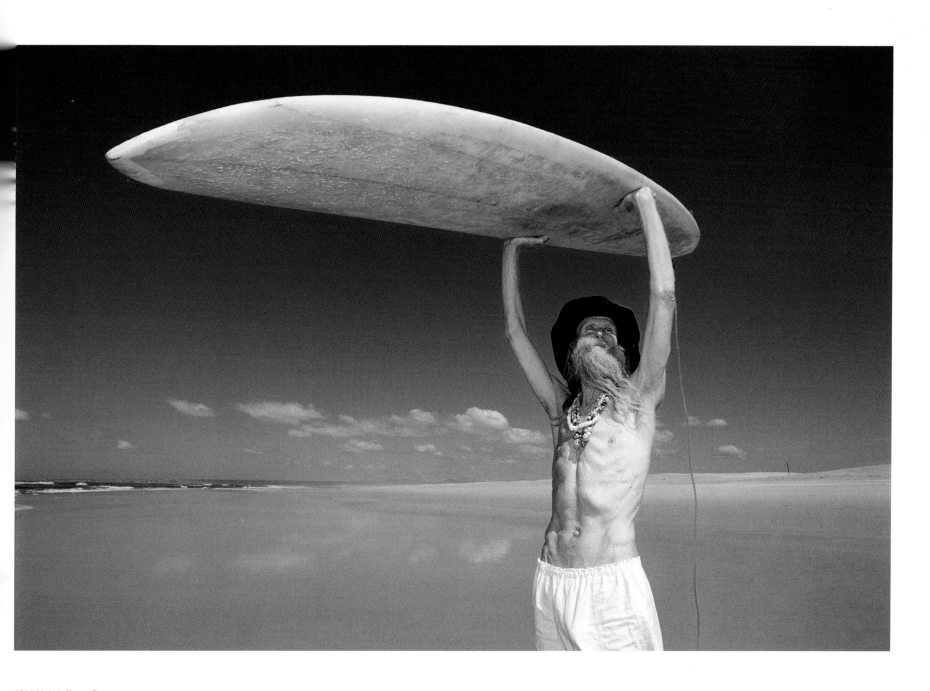

'Old Mo', Jeffreys Bay, 2001.

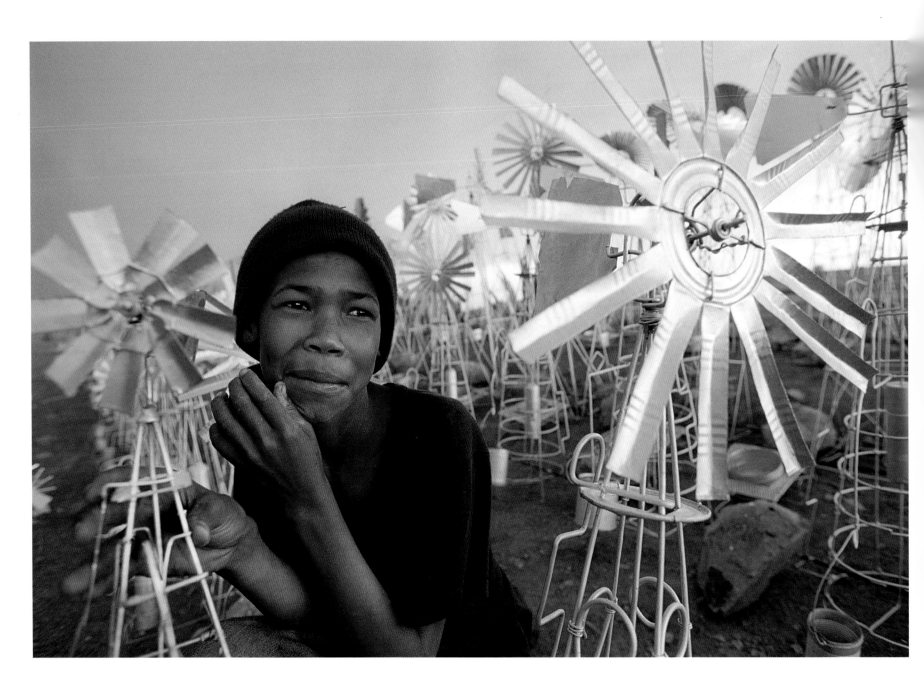

Windmill seller, Cradock, 2001.

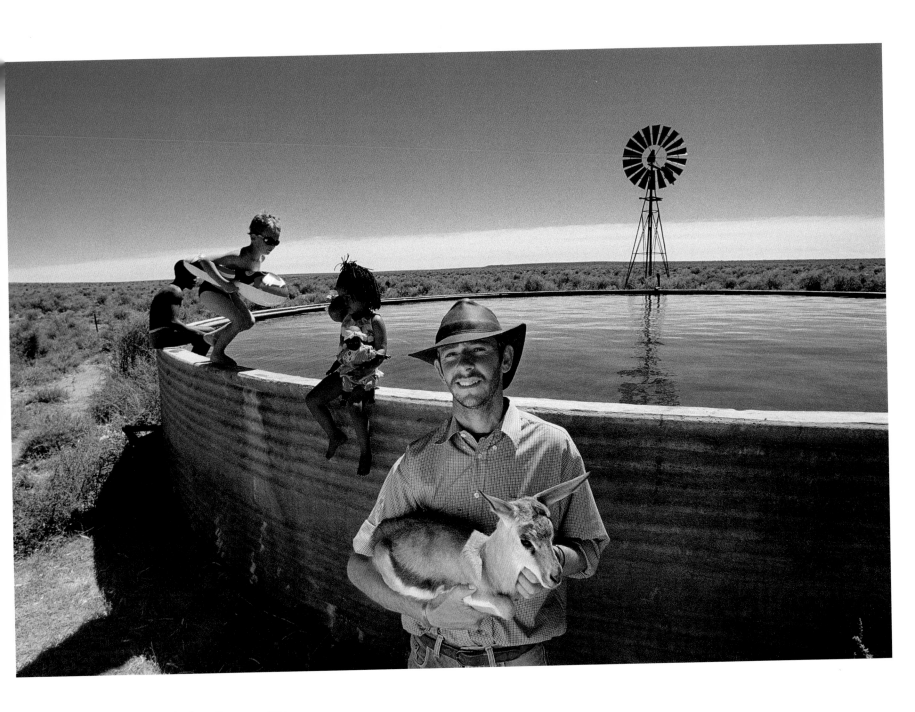

Gideon van der Westhuizen, Sandrivier Farm, Carnarvon, 2001.

Expecting, Pretoria, 1998.

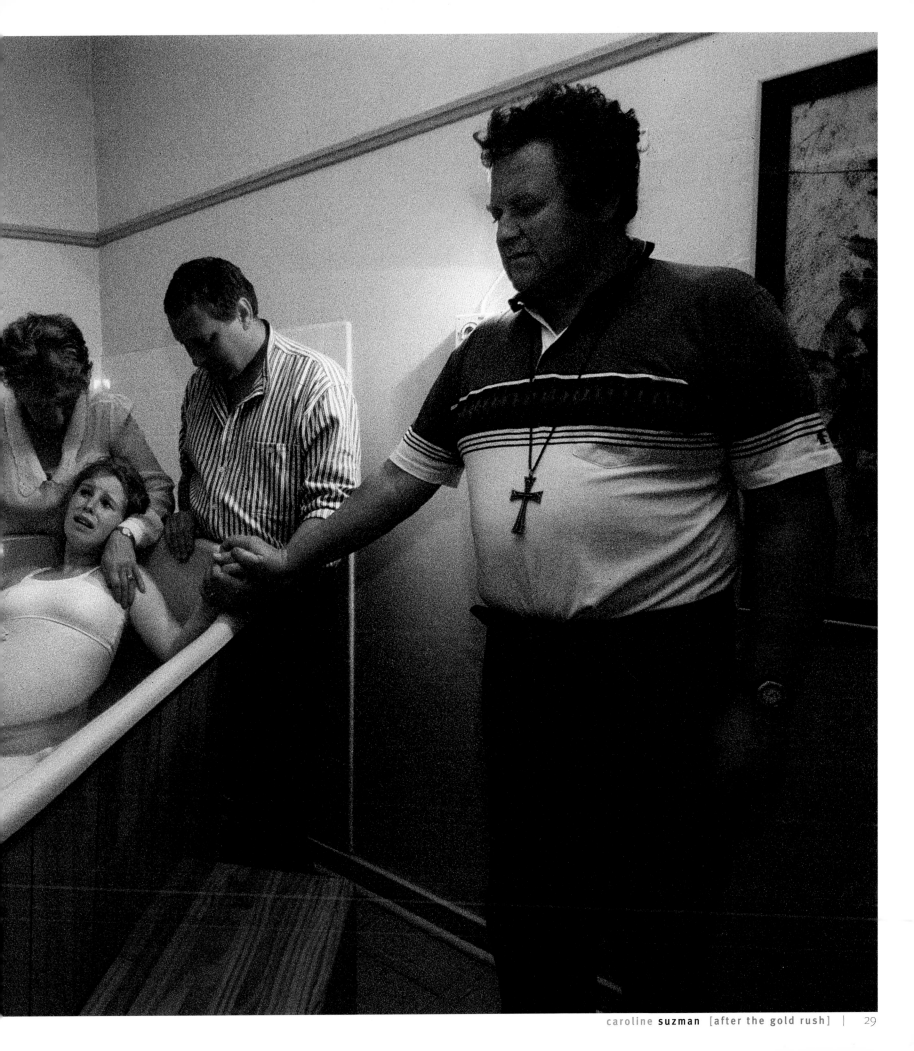

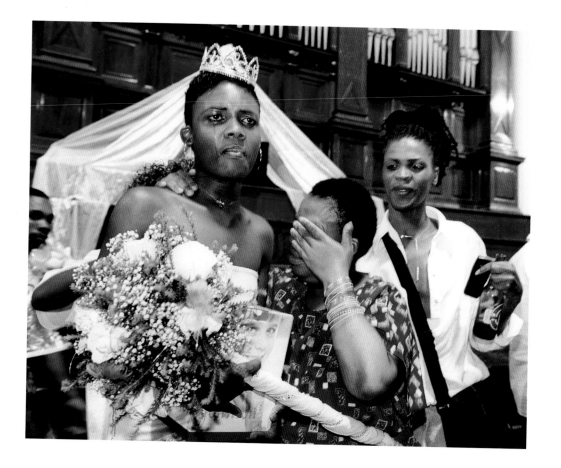

Karapo Maloi fights back tears after being crowned first princess, Miss Gay Soweto Beauty Pageant, Johannesburg City Hall, 2001. He is being comforted by his mother.

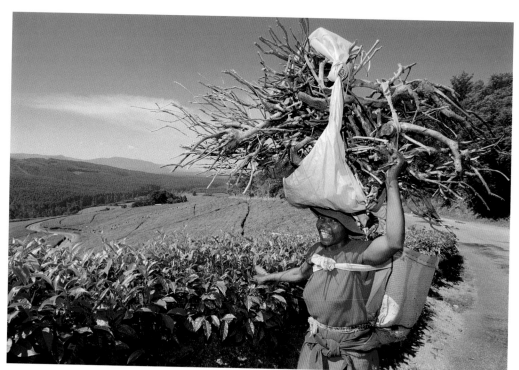

Tea plantation worker, Tzaneen, 2002.

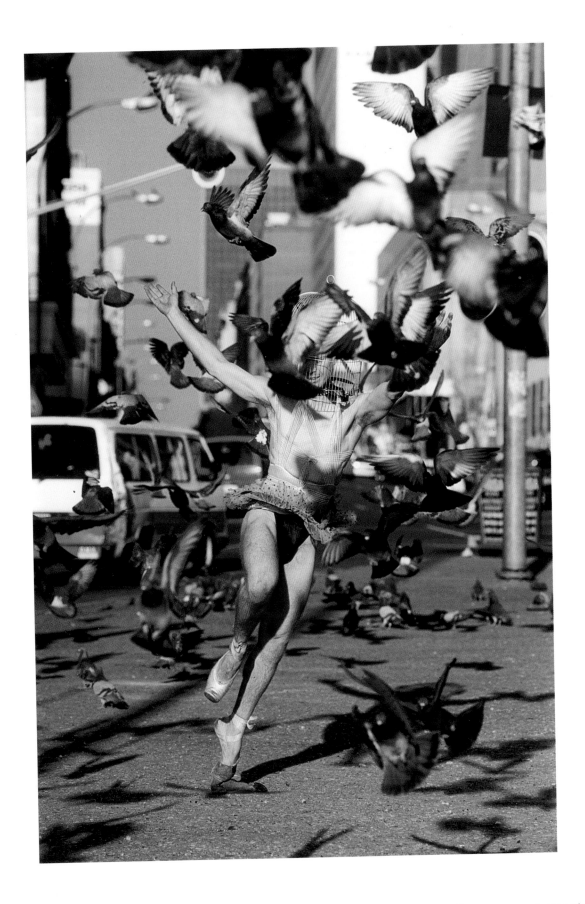

Dancer Elu performing 'Broken Bird' in rush hour traffic, Johannesburg, 2001.

Journalist Mike Hanlyn and police during a PAGAD march on Cape Town International Airport, December 1996. [ **Leon Muller** / Independent Newspapers ]

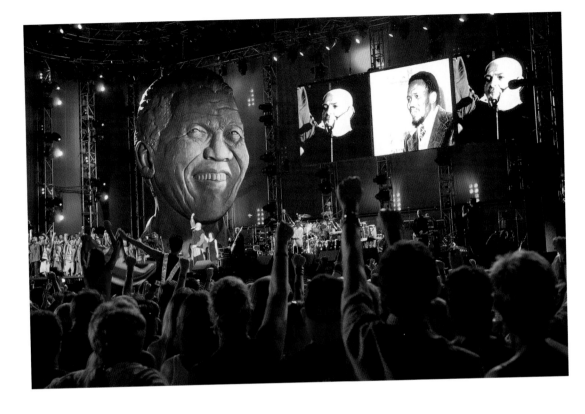

Peter Gabriels sings the song 'Biko', 46664 AIDS awareness concert, Cape Town, December 2003. [ Karin Retief / Independent Newspapers ]

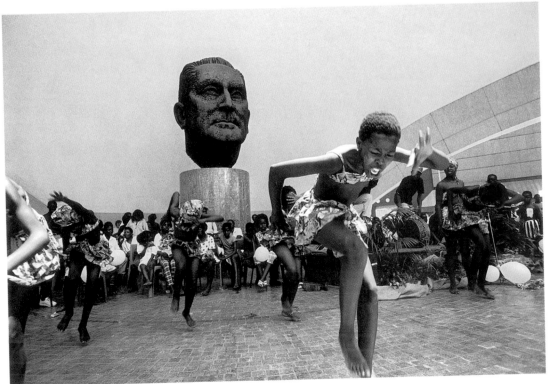

Children dancing in front of a bust of J G Strydom, 'lion of the north', National Party prime minister from 1955 to 1958. Youth Day, Pretoria, 5 November 1994. [ Paul Alberts ]

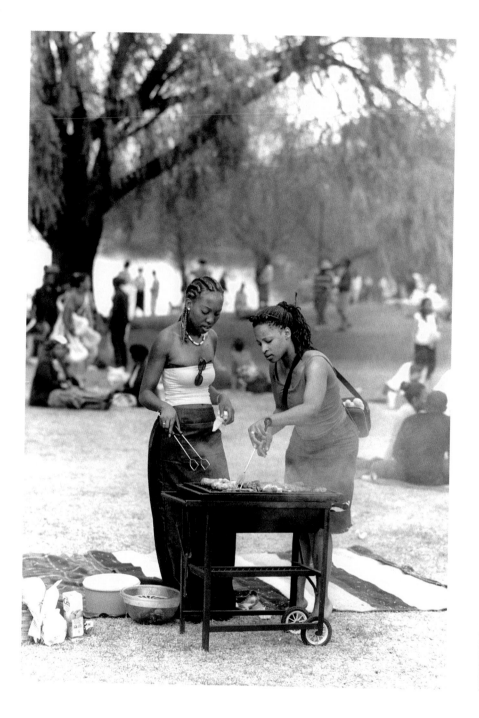

Jazz festival, Zoo Lake, 2002. [ **Jürgen** Schadeberg ]

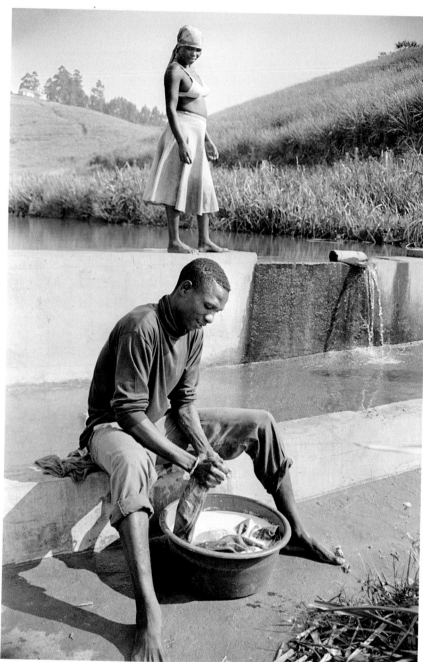

Man washing clothes, northern KwaZulu-Natal. [ **Andrew** Tshabangu ]

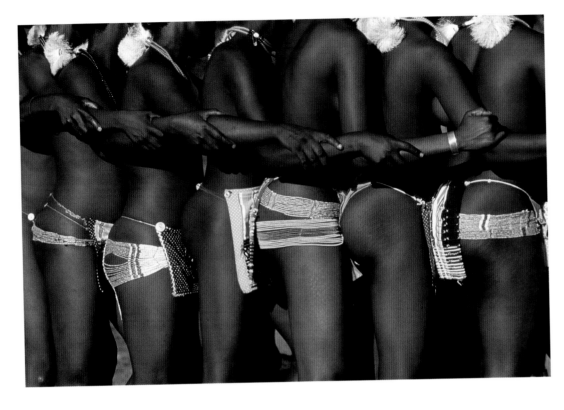

Venda snake dance, Limpopo. [ **Gideon Mendel** / South Photographs ]

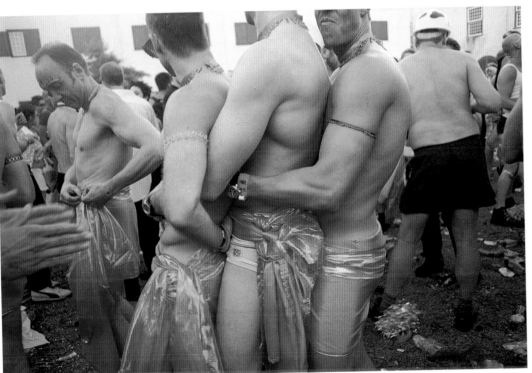

Mother City Queer Party, Cape Town, 2002. [ **Rodger Bosch** ]

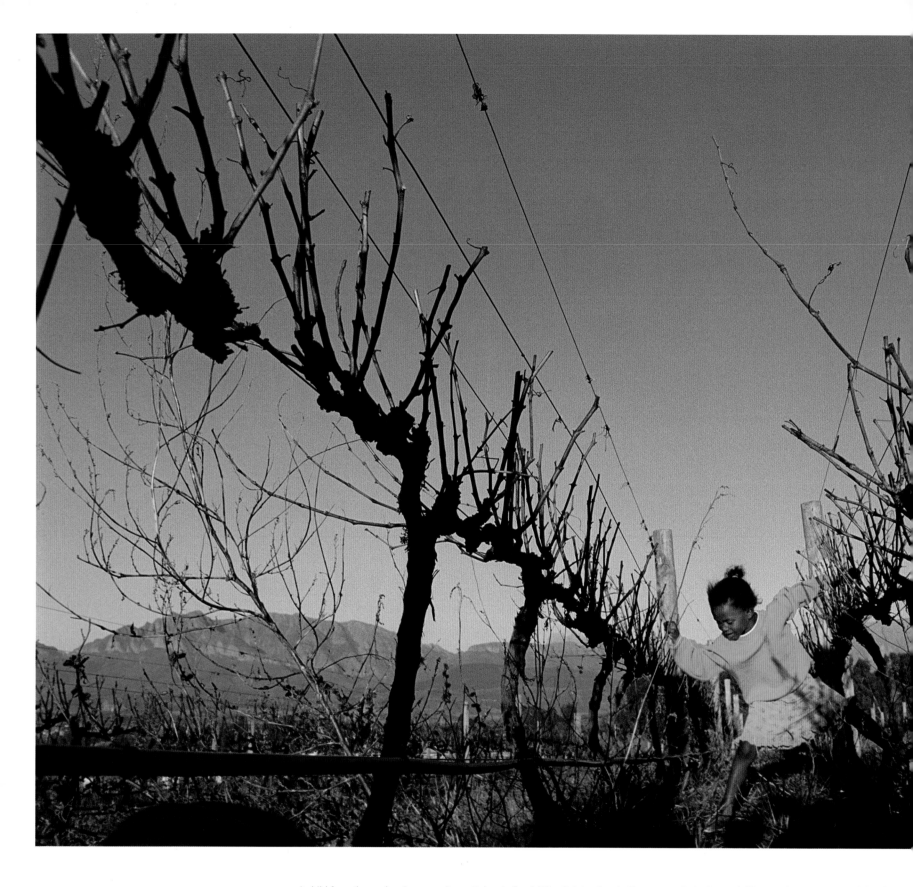

A child from the workers' community on Nelson's Creek Wine Estate plays in the community's vineyard. She now has a more promising future.

# jodi **bieber**
# [change in the winelands]

For many years, the lush vineyards of the Western Cape concealed some of the harshest working conditions in the country. During the past ten years, however, conditions have improved significantly, and a number of schemes have been launched to give farm workers a stake in the wine industry.

At Nelson's Creek Wine Estate, in the Paarl district, farm workers have pooled their government housing subsidies to replant vineyards allocated to them by the farm's owner, Alan Nelson. They use the Nelson's Creek cellars and other facilities to make and market their own wine. Profits from sales are used to buy farm land, and to fund community projects. This empowerment model has been widely emulated.

Also in Paarl, workers on Fairview Wine Estates, owned by Charles Back, have used their government housing subsidies – and financial support from Fairview – to buy an adjacent farm, Fair Valley. They currently produce Fair Valley wines in the Fairview cellar, but intend building a cellar of their own. Income from the sale of Fair Valley wines flows to a communal property association.

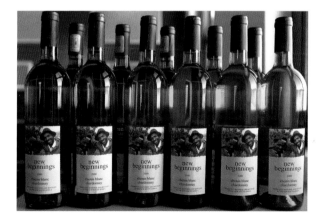

New Beginnings, the wine made by Nelson's Creek workers. This and other labels from similar ventures are selling well overseas.

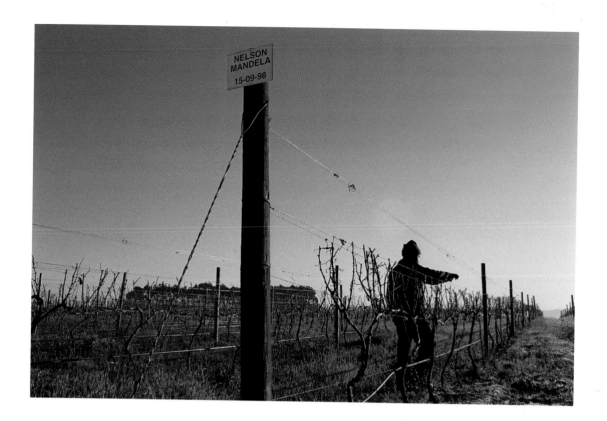

Nelson's Creek workers have dedicated this row of vines in their vineyard to Nelson Mandela.

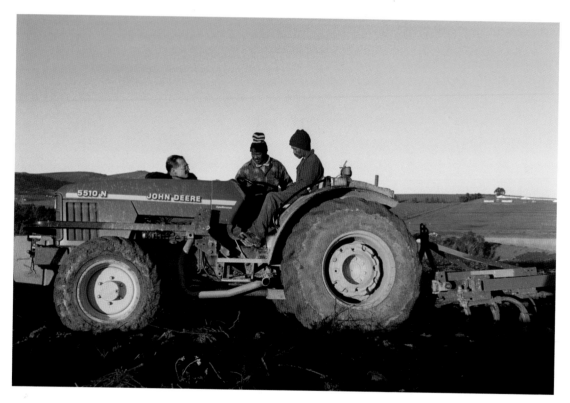

Alan Nelson visits workers in the field. They largely manage their own project, and Nelson only offers them occasional advice.

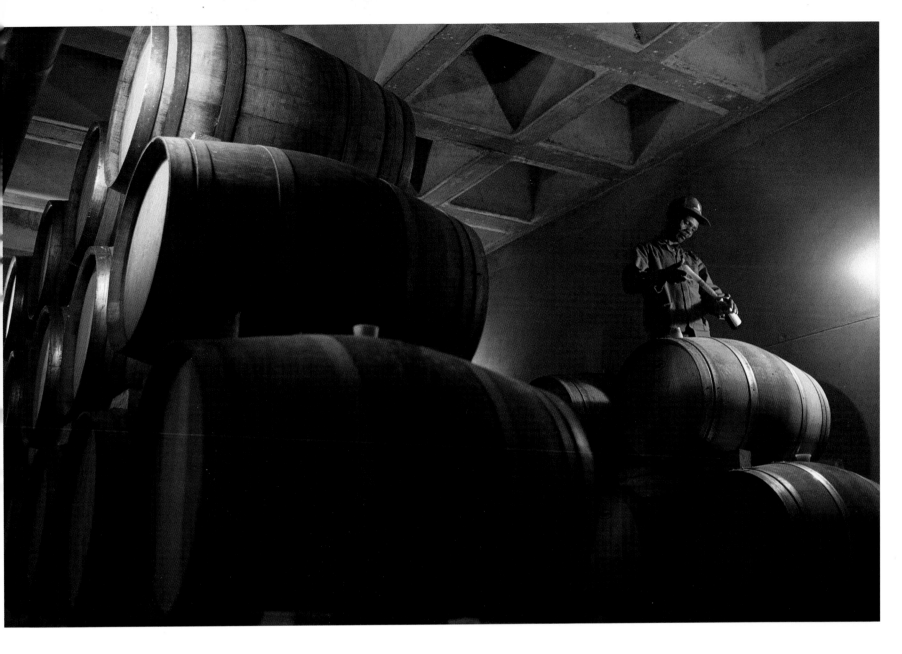

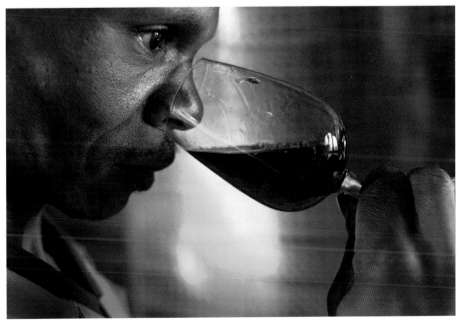

Awie Adolph, a former farmhand, is now cellarmaster at Fairview Wine Estate.

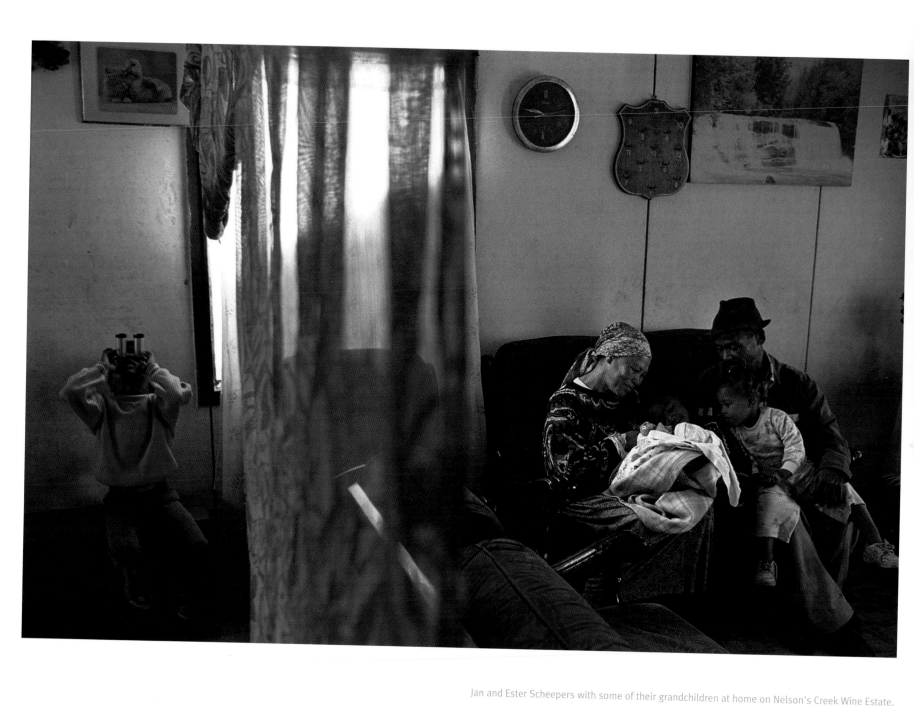

Jan and Ester Scheepers with some of their grandchildren at home on Nelson's Creek Wine Estate.

The Fair Valley community has used the profits from their own wine to build eight new houses, which have been occupied by the longest-serving employees.

Children from Nelson's Creek at Windmeul Primary School. The workers are making every effort to have their children educated.

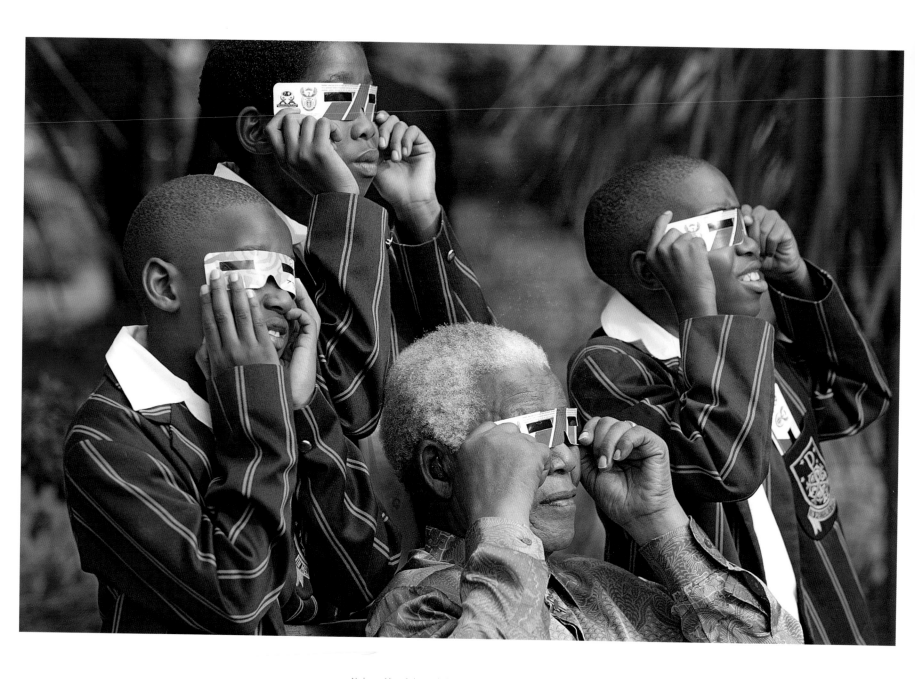

Nelson Mandela and children viewing a solar eclipse, Houghton, Johannesburg. [ **Debbie** Yazbek / Independent Newspapers ]

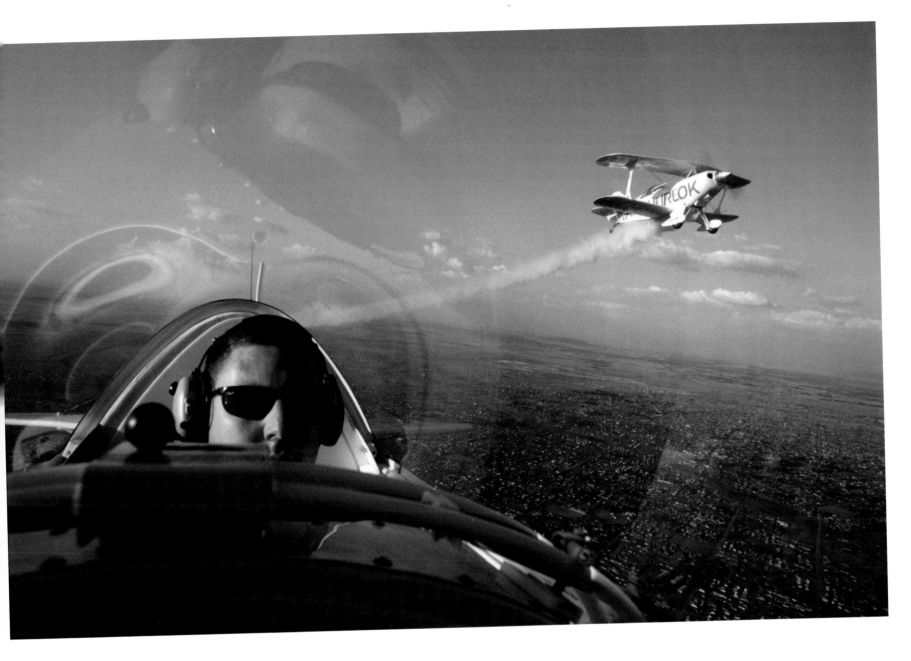

Ellis Lervin, a member of the Shurlok aerobatics team, performing over the Rand Easter Show, 1999. [ **Steve** Lawrence / Independent Newspapers ]

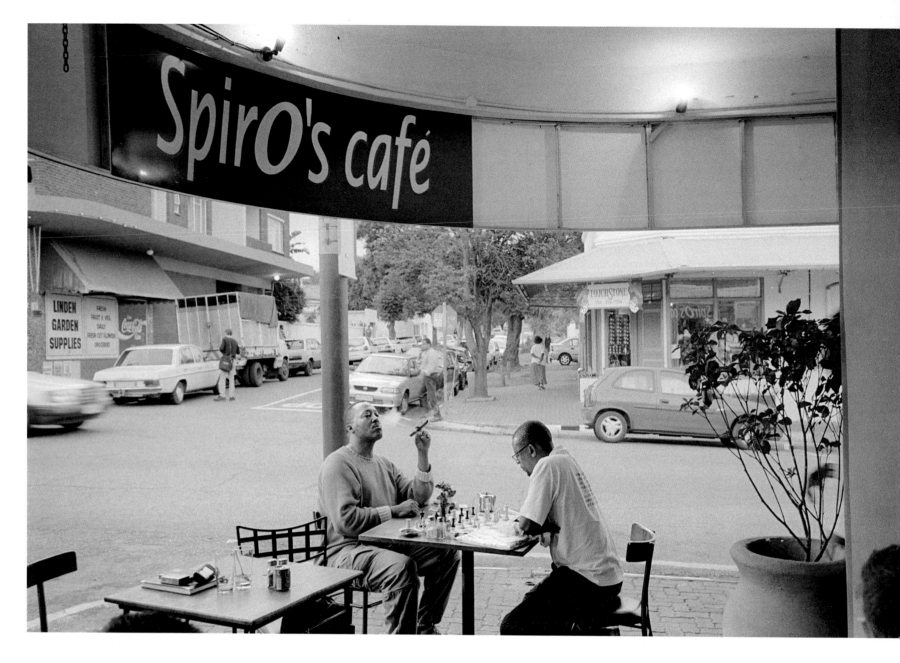

Chess players in Melville, Johannesburg. [ **George** Hallett / South Photographs

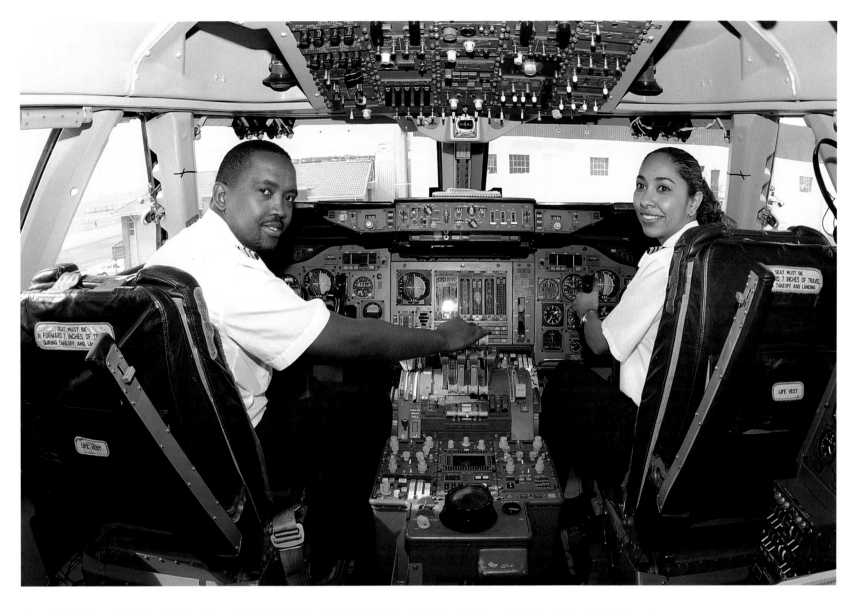

Captain Mpho Mamashela, South African Airways' first black pilot, with first flight officer Amina Moola in the cockpit of an airliner. [ **Peter** Morey ]

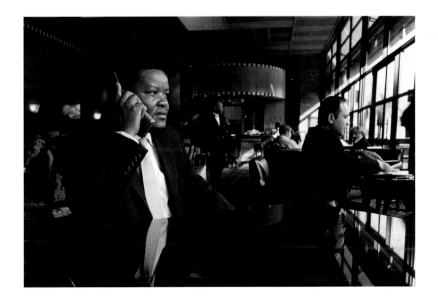

Saki Macozoma, businessman and adviser to the president, at the Hyatt Hotel in Rosebank, Johannesburg. [ **Graeme** Williams / South Photographs ]

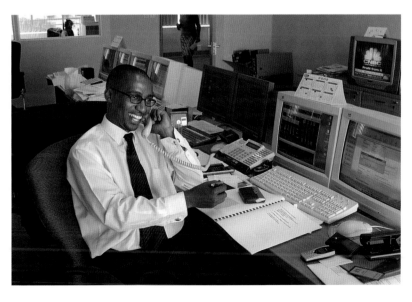

The stockbroker Andile Mazwai, Rosebank, Johannesburg. [ **Louise** Gubb / Trace Images ]

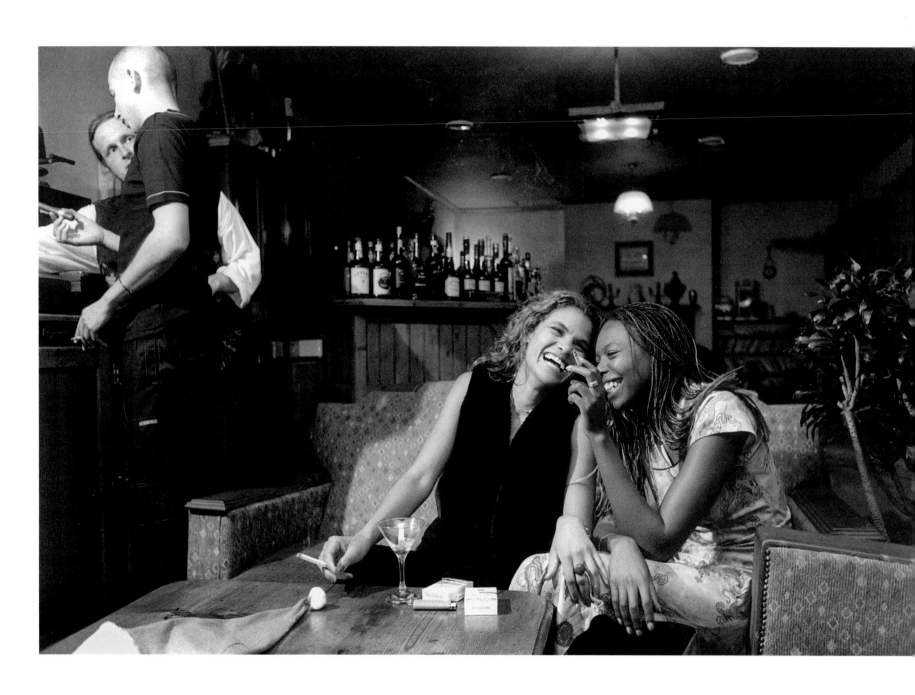

Cigar bar, Westdene, Johannesburg. [ **Jürgen** Schadeberg

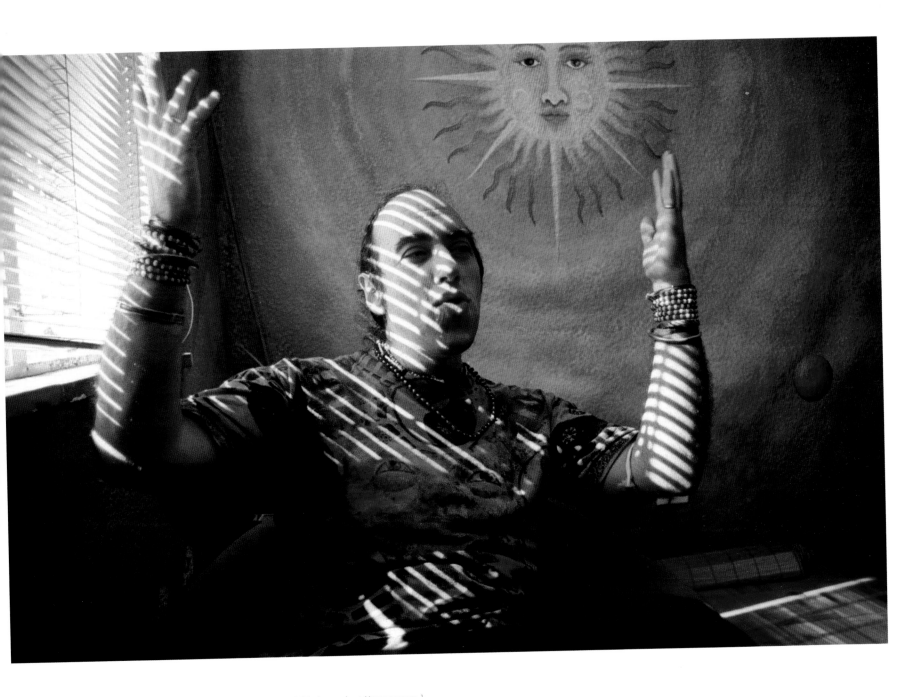

The astrologer Rod Saskin, Vredehoek, Cape Town. [ **Rogan** Ward / Independent Newspapers ]

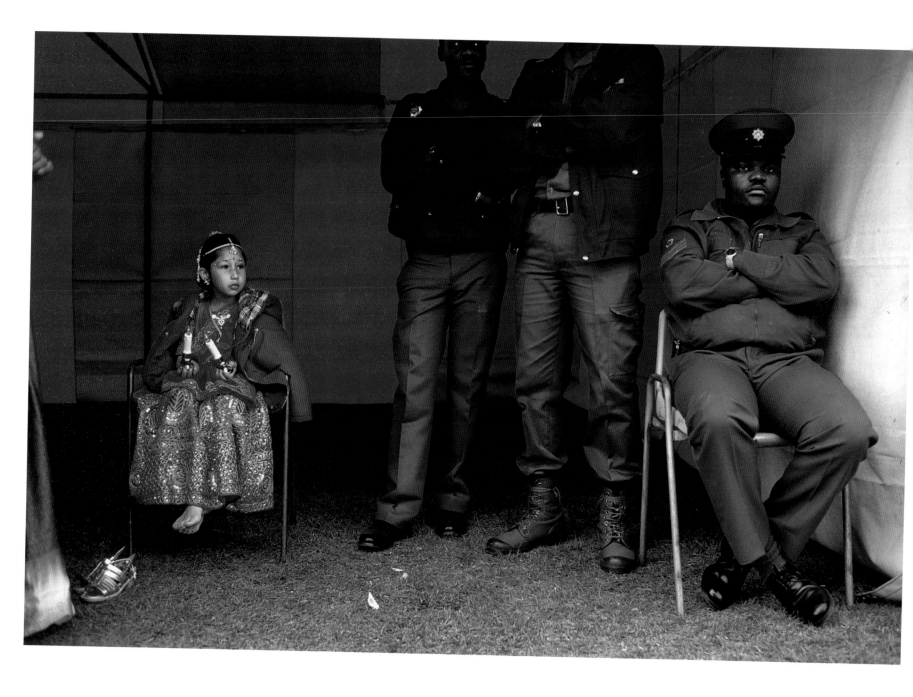

Divali, Lenasia, Gauteng. [ **Lori Waselchuk** ]

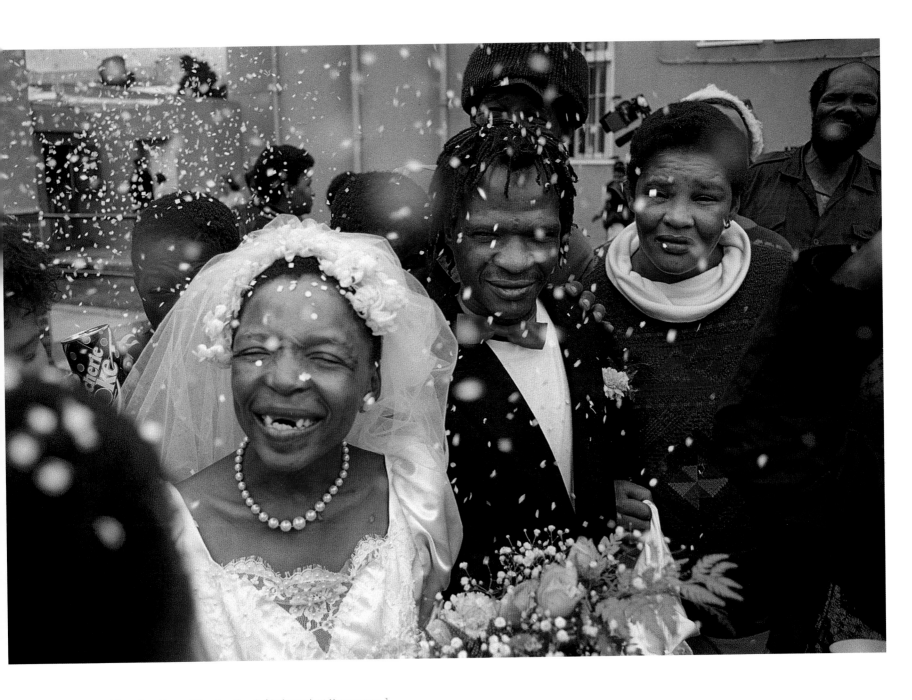

Homeless people's wedding, Cape Town. [ **Brenton** Geach / Independent Newspapers ]

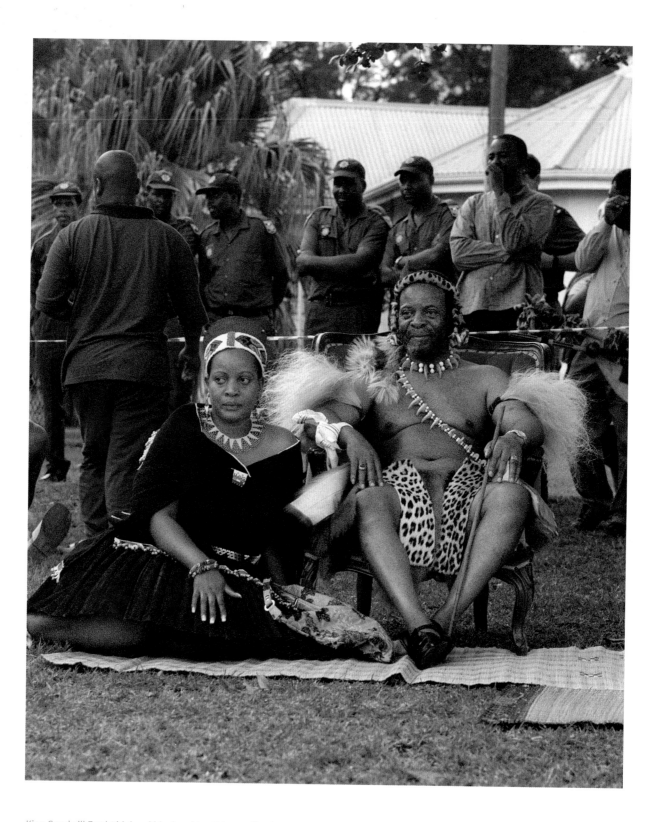

King Goodwill Zwelethini and his daughter, Princess Nombuso, Nongoma, KwaZulu-Natal. [ **Andile** Komanisi ]

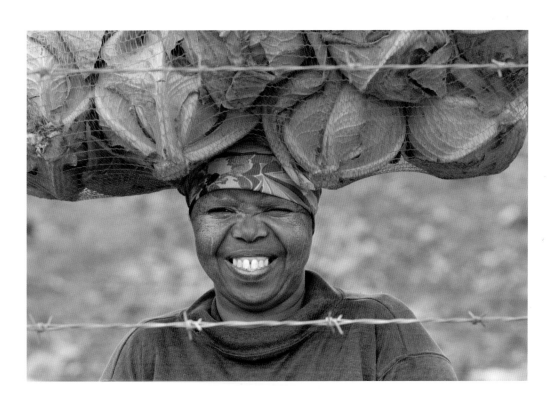

Trainee sangoma, Heidelberg, Gauteng.
[ **Debbie Yazbek** / Independent Newspapers ]

Woman with cabbage, Port Shepstone, KwaZulu-Natal. [ **Benny Gool** ]

Punters at the J&B Metropolitan Handicap, 2002.

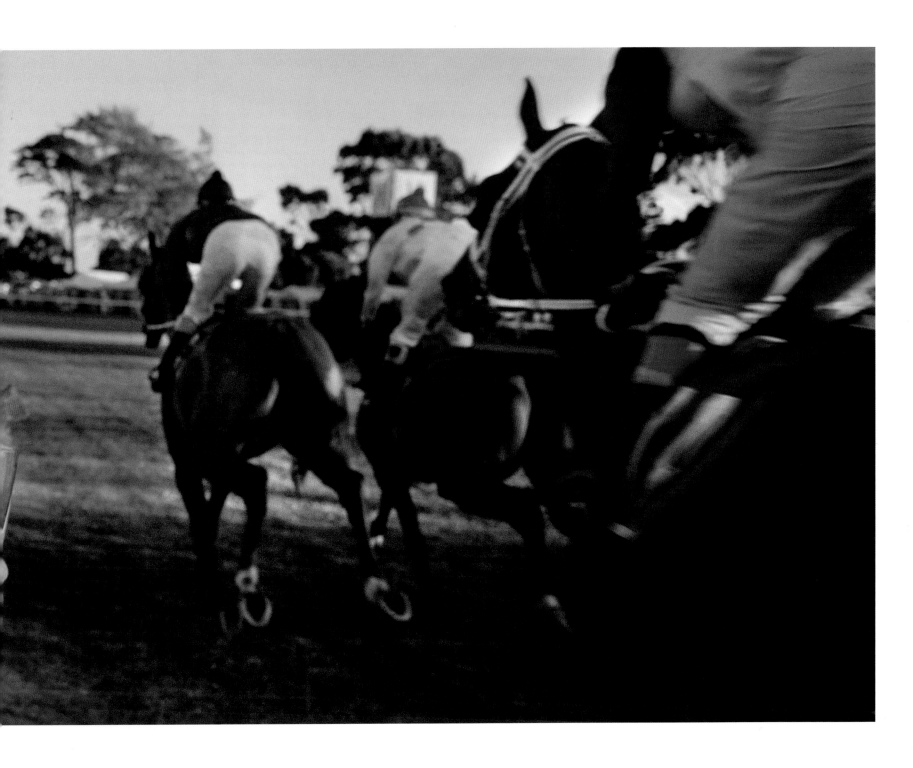

Beach dance, Buffels Bay, Cape Peninsula, 2001.

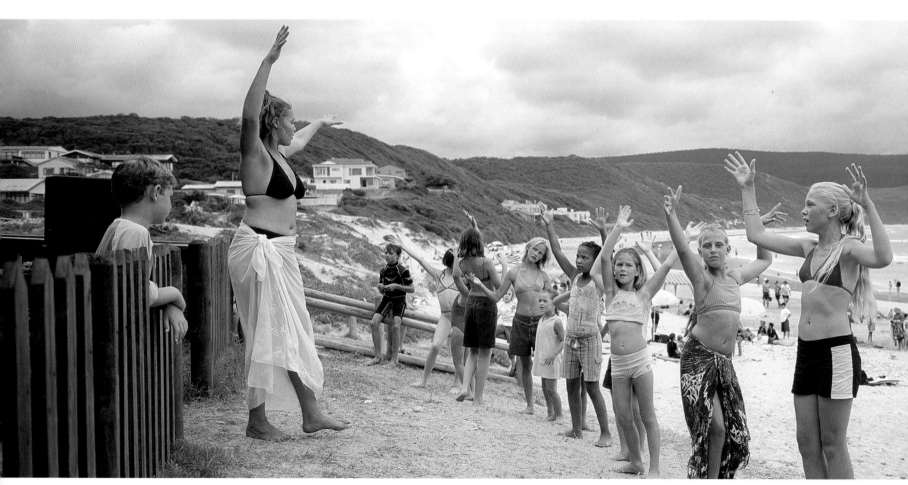

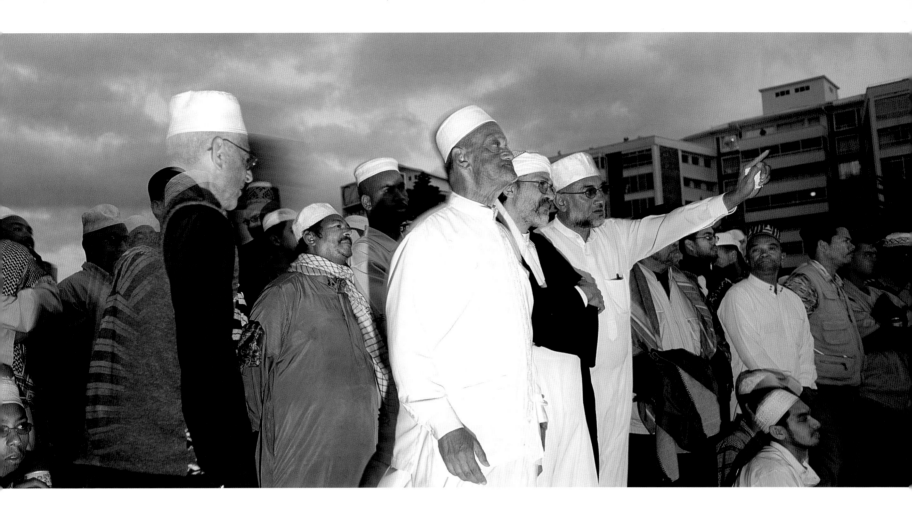

Muslims gather at Sea Point for the sighting of the moon signifying the end of Ramadan and the celebration of Eid. Cape Town, 15 December 2001.

Minstrel carnival, Cape Town, 2001.

Portia and a friend celebrate their successful matric results, Clifton, Cape Town, December 2001.

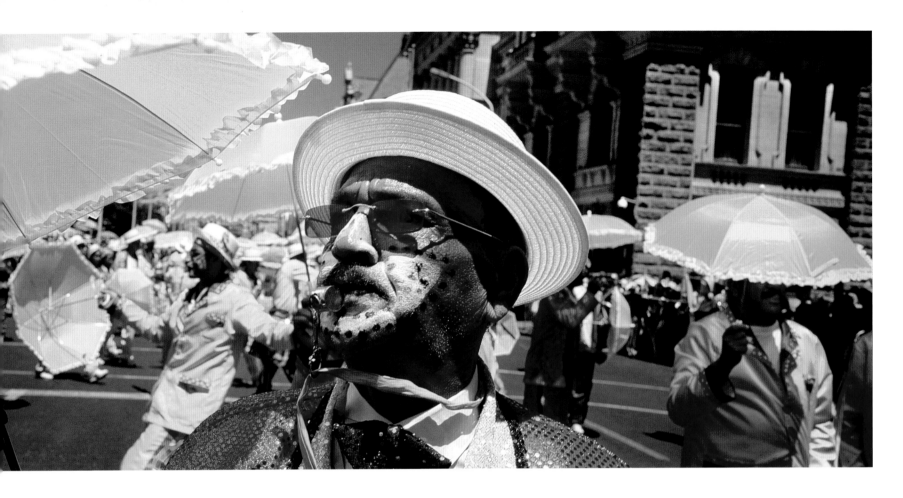

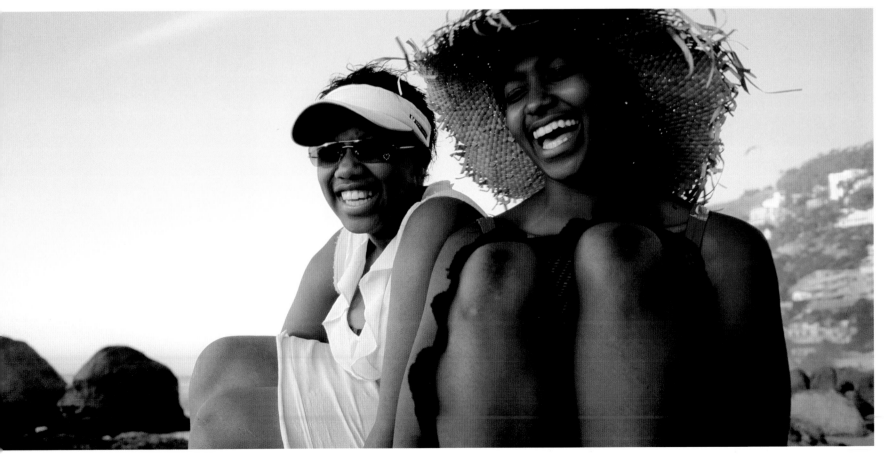

# obie **oberholzer** [happysadland]

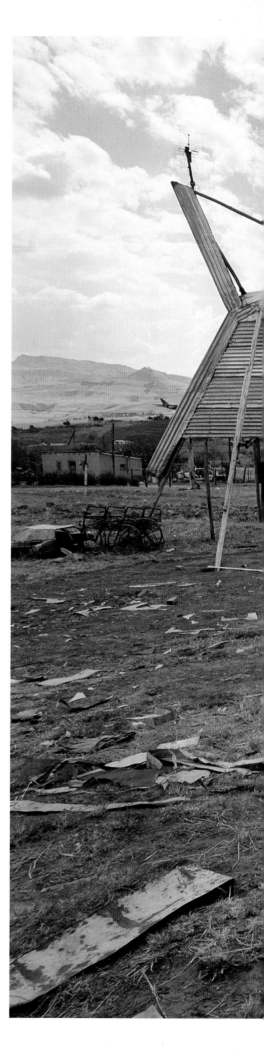

Sibusiso Mbhele the planemaker, near Zwelitsha, 1999.

Jan Golly laughing at me in Voortrekkerstraat, Niewoudtville, Northern Cape. 1999.

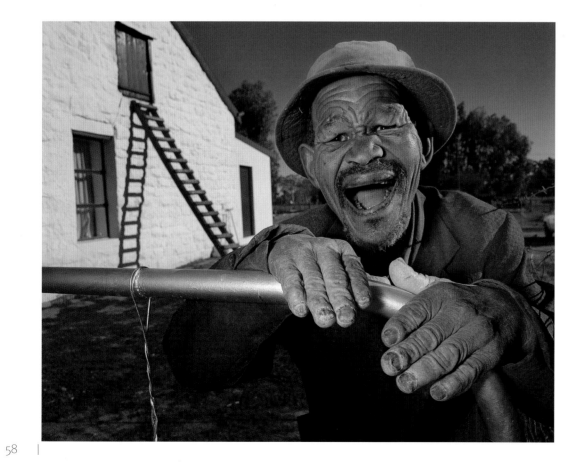

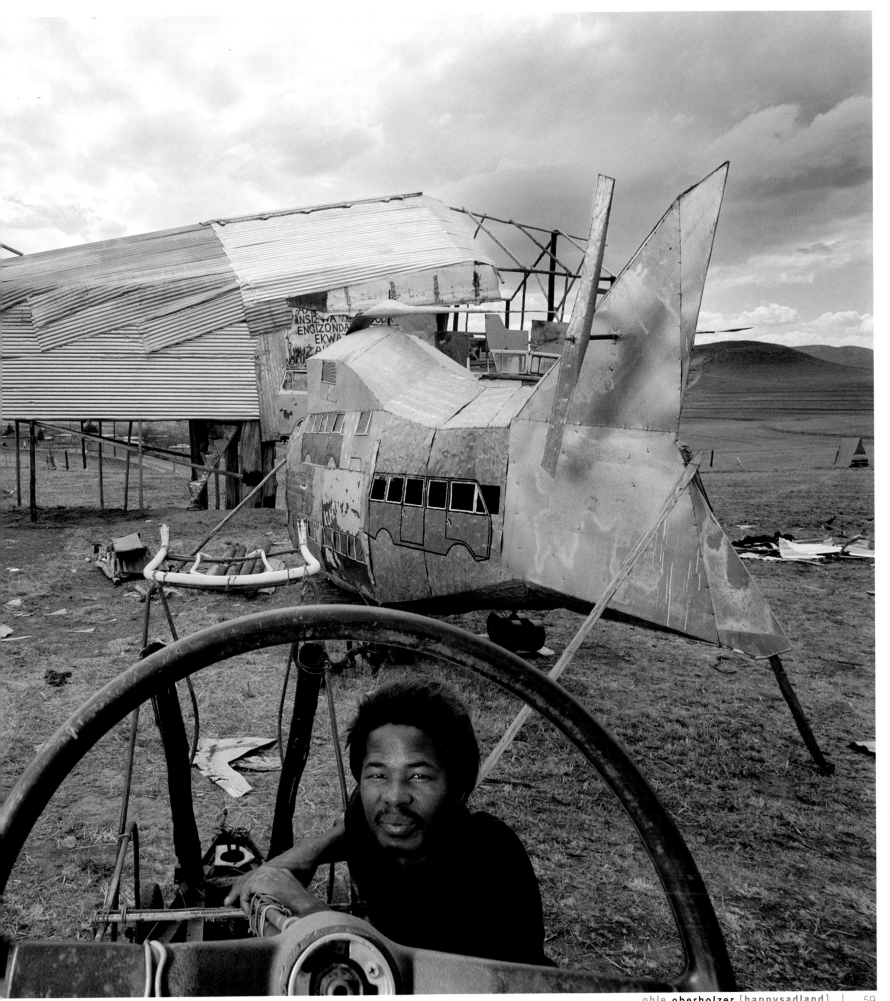

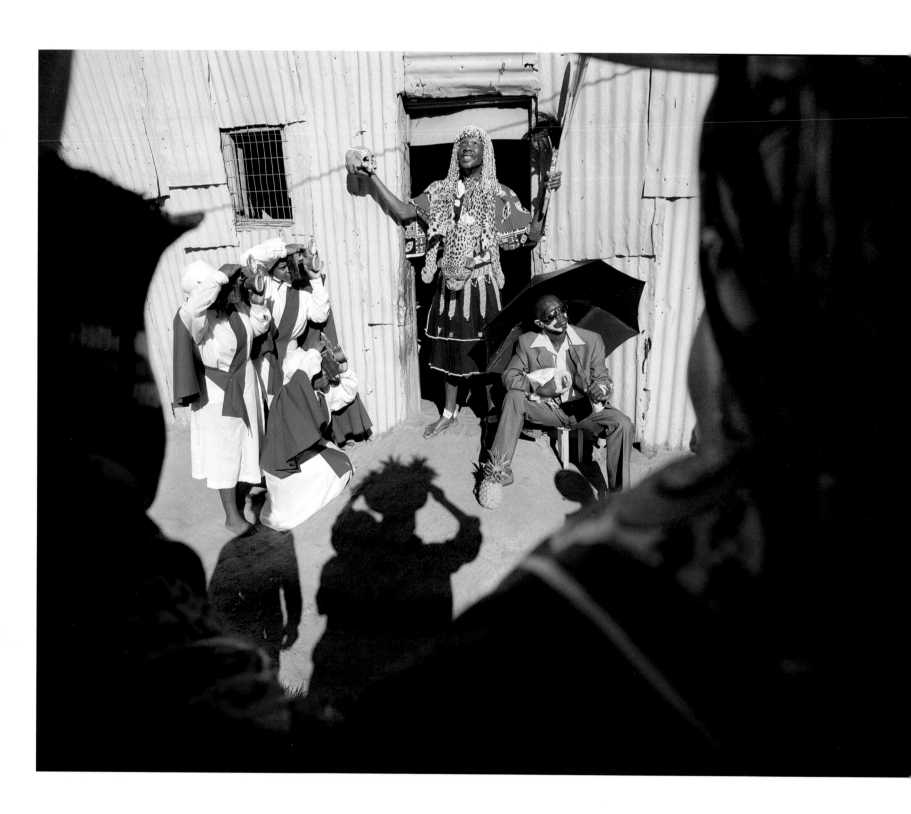

Ancestral skull that came alive in Brett Bailey's play, 1997

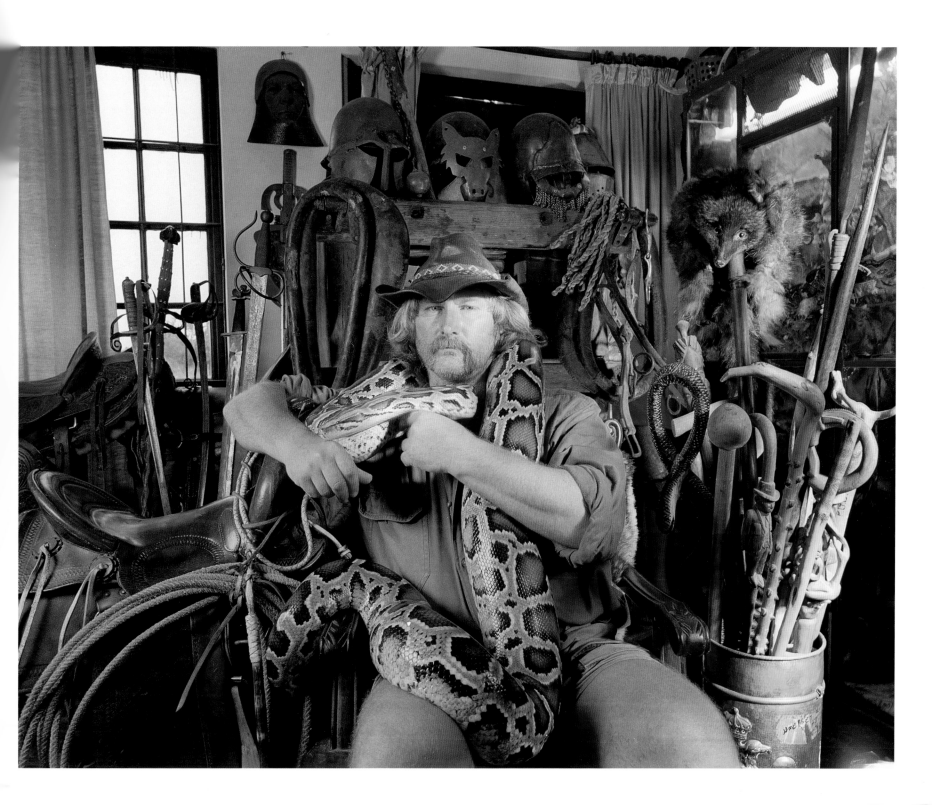

Basil Mills and Monty the Python, Grahamstown, 2000.

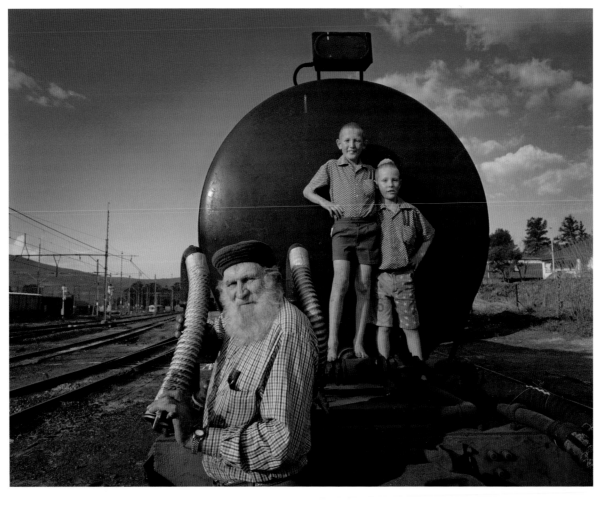

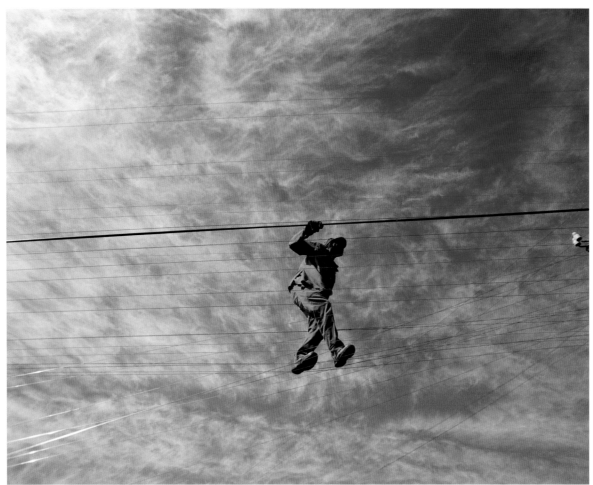

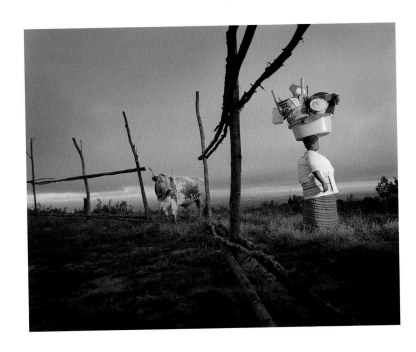

Very happy man using Uvoto poster as shelter in a storm.
Butterworth, 2003.

Basil's tame ox watching Silvia. Outside Grahamstown,
Eastern Cape. 1999.

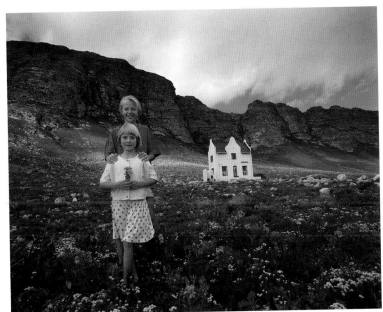

Elanie and Merinda with their holiday house, Betty's Bay,
Western Cape. 1994.

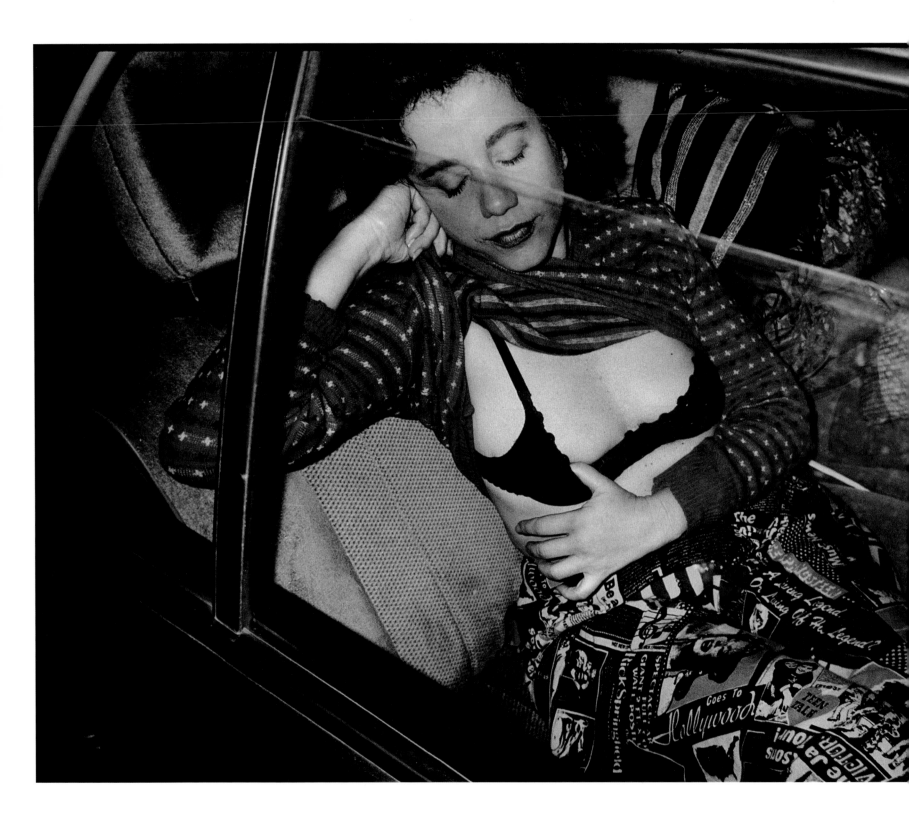

Winnie. 44a Louis Botha Avenue, Berea, Johannesburg, 1996.

Sharon Bone. New moon. Johannesburg, 2000.

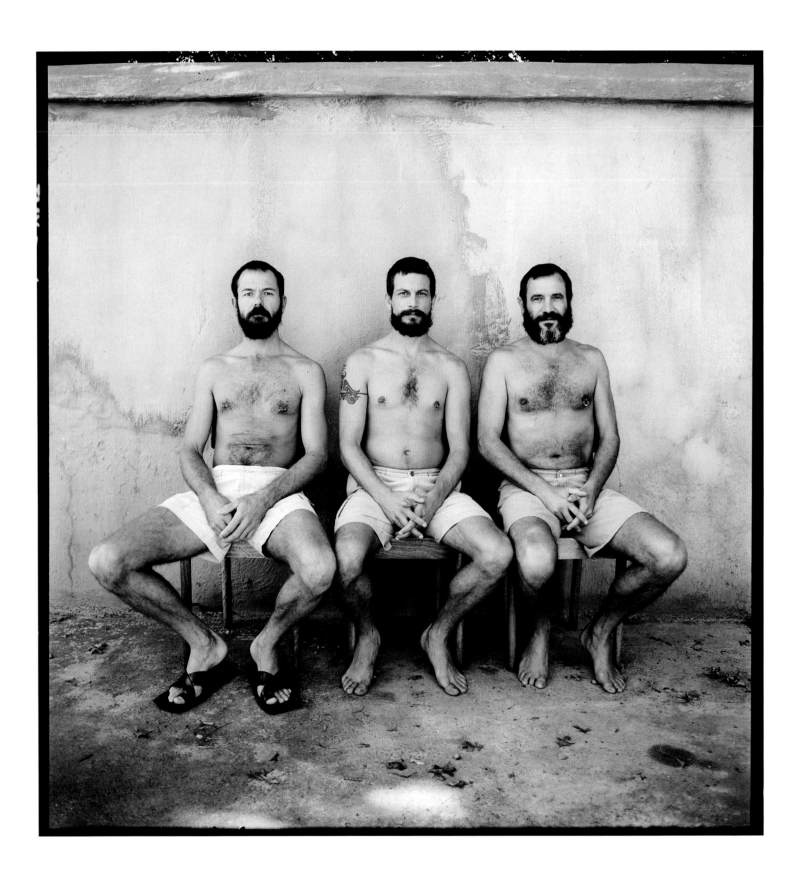

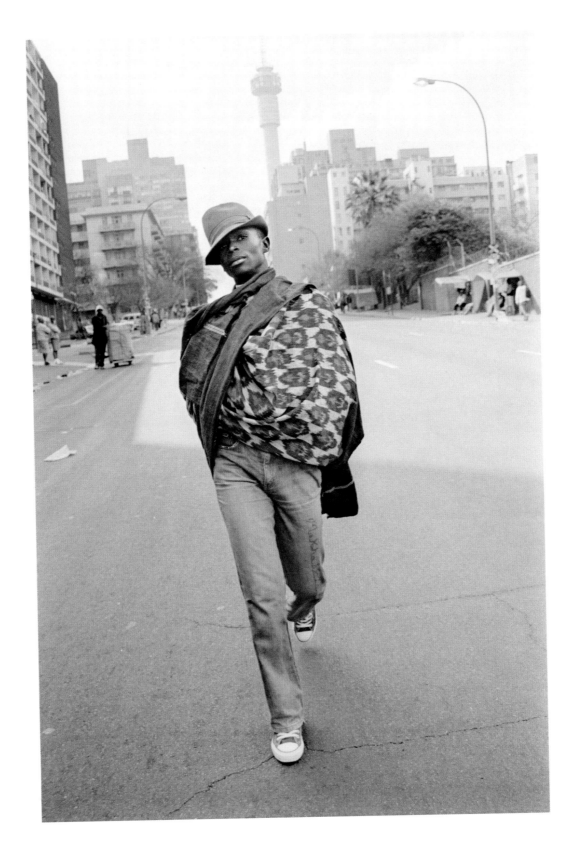

Martin Machapa. Claim Street, Johannesburg. August 2001.

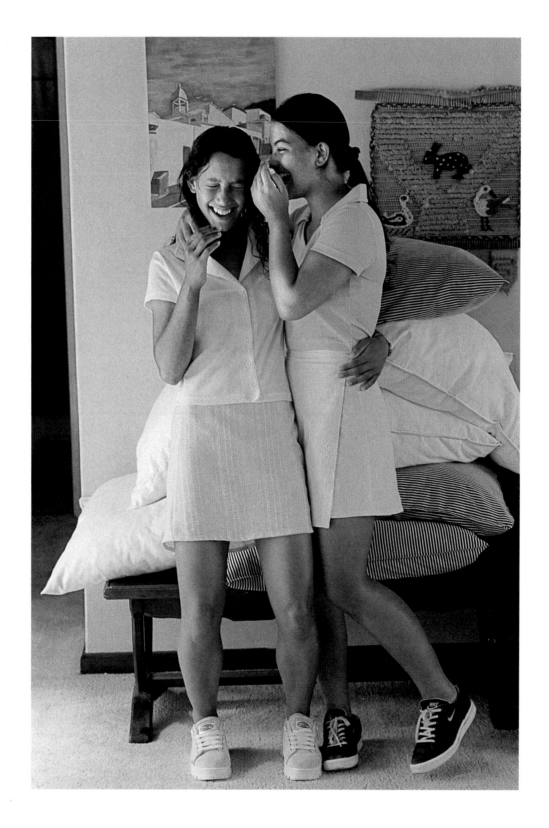

Teenagers.

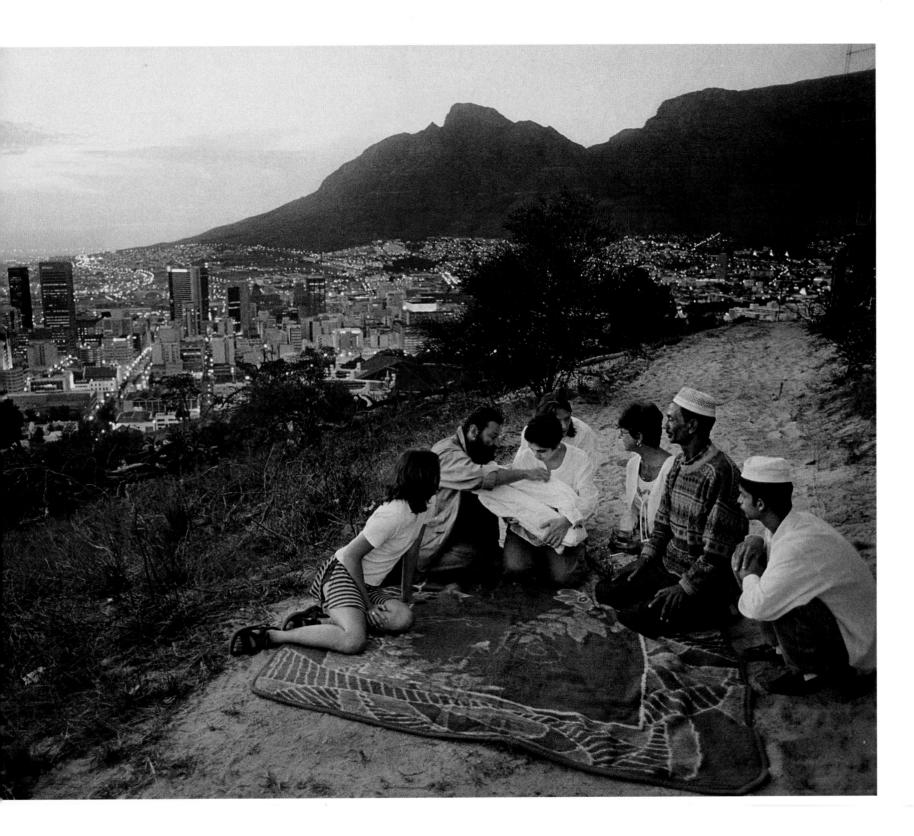

Naming the child, Signal Hill.

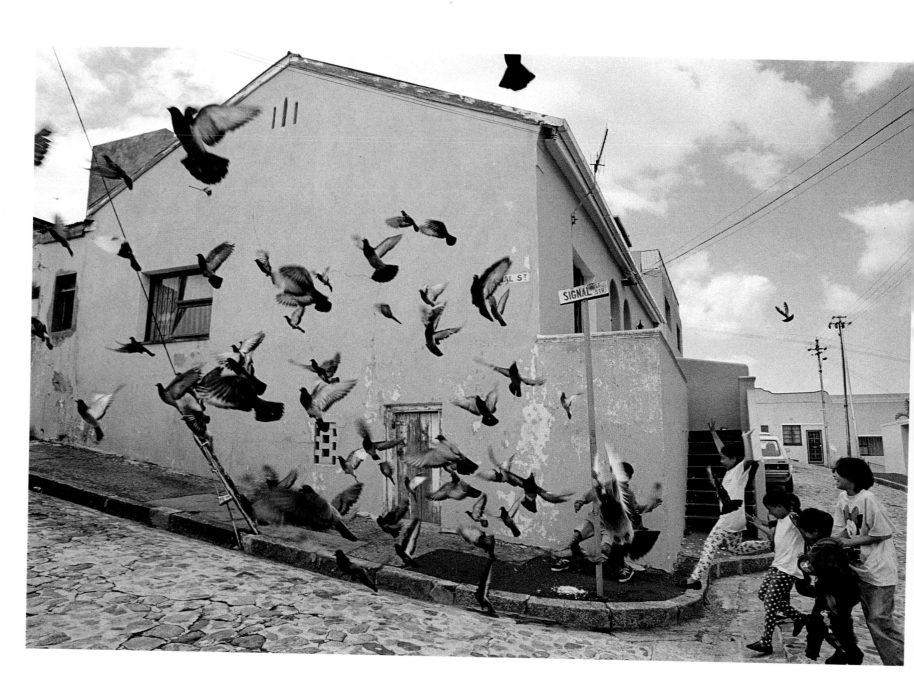

Pigeons on Signal Street.

...arate class.

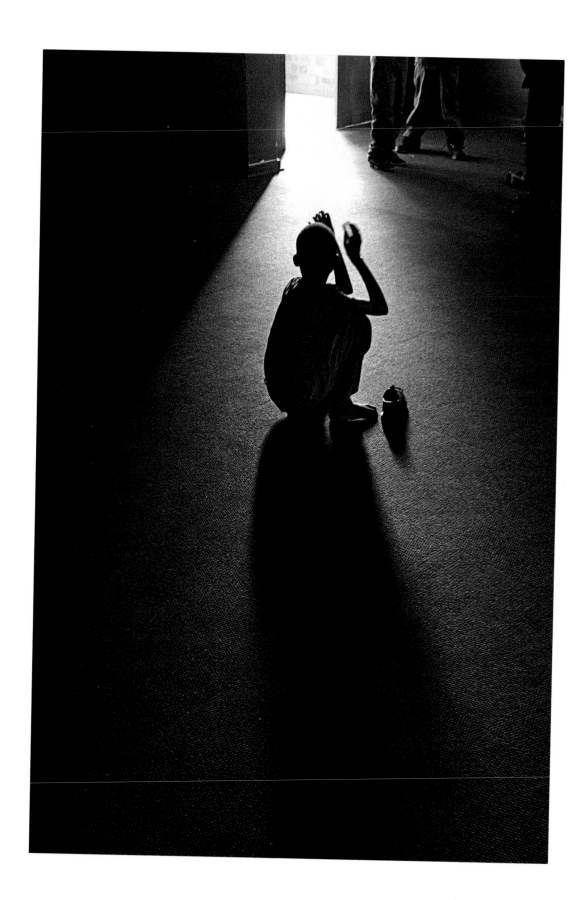

A blind and deaf pupil at the Sibonile School for the Blind at Klip River, south of Johannesburg, soaks up the last rays of the afternoon sun while waiting for a housekeeper to lead him back to his dormitory. [ Siphiwe Sibeko / Independent Newspapers ]

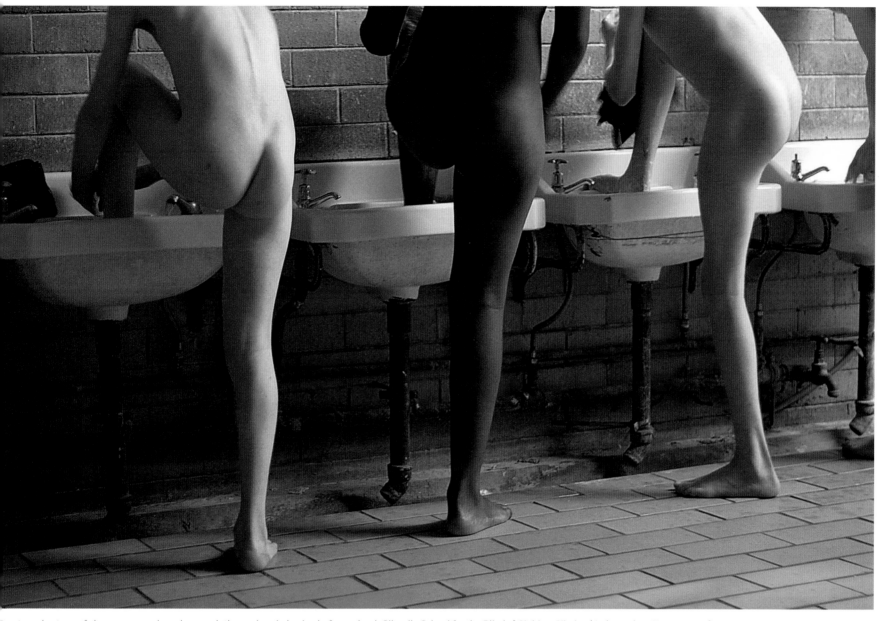

Due to a shortage of showers, some boarders wash themselves in basins before school. Sibonile School for the Blind. [ **Siphiwe** Sibeko / Independent Newspapers ]

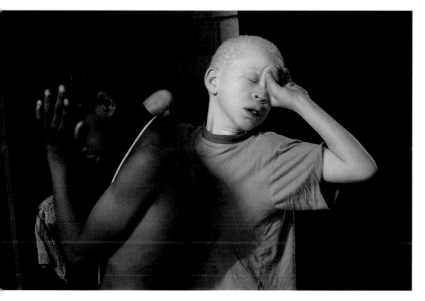

uvo Ntila, 12, right, and Paseka Lentsha queue for a shower in the boarding school, ibonile School for the Blind. [ **Siphiwe** Sibeko / Independent Newspapers ]

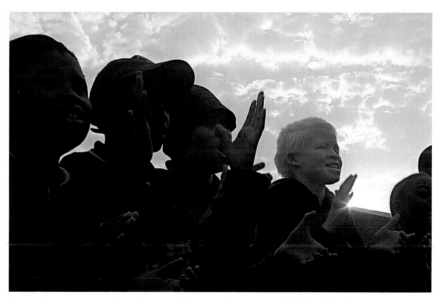

Berlina Motswahole, 13, far right, leads fellow pupils in a song, Sibonile School for the Blind. [ **Siphiwe** Sibeko / Independent Newspapers ]

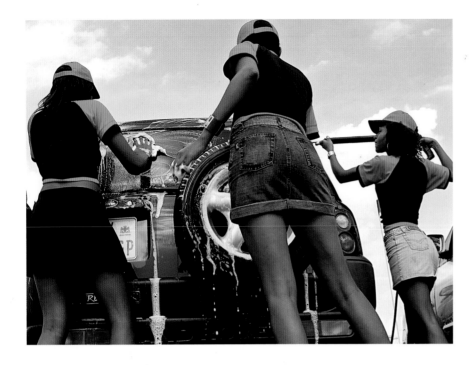

Car wash on a Sunday afternoon. Alexandra, Johannesburg.
[ **Neo Ntsoma** / Independent Newspapers ]

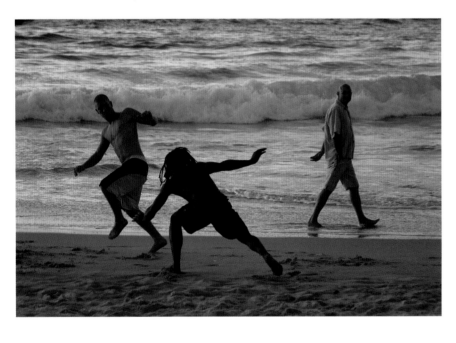

Friends playing, Clifton Beach, Cape Town. [ **Jeremy Jowell** ]

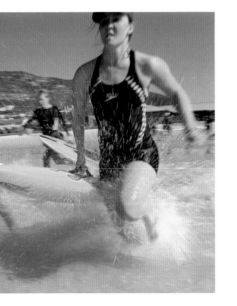

Members of the Fish Hoek Surf Life Saving Club in training,
Cape Town. [ **Mark Hutchinson** / Independent Newspapers ]

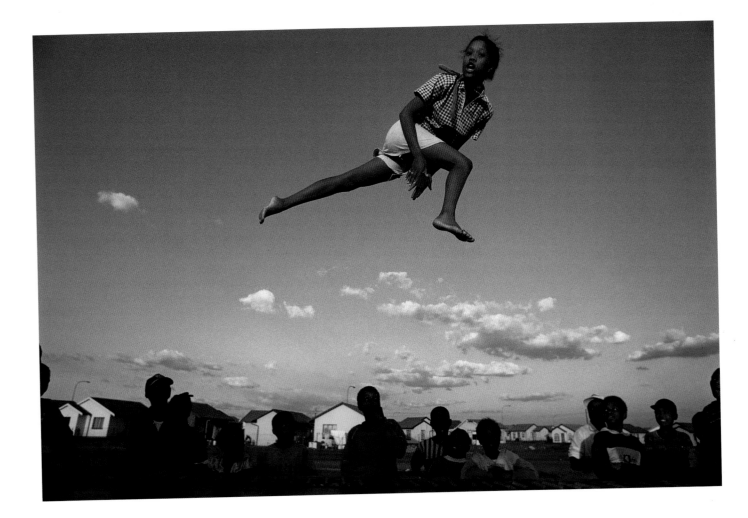

Girl on trampoline at a new housing project, Soweto. [ **Jodi Bieber** / South Photographs ]

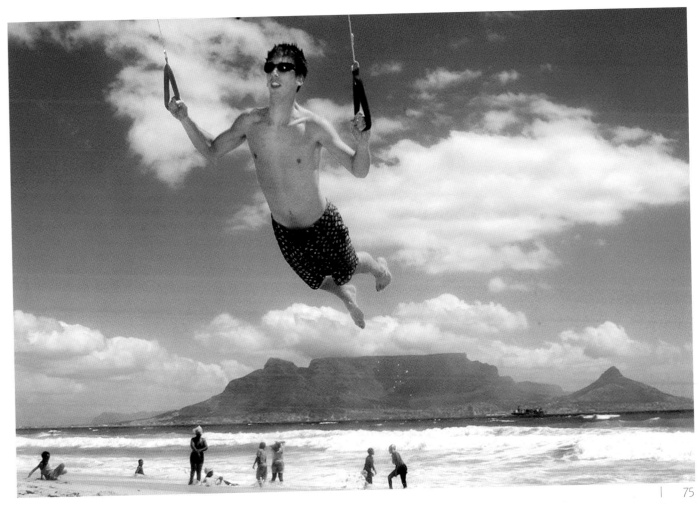

Kite surfing, Blaauwberg, Cape Town. [ **Mike Hutchings** / Reuters ]

75

Youths 'driving wheels' on land restored to the Bakubung tribe after the transition to democracy, Boons, North West. [ Shaun Harris / Afrika Moves ]

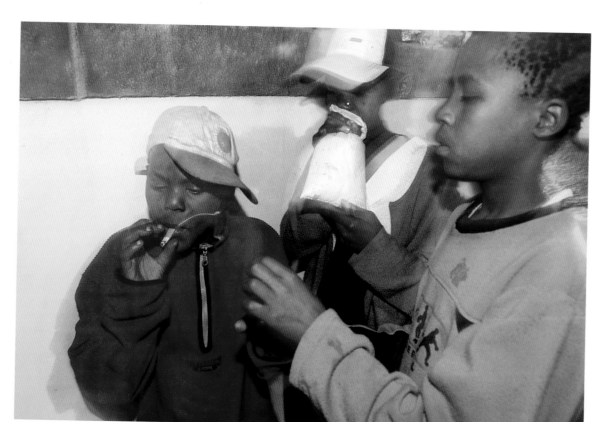

Street children, Cape Town.
[ Rogan Ward / Independent Newspapers ]

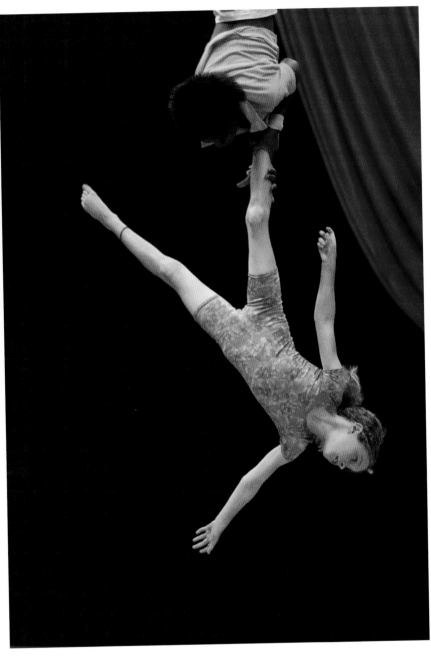

Zip Zap Circus, Cape Town. [ **Mike** Hutchings / Reuters ]

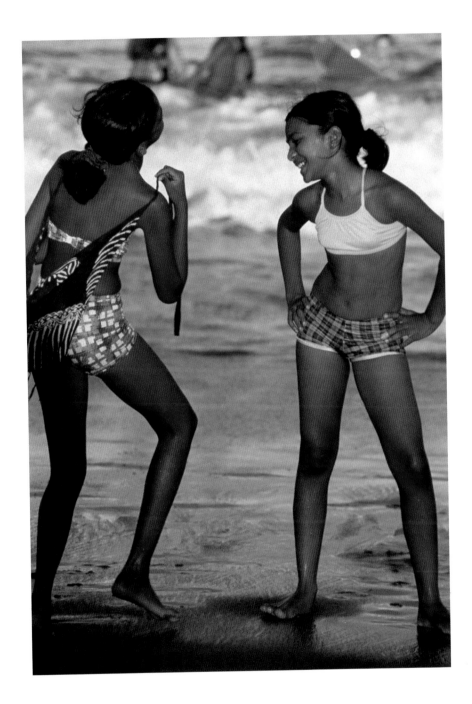

Young bathers, Amanzimtoti, KwaZulu-Natal. [**Paul** Weinberg / South Photogarphs]

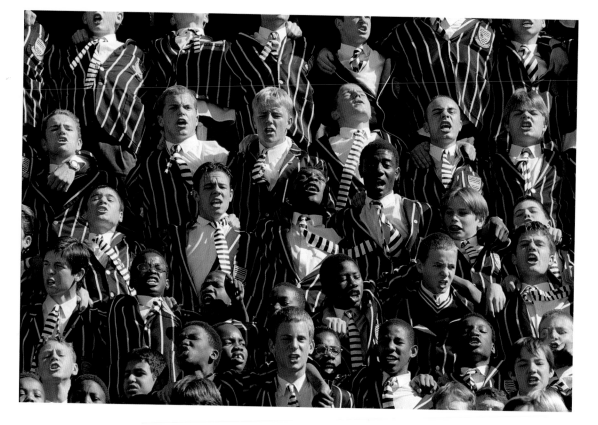

Pupils of Jeppe Boys' High School in Johnnesburg support their first rugby team against their archrivals, King Edward College. [ John Hogg ]

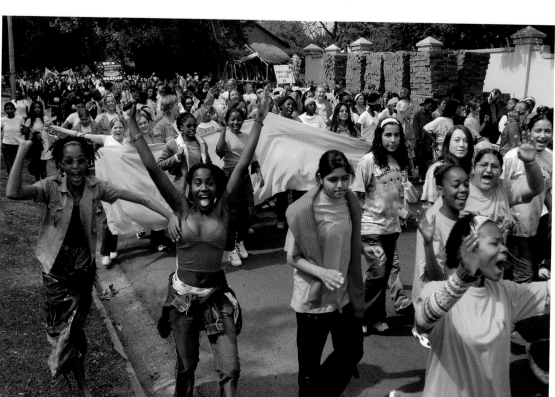

Fun day, Parktown Girls' High School, Johannesburg. [ Louise Gubb / Trace Images ]

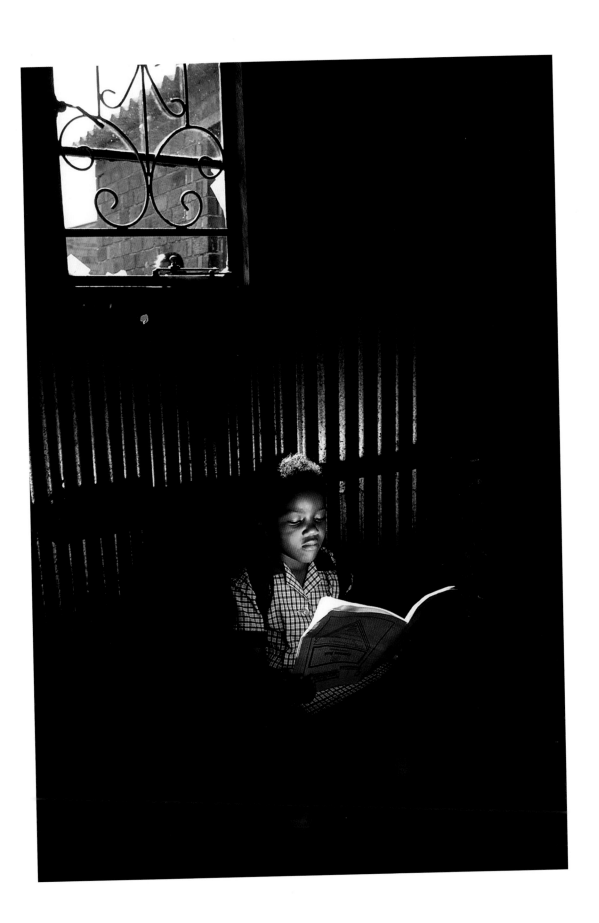

Molai Mpolokeng studying in a backyard shack, Soweto. [ **Mujahid Safodien** / Independent Newspapers ]

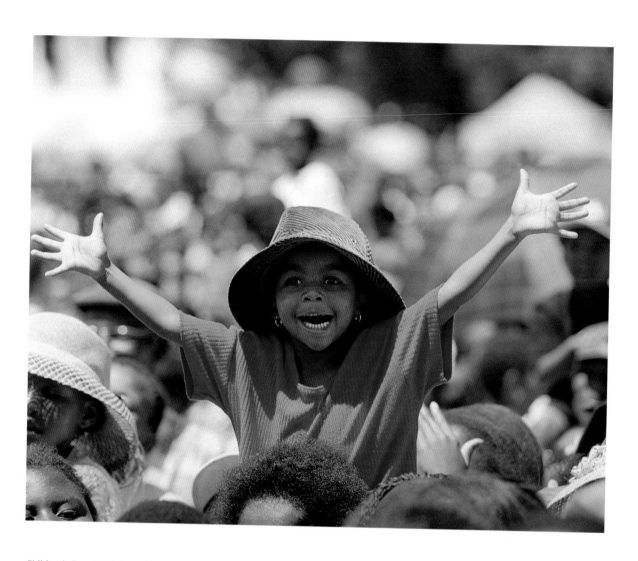

Children's Day, Zoo Lake, Johannesburg. [ **John Hogg** ]

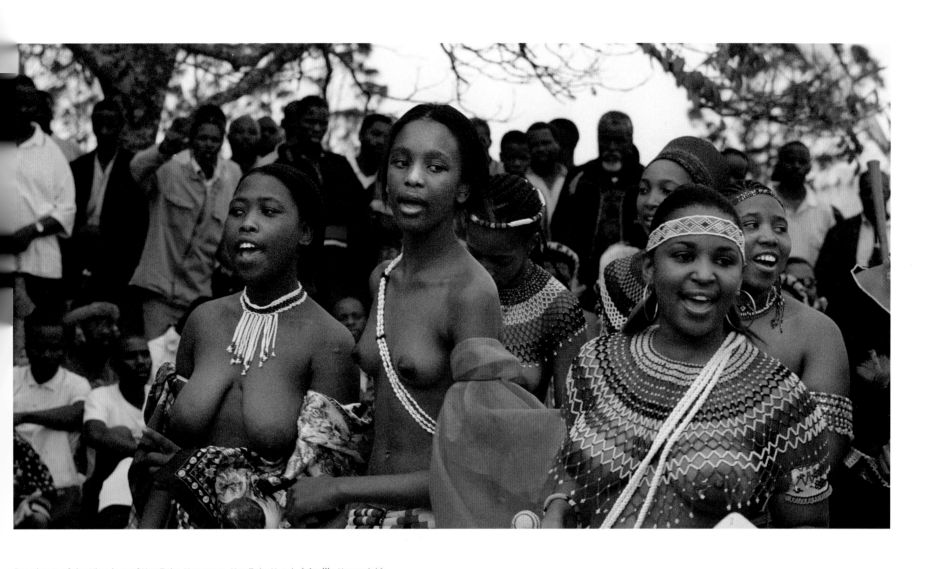

Daughters of the Kingdom of KwaZulu, Nongoma, KwaZulu-Natal. [ **Andile** Komanisi ]

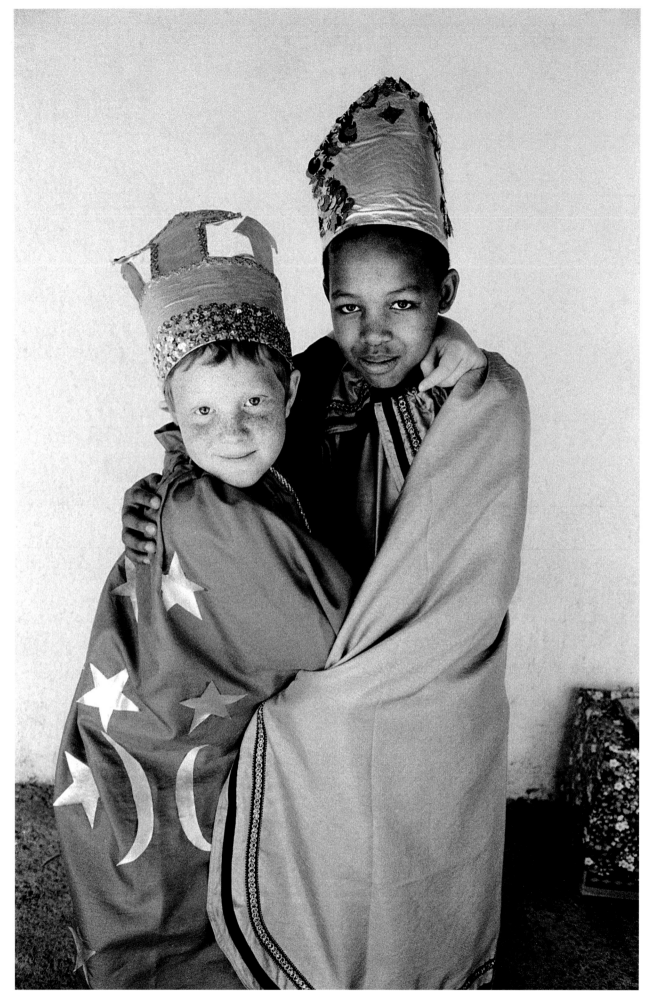

Paul and Charlie in a Nativity play. [ Jürgen Schadeberg ]

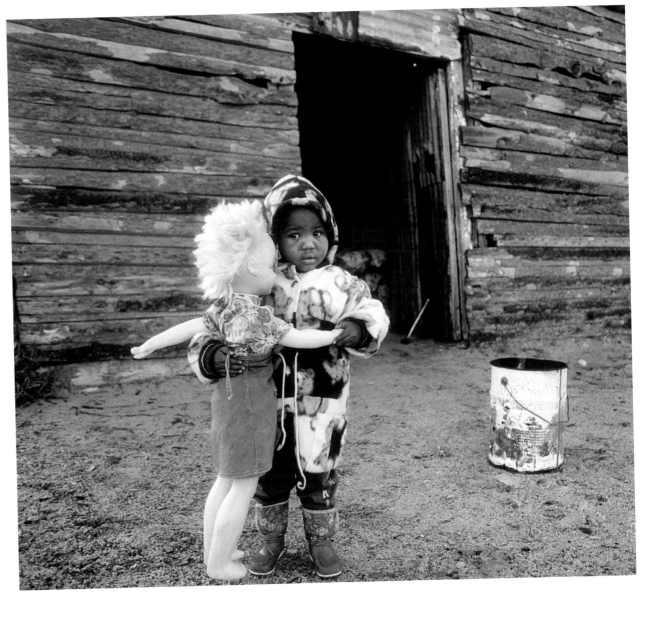

Site B, Khayelitsha, Western Cape. [ Fanie Jason ]

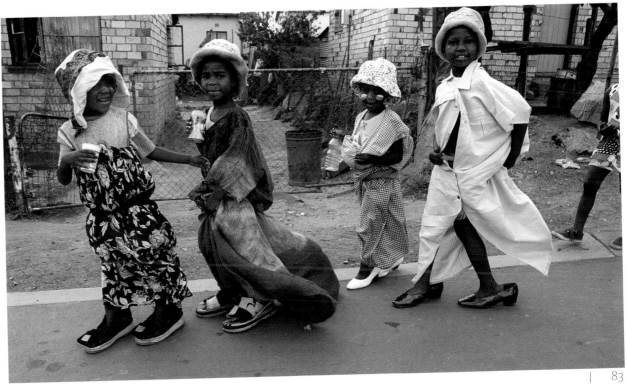

Penny Guy Fawkes, Soweto, 5 November 2000.
[ T J Lemon / Independent Newspapers ]

African skipping: the skipper sets out to weave a design around her body with the rope.

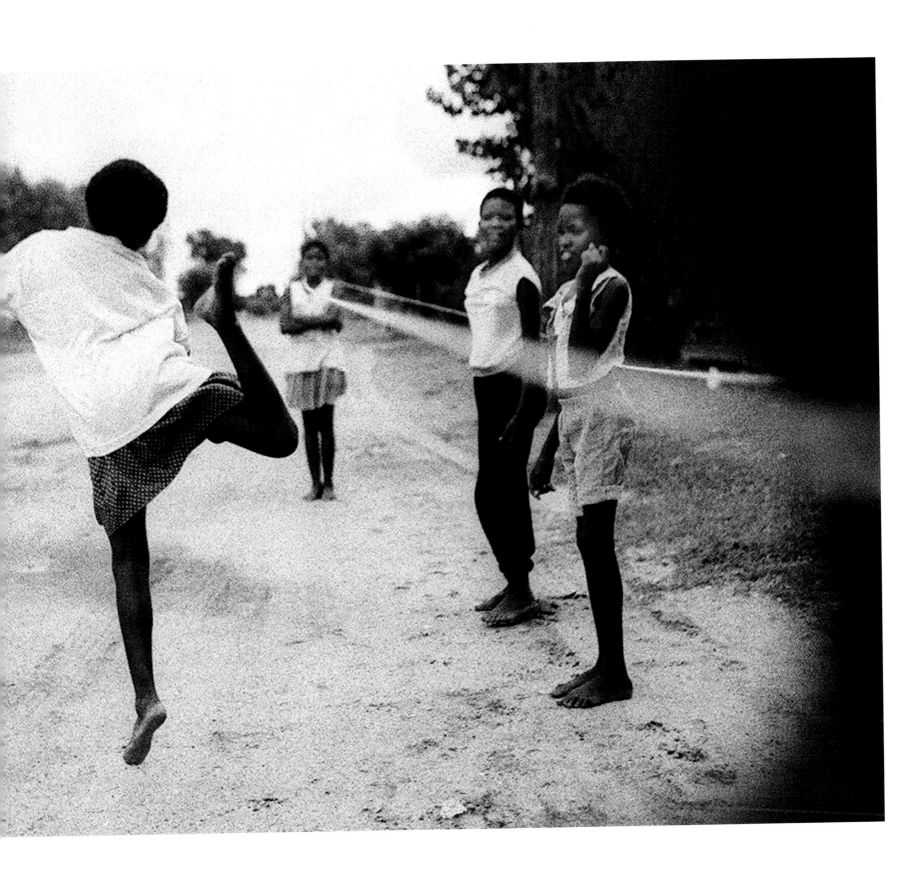

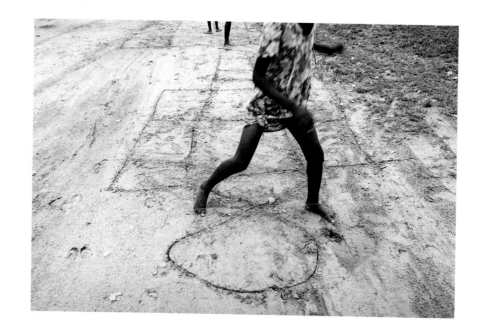

Hopscotch, a universal game, is also played in South Africa's villages and townships.

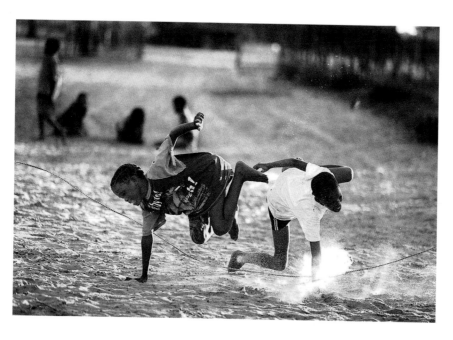

*Dipere*, or 'horse'. Players jump around on all fours while others try to trip them up with a rope.

*Kgati*, a rhythmic jumping game popular among girls. Two players swing the rope, while the others jump.

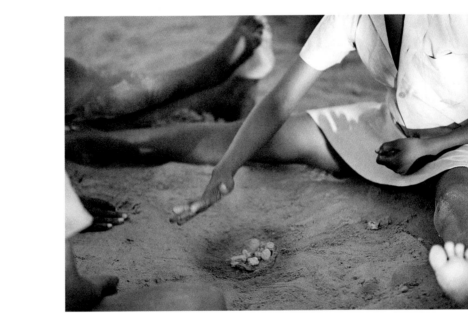

'No entry', or 'gates'. The best player is the one that can make the most complicated designs.

*Diketo*. Players throw a stone in the air, and have to snatch stones from the hole before catching the one in the air on its way down.

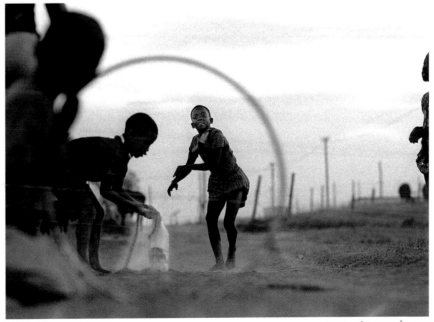

*Meteme*. Two children try to hit a third with a ball while he or she fills a bottle with sand.

## gísèle **wulfsohn** [bongani's day]

These photographs are drawn from material for a children's book commissioned by Frances Lincoln Publishers in London. One of a series from around the world, it tracks a day in the life of Bongani Mofokeng, who lives in Westdene, Johannesburg, with his aunt, Manana Coplan, her husband, David, and his cousins, Florrie and Thabi. *Bongani's day – from dusk to dawn in a South African city* will be published by Pan Macmillan South Africa.

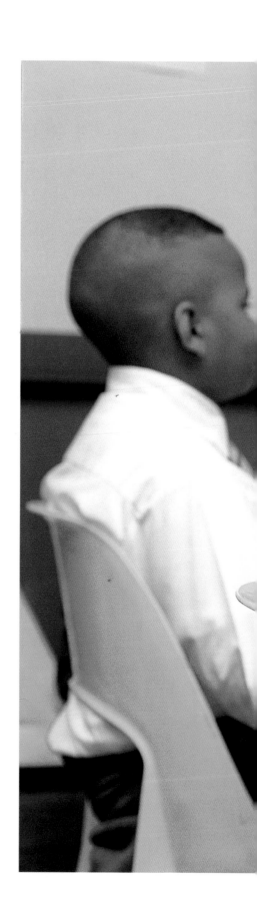

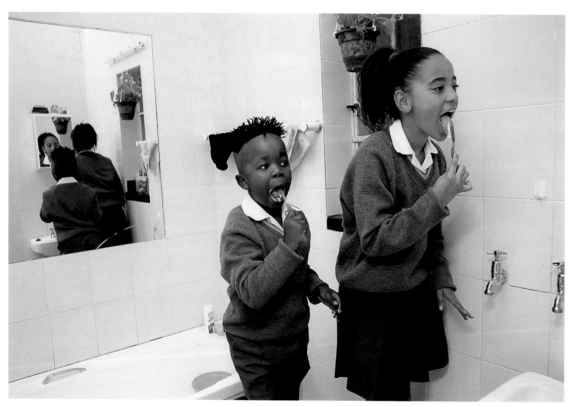

Bongani and his cousin Thabi brush their teeth and tongues before school.

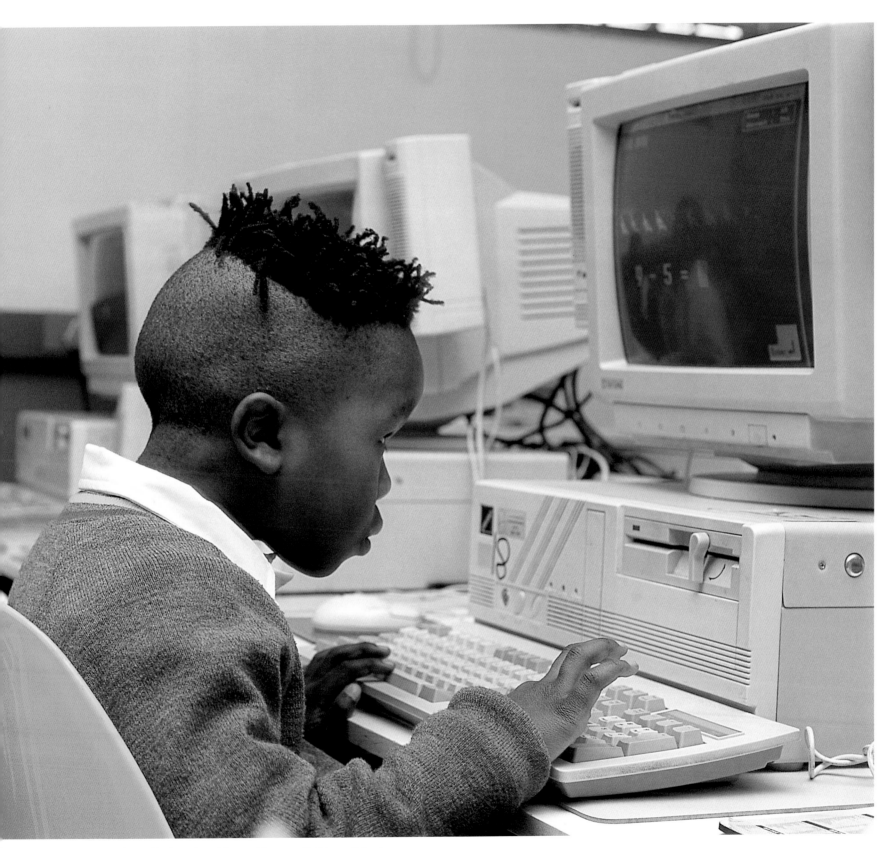

Bongani during a computer class – his favourite subject – at Emmarentia Primary School.

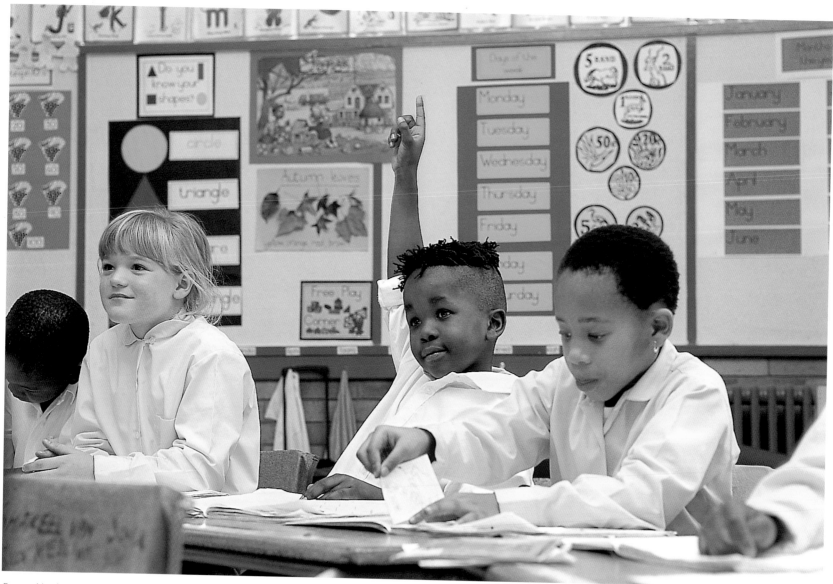

Bongani in class, Emmarentia Primary School.

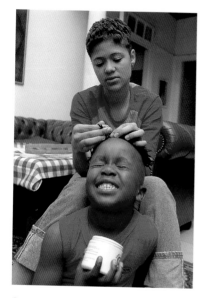

Bongani is a soccer fan, and wears the same hairstyle as his hero, Lucas Radebe. His cousin Florrie shaves the sides of his head, and helps him to wax his dreadlocks.

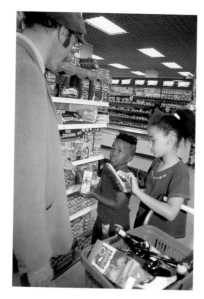

Bongani and Thabi negotiate for sweets during a grocery shopping trip.

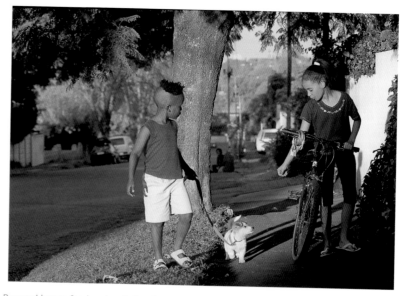

Bongani has to feed and walk the dog every day. Thabi keeps him company.

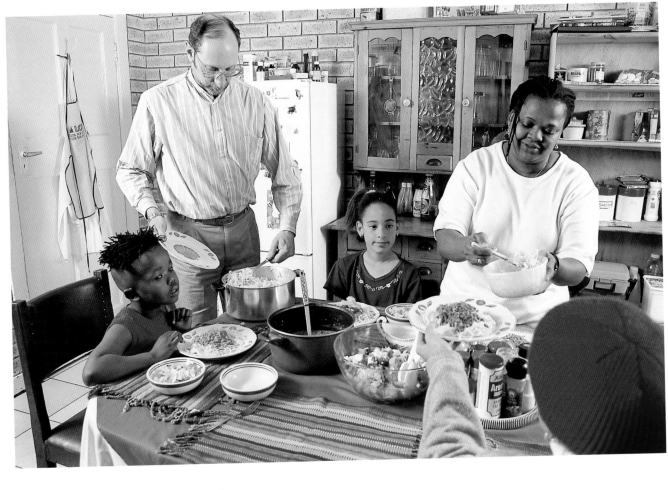

The Coplan family gather for a sit-down dinner.

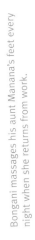

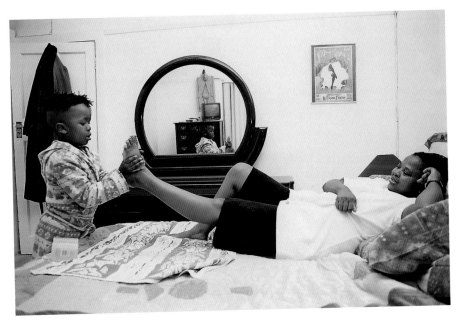

Bongani massages his aunt Manana's feet every night when she returns from work.

Thabi reads to Bongani from a Harry Potter book until he falls asleep.

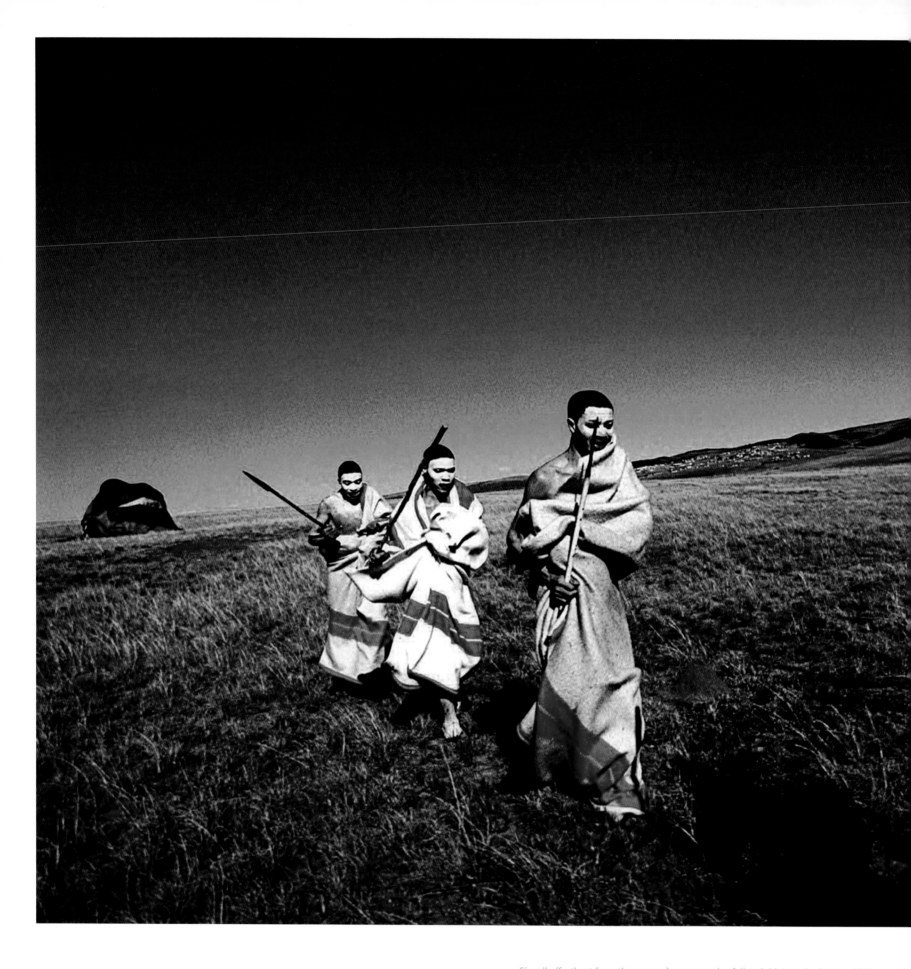

Sivuyile (furthest from the camera) accompanies fellow initiates who have paid him a visit

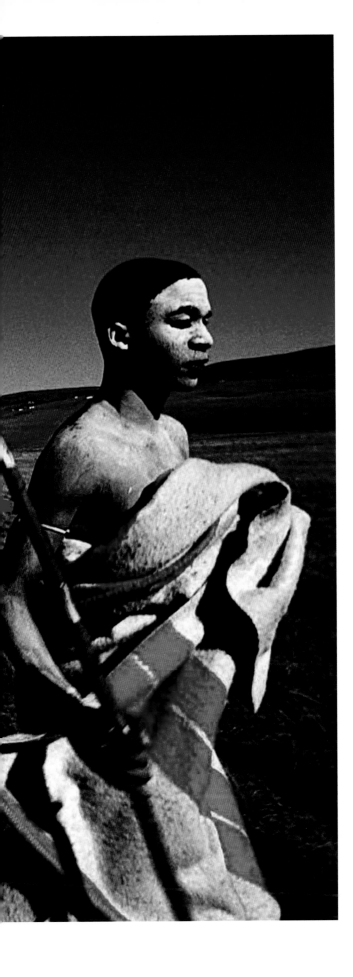

## siphiwe **sibeko** [initiation]

In this essay, I depict some of the experiences of Sivuyile Ndondo, a young Xhosa from Mahlubini village in the Eastern Cape, during his initiation into manhood. Sivuyile works in Cape Town, but took leave and returned home for this ritual period, during which initiates are circumcised. Initiation is an intrinsic part of Xhosa culture. You will never be respected if you do not undergo it.

In recent years, in some parts of the country, initiation has become devalued; initiations are run by inexperienced people, who then demand money from initiates' relatives. Circumcisions are badly performed, and some deaths have occurred.

In the Eastern Cape, circumcisions are normally performed by respected elders with many years of experience. I have tried to show that initiations in this region are carefully managed, and still mean a lot to participants and the community.

Initiation takes about three weeks to a month. Initiates live in the veld, in huts which they have to build themselves. They wear blankets, and paint their bodies. They live in isolation; they may visit each other, but may not have any contact with their families.

The circumcision is performed at the start of initiation. For the rest of the period, initiates tend their wounds until they heal. The circumcision is performed by an *Ingcibi*, a specialist at this task. After that, an *Ikhamkatha*, or instructor, takes over, teaching initiates how to treat their wounds, and instructing them in traditional values.

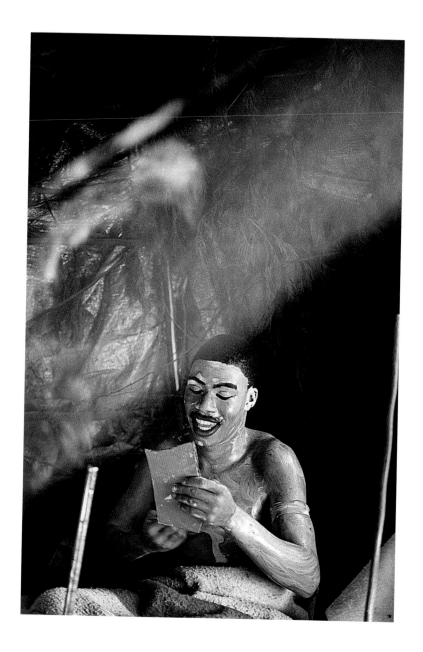

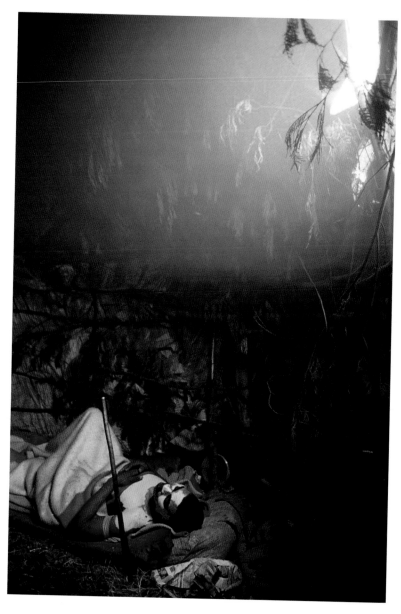

Sivuyile Ndondo looks at himself in a mirror after painting himself with *ikota* (limestone).

An initiate asleep after a hard day in the veld.

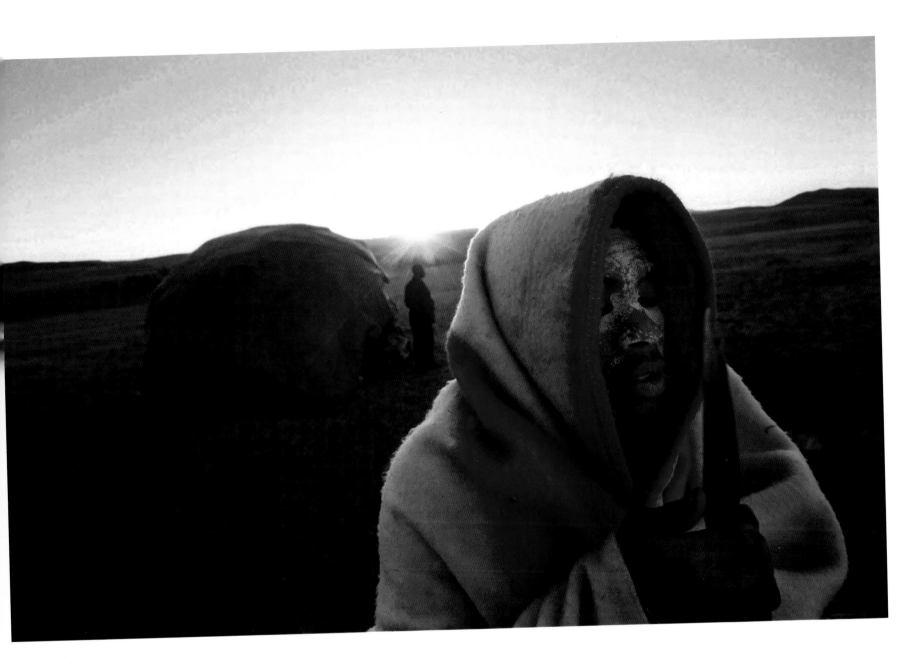

Sivuyile inspects the spear he is meant to use for protection during his stay in the veld.

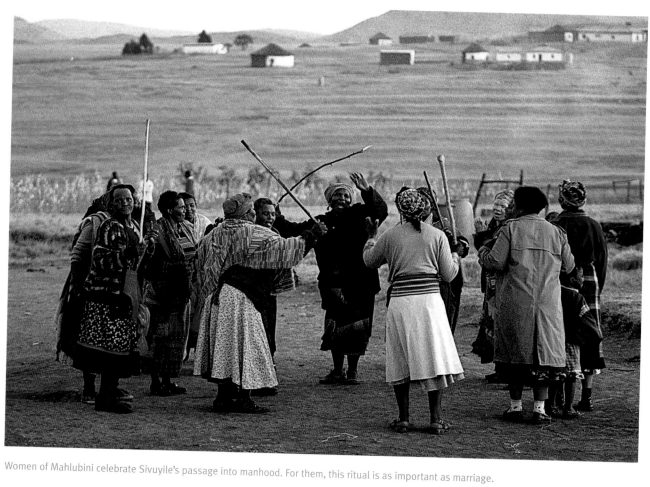

Women of Mahlubini celebrate Sivuyile's passage into manhood. For them, this ritual is as important as marriage.

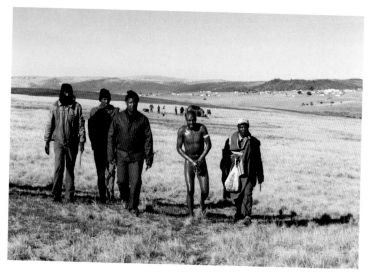

Sivuyile leaves the hut he has lived in for the past four weeks. The hut will be pulled down and burnt. The belief is that, if an initiate looks back at this time, he will go mad.

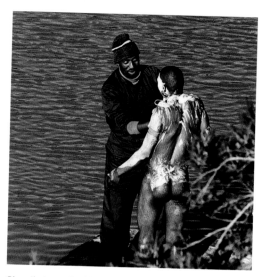

Sivuyile is washed in the Tsomo River by one of his brothers. The white paint must be completely washed off before he returns to his village.

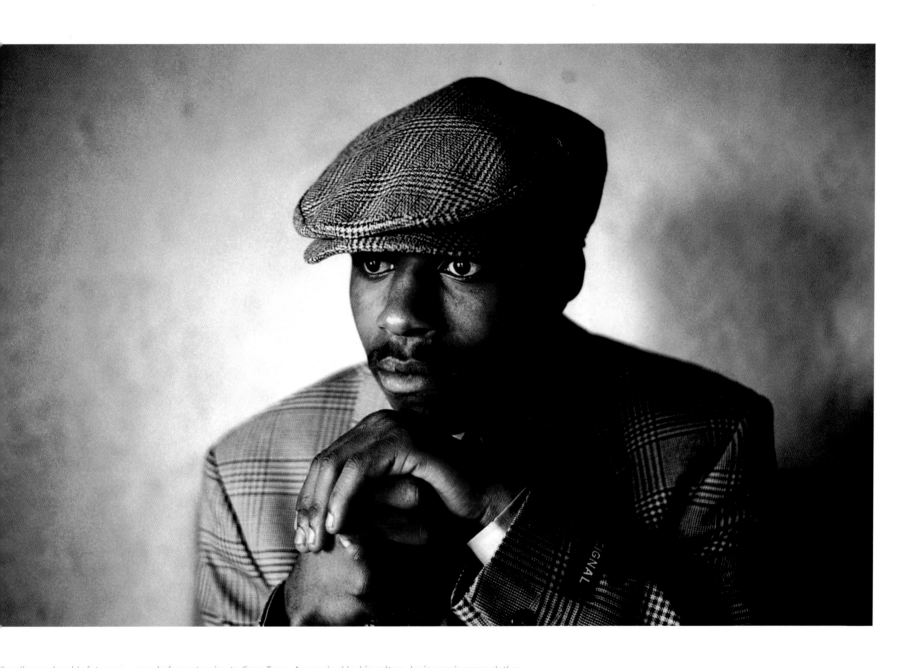

Vuyile ponders his future as a man before returning to Cape Town. As required by his culture, he is wearing new clothes.

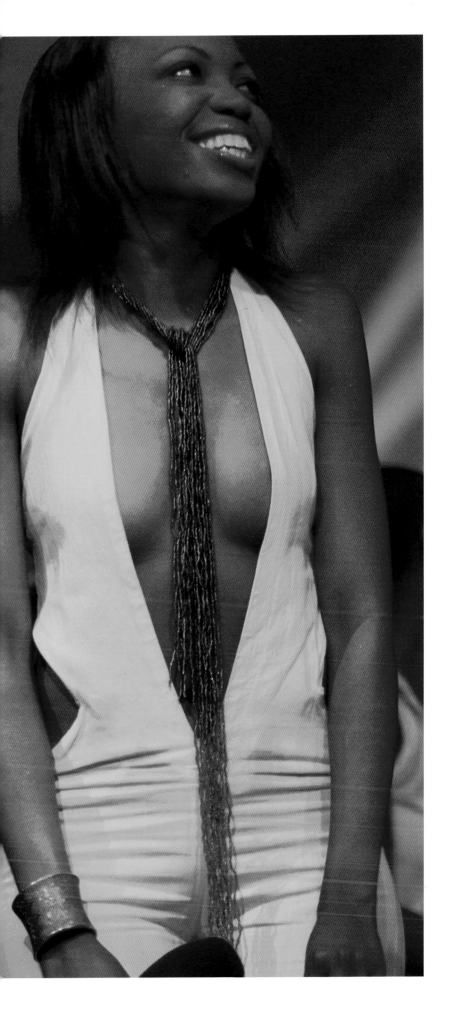

## neo **ntsoma** [kwaito culture]

The youth forms a large part of South Africa's population. Youths represent the future; they are a source of energy and renewal. For the past 10 years, while the country has been undergoing a process of transformation and reconciliation, youths have been developing their own identity which is truly and proudly South African. You can call it kwaito culture, if you wish, but it's all about peace, love, and unity, about being yourself, and about loving yourself enough to be YOU.

Some claim that kwaito is sexually too explicit, and that the lyrics are infused with industrialised sexual clichés in dress, melodies, and dance style. But the truth is, we are here for the long haul. We are determined to make it.

Kwaito is about the township, knowing the township, understanding the township, walking the walk, talking the talk (*Isicamtho*, in township slang), and, above all, being proud of all these things.

"Those who think "for every black cloud there is a silver lining" have it all wrong. I am proud to be black, and black is not only beautiful – it is life."

'BEFORE THERE WAS WE WERE forced to preserve beauty within our cemented gardens. A true reflection of our past times. DEEPLY ROOTED TO WHO WE ARE. Finding balance within our vain extremes. We navigate the full moon, there are answers for everyone. A NEW WORLD ORDER SHALL BE CREATED ...' – Ymagazine.

Fashion is not just about clothes. It is a statement about society, and about allegiances. Style is not all about dress sense. It is about cultural identity and expression. It can even be a way of resisting oppression.

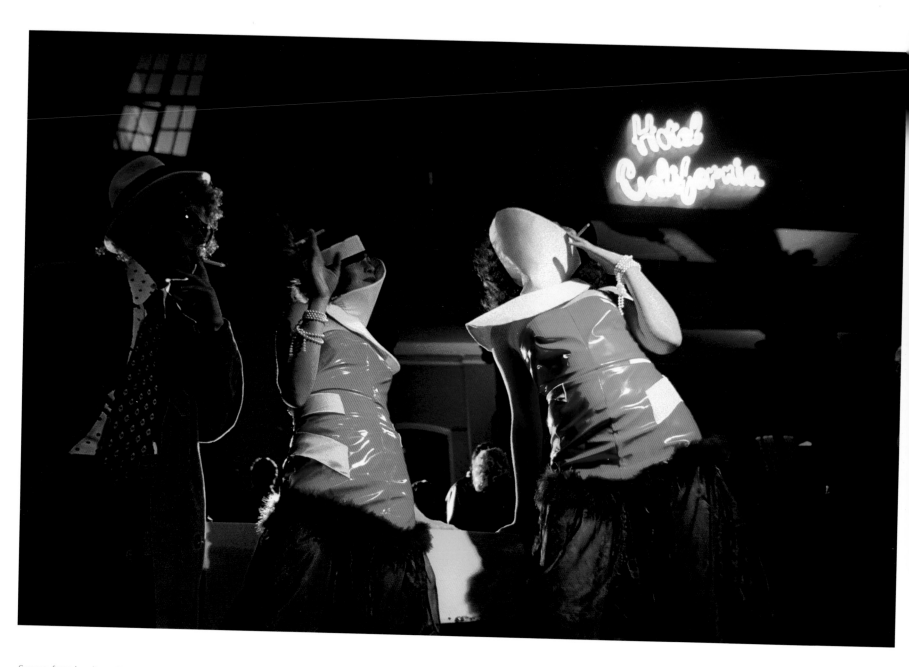

Scenes from kwaito culture.

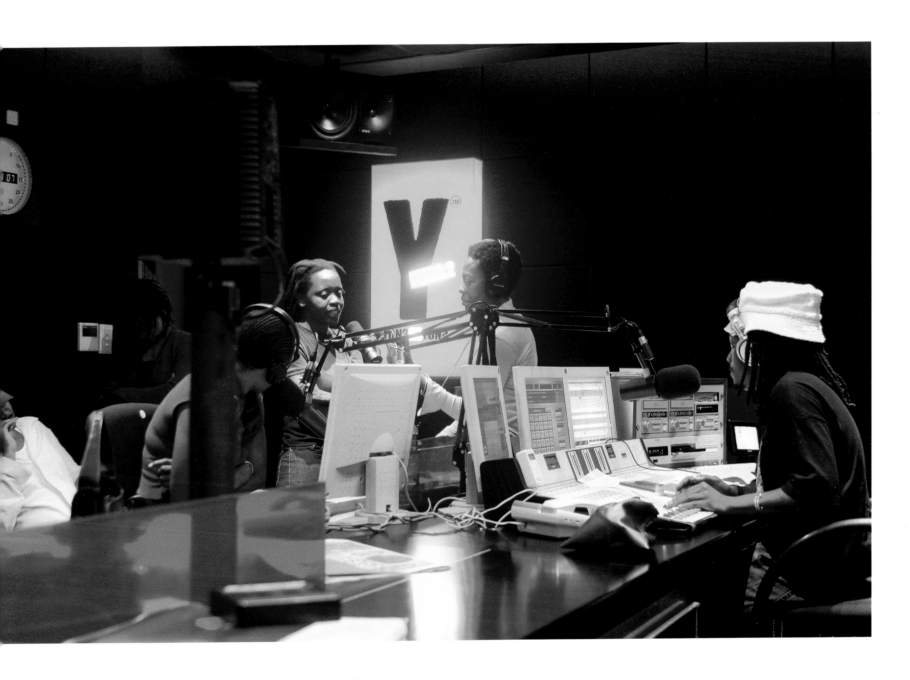

hink kwaito, think Yfm – this radio station for young people plays a key role in underpinning the kwaito movement.

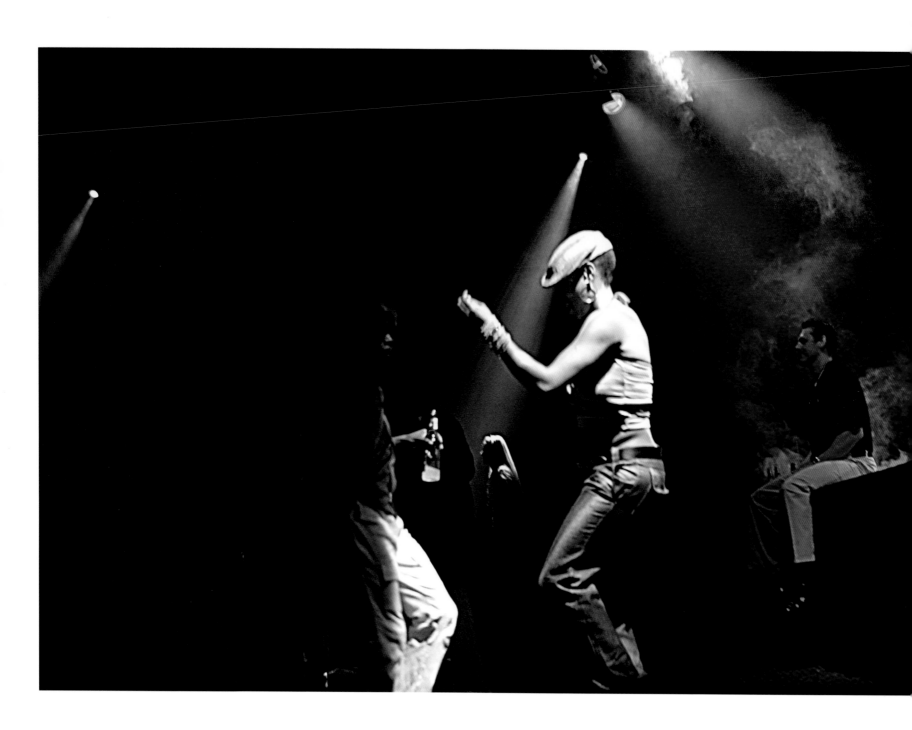

'Certain emotions and stories cannot always be expressed or articulated well in words – they are better danced.' – Themba ka Math●

'he good of the most bad there are, floods of questions, only drops of answers. In a plantation of confusion, the order being erosion ...'
Paul Mnisi (Rudeboy Paul), poet, musician, DJ, actor, and editor of Ymagazine.

# kim ludbrook [bikers]

This essay began when I started to photograph
my friends at the motorcycling club I ride for.
Also, I'm very interested in subcultures, and my
work on bikers forms part of a broader study on
this topic. The most interesting thing about
bikers is their camaraderie – there definitely is an
unwritten bond among them. Maybe this stems
from the fact that riding bikes is a dangerous
pastime. Of course, they also celebrate their
machines. I have tried to depict that brotherhood,
and reveal something about a subculture that
most people don't get to know – to show a bit of
the life of bikers to the average car driver.

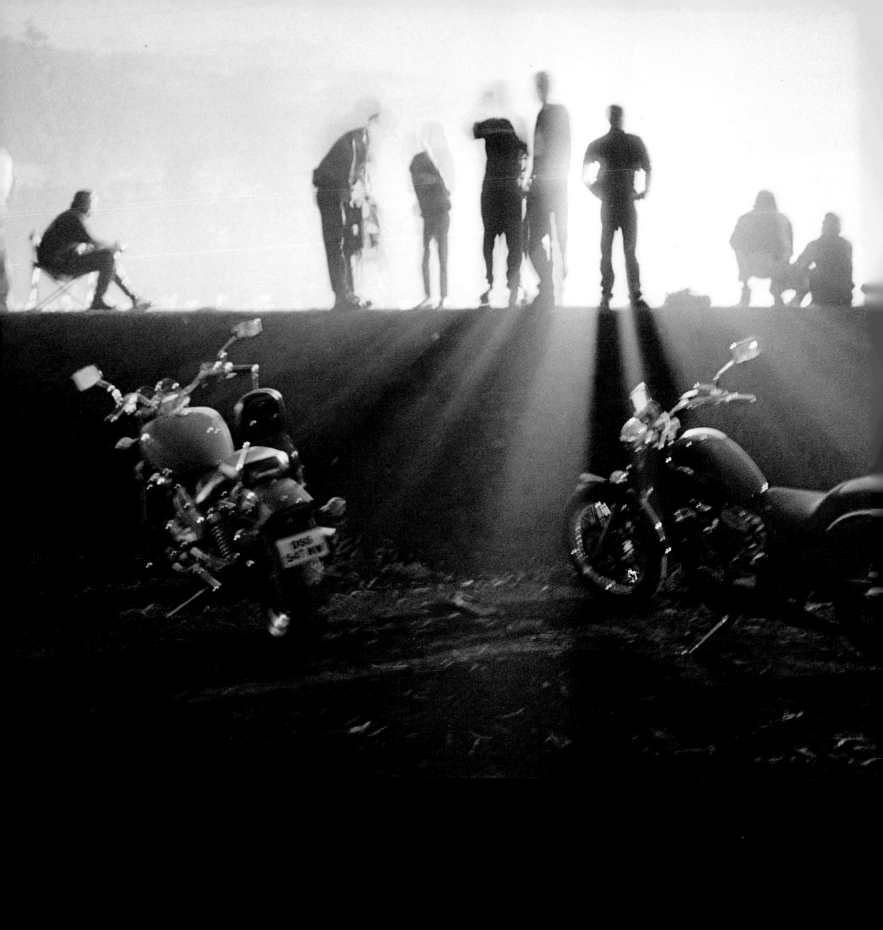

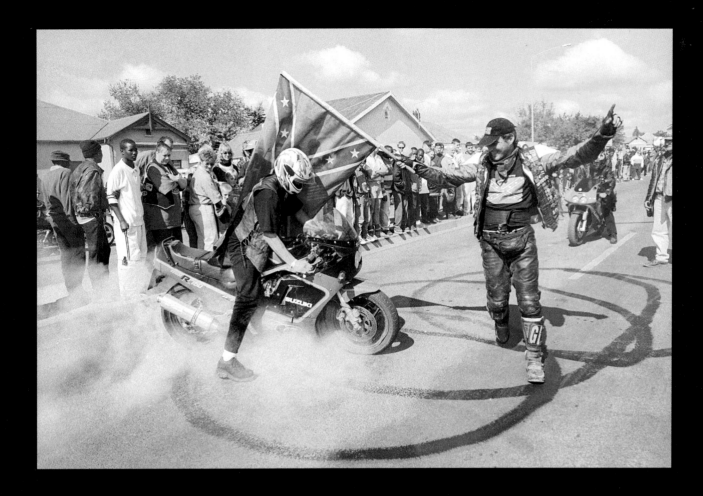

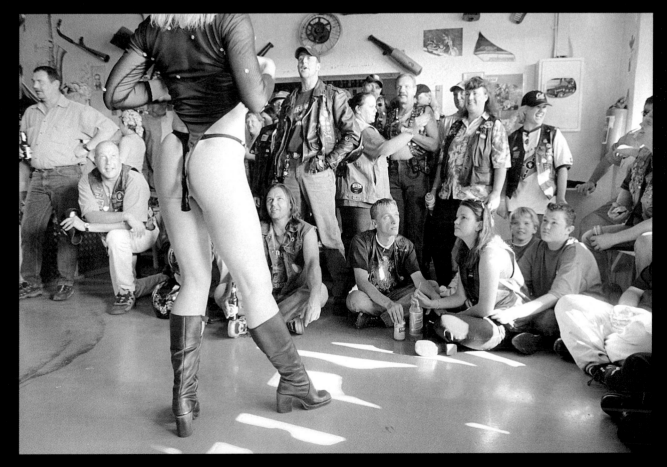

Joburg by night. [ **Neo** Ntsoma / Independent Newspapers ]

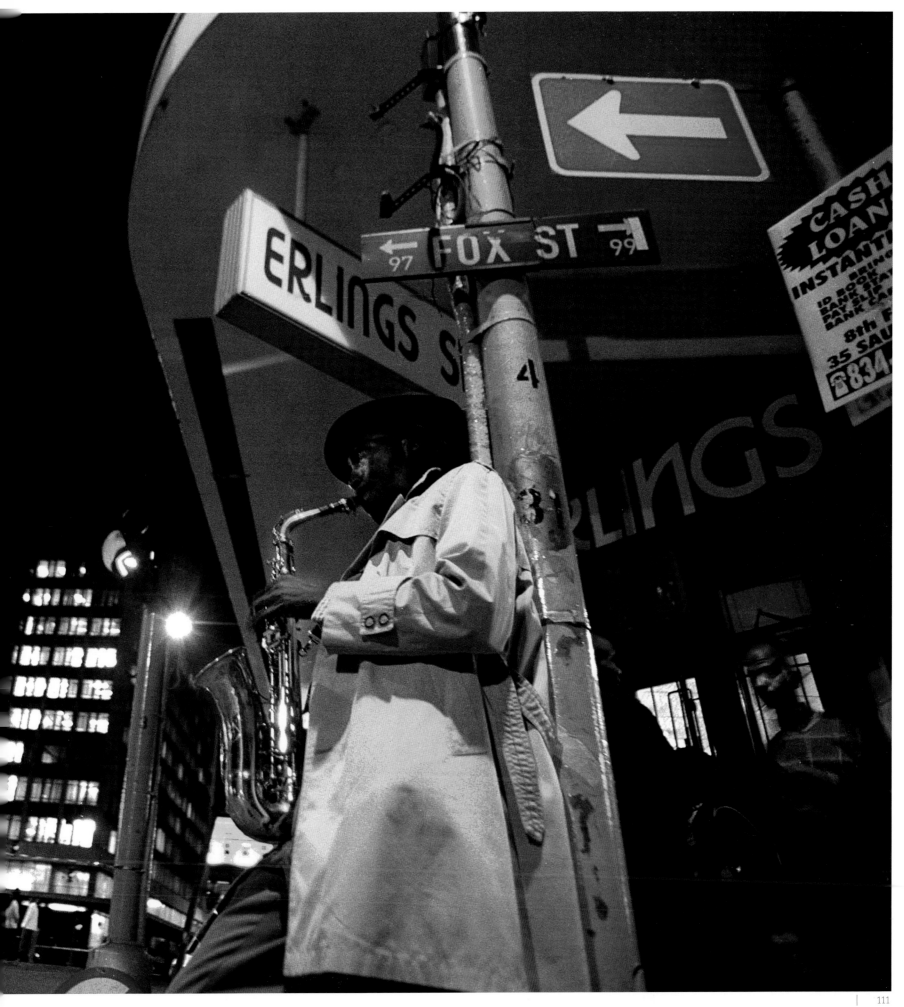

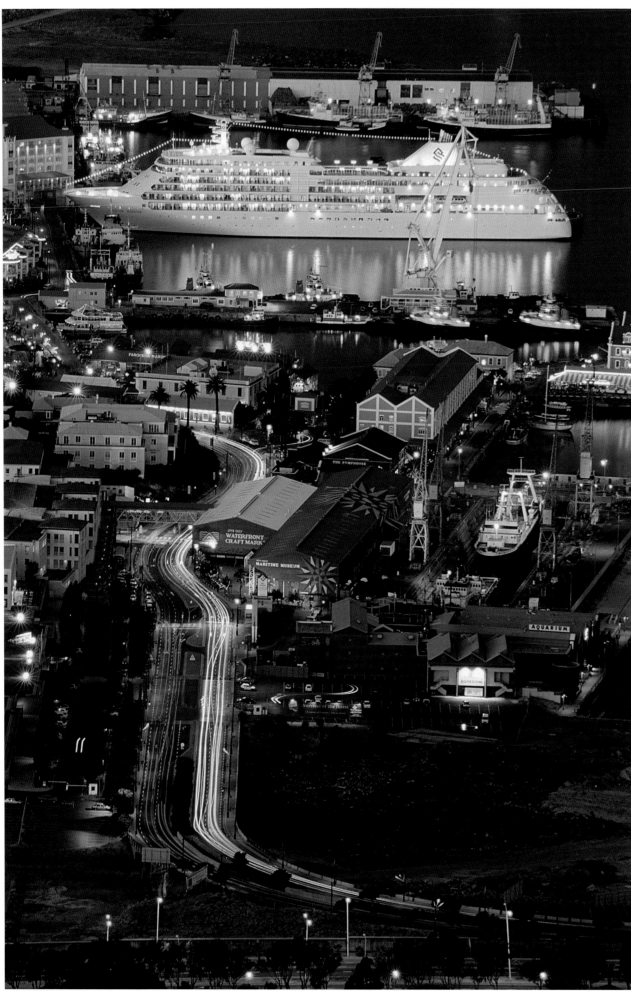

Cruise ship at the V&A Waterfront, Cape Town. [ Jeremy Jowell ]

Multimedia arts event co-ordinated by the artist Rodney Place under way in the Parkade in Bree Street, Johannesburg, 2001. [ **John** Hogg / Independent Newspapers]

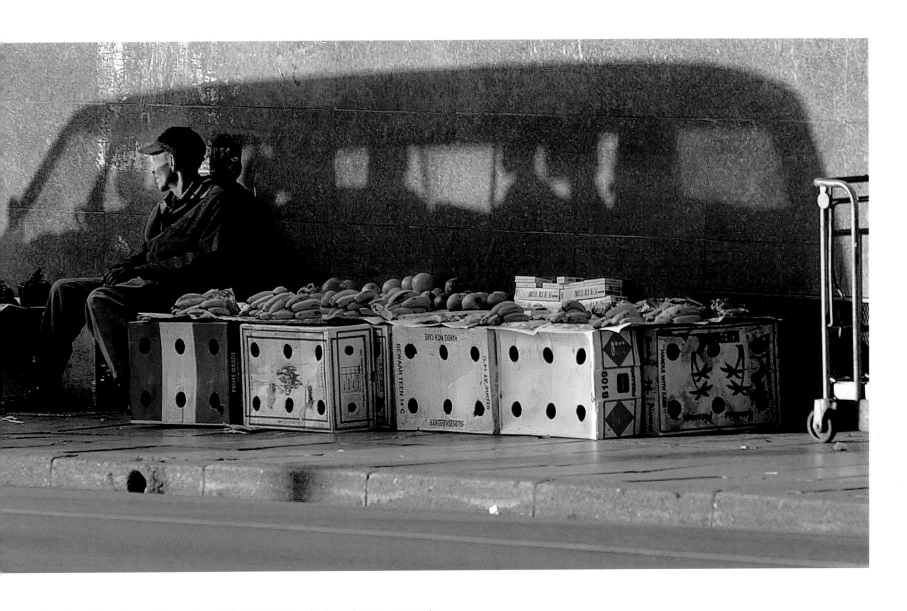

reet vendor and taxi, Sauer Street, Johannesburg. [ **Mujahid** Safodien / Independent Newspapers ]

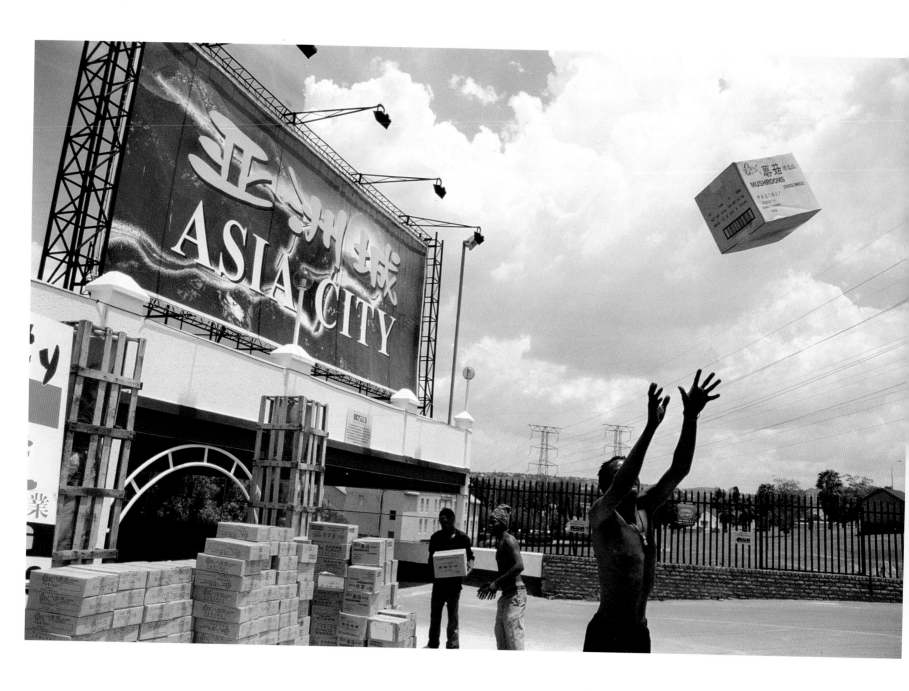

Goods in flight, Asia City, Doornfontein, Johannesburg. [ **Nadine** Hutton ]

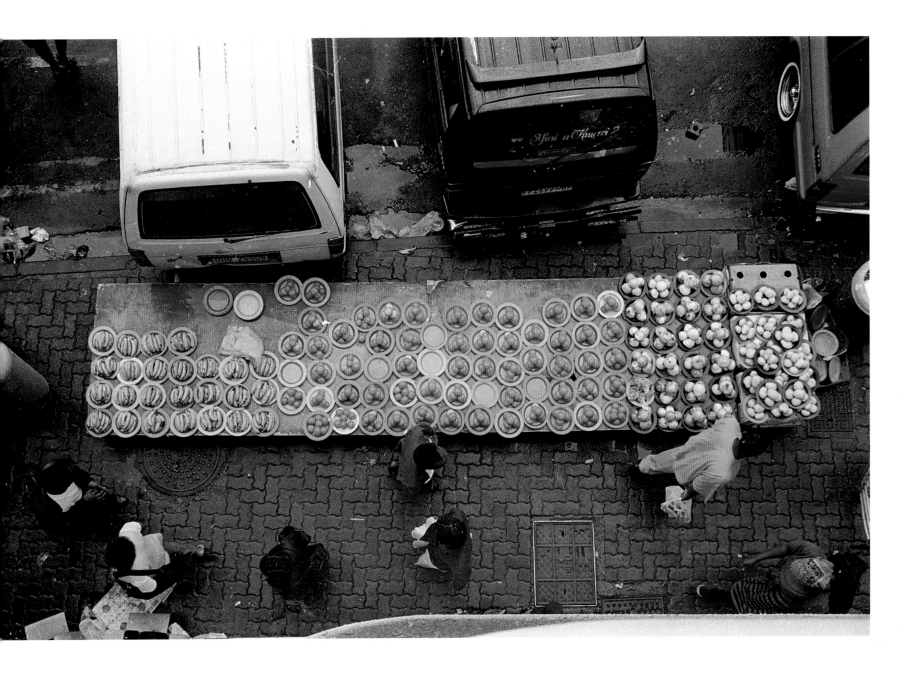

...xis and tomatoes, Johannesburg. [ **Nadine** Hutton ]

Poetry reading, Hillbrow. [ Cedric Nunn

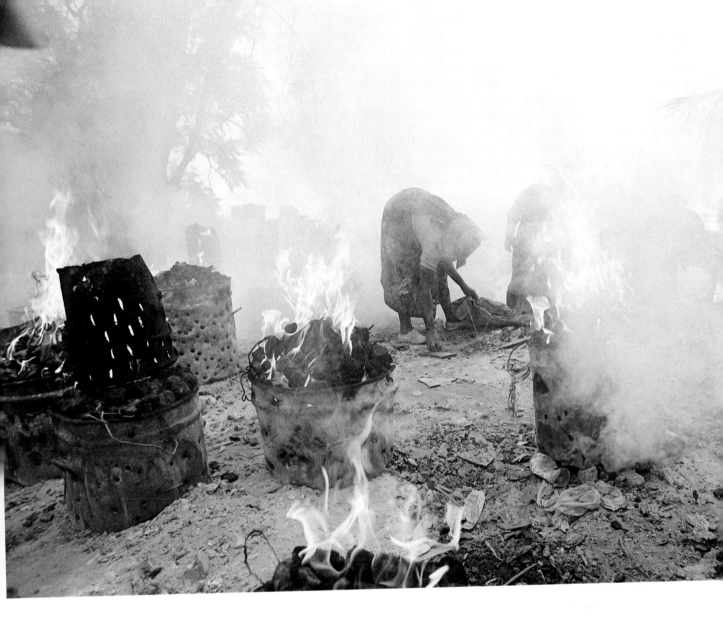

Mealie sellers prepare their braziers in Joubert Park, Johannesburg. [ **Andrew** Tshabangu ]

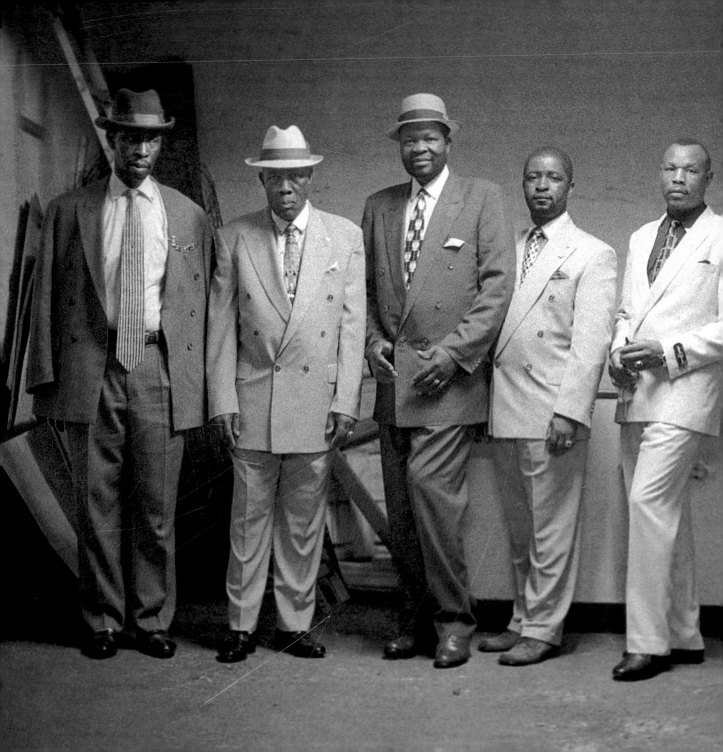

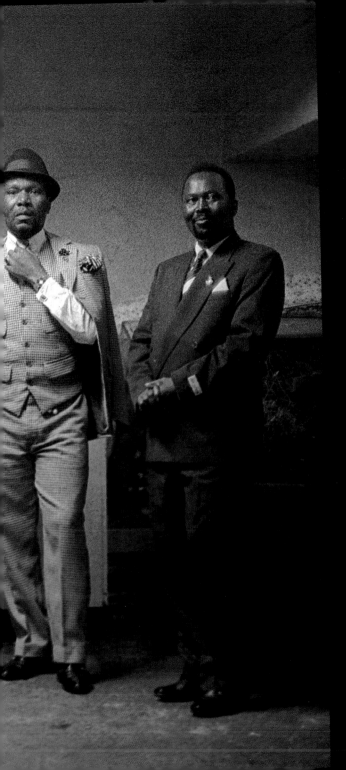

# t j lemon [oswenka]

Every Saturday night, a group of men turn up in the dim orange light outside the basement of Jeppe Hostel in Johannesburg – a huge hostel for single men dating from the apartheid era – wearing white dust coats and hats. Beneath their coats are zooty suits, with folded handkerchiefs peeping from the top pockets. *Isichatamiya* groups rehearse for the main part of the programme, their sweet harmonising and booming barotones contrasting with the piles of refuse, car wrecks, and sewage smells.

The grim hostel is home to thousands of men. On Saturday nights many stand around open fires, drinking and eating barbecued meat. Others perform in the basement, asserting their dignity in this extraordinary competition to find the best-dressed man ('swanker') and the best *isichatamiya* group. Spectators pay R5 for an all-night vigil on a wooden bench. Some are visitors Competitors may come from the townships, or from other hostels. Only half the audience is awake at any one time. Heads loll and bodies slump as night moves slowly towards day. Each swanker has his own style. Some are poised city gentlemen; others are flowery prancers.

The competition began in the late 1950s among young men who returned to KwaZulu at Christmastime. Keen to impress the village girls, they would strut around in fashionable outfits. This parade evolved into competitions at local trading stores (which still take place today). In the 1960s the men also began to stage competitions in hostels in the city, as a means of asserting their identity under the dehumanising conditions of the migrant labour system. The dingy basement at Jeppe Hostel remains the regular urban venu

Before the transition to democracy, judges had to be white – because, it was argued, they wouldn't know any of the performers. It was hard to find a white person in downtown Johannesburg after midnight, and so the judge would often be a tramp, pulled off a bench in Joubert Park. This tradition changed some time after the 1994 elections; now people of all races and genders may judge.

A swanker typically has five suits, but some have many more. Accessorie are important, and include lapel brooches, studded collar tips, and tie pins. Briefcases convey distinction, and are also used for carrying accessories su as mirrors, lip-balm, brushes, and shoes. The swankers compete for prizes drawn from R20 entry fees. If there are more than 10 entries, the winner get about R100.

Most swankers are labourers, and can't really afford designer suits and imported shoes. But the competition provides them with a means of affirmi their dignity under otherwise humiliating conditions. To swank is to be a gentleman, a somebody in the spotlight in the urban slums of Johannesburg

tants, their dust coats concealing expensive suits, begin to gather [insid]e the basement of Jeppe Hostel.

The audience forms for an all-night vigil on wooden benches.

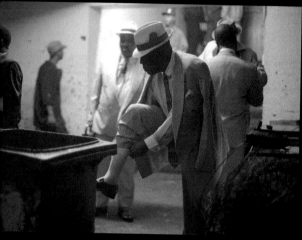

[Mo]s Mbatha hitches up his socks.

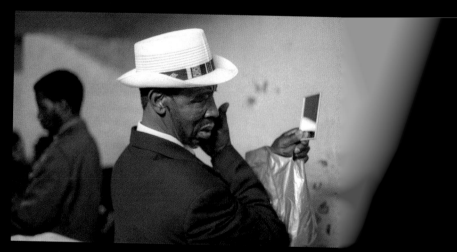

Dingani Zulu, who has wielded jackhammers on demolition sites for 30 years, prepares to perform. Contestants often carry briefcases containing mirrors, hair brushes, and other accessories.

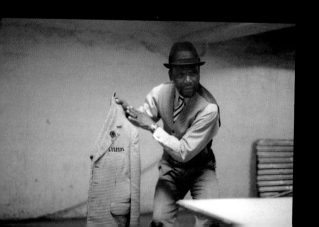

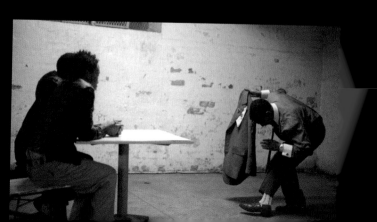

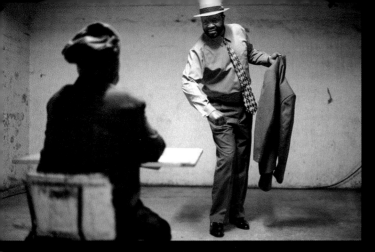

Alpheus Hlatshwayo, machine operator. His son Sabelo is also a swanker.

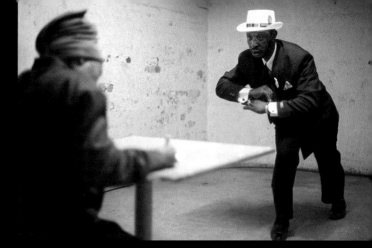

Dingani Zulu shows off his cufflinks. Accessories play an important role.

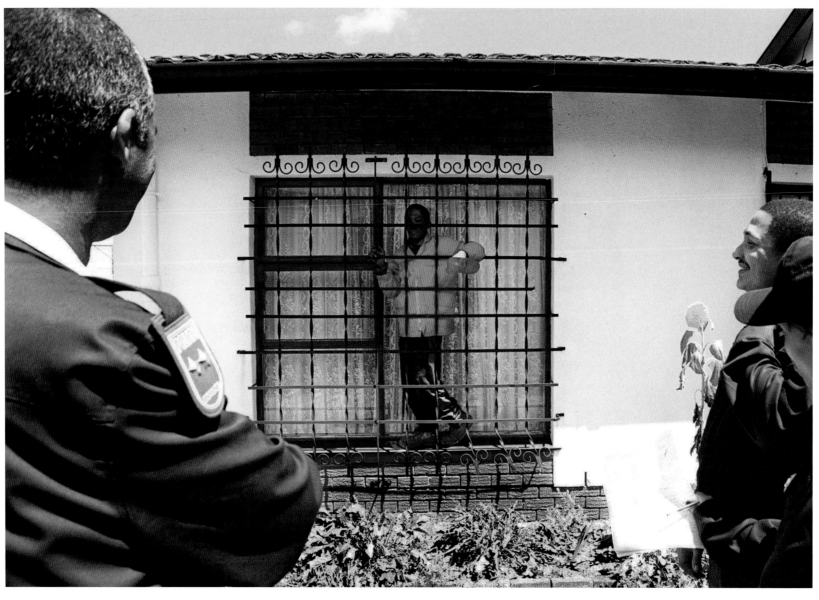

A burglar stuck behind burglar bars. Belville, Cape Town.  [ **Karin** Retief / Independent Newspapers ]

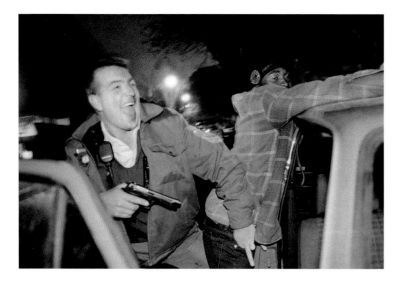

Midnight cowboy, Johannesburg.  [ **Nadine** Hutton ]

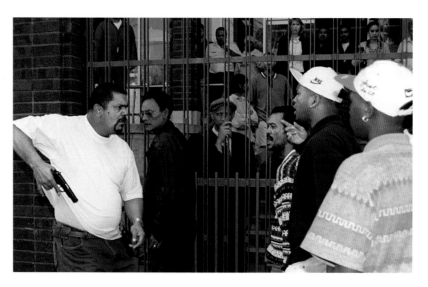

Confrontation between members of PAGAD and a group of gangsters, Wynberg Magistrates' Court, Cape Town.  [ **Leon** Muller / Independent Newspapers ]

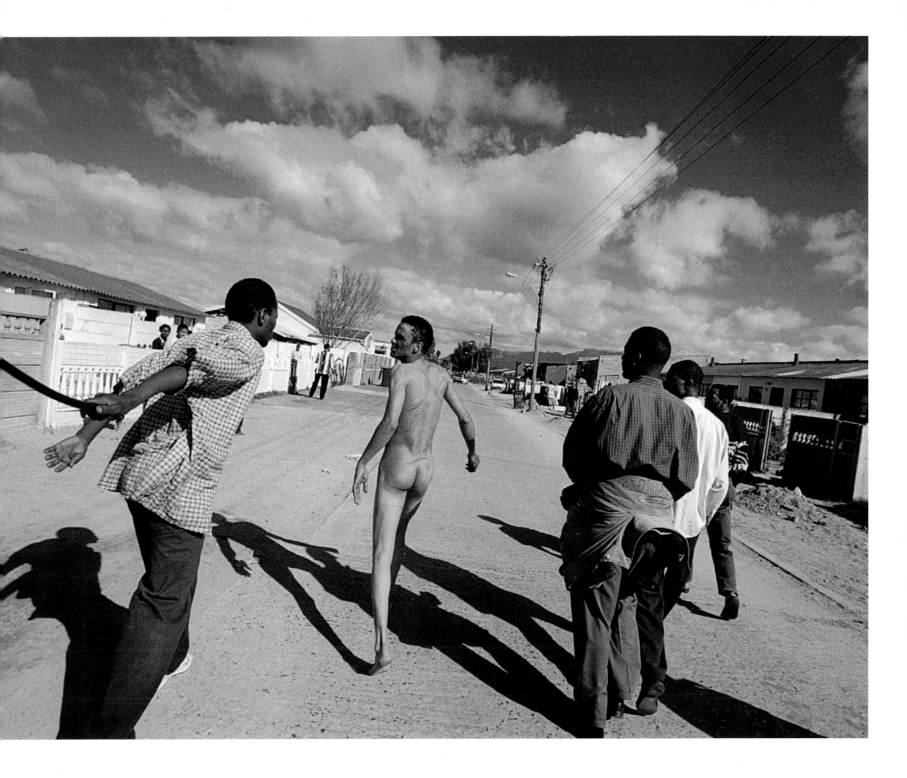

ough justice, Guguletu, Cape Town. [ Fanie Jason ]

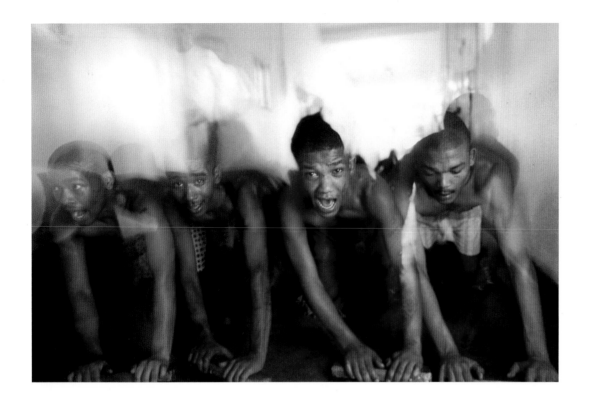

Juvenile prisoners scrub a hallway. Their 'commander' is chanting a tune, which they must repeat. The faster he chants, the faster they must scrub. Pollsmoor Prison, Cape Town. [ **Garth Stead** ]

Taxi violence, Phillippi, Cape Town.
[ **Mujahid Safodien** / Independent Newspapers ]

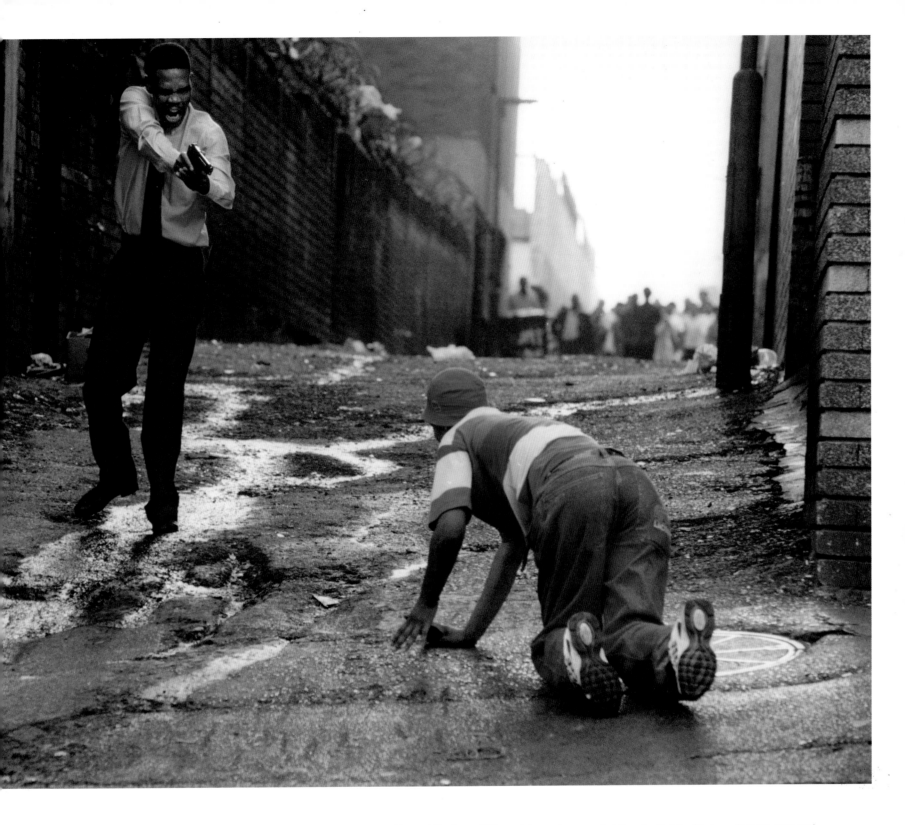

Johannesburg businessman, Bobby Lawrence, takes aim at a youth who tried to rob him of his mobile phone, Hillbrow, Johannesburg, 1998. [ **Themba** Hadebe / Independent Newspapers ]

# david **lurie**
## [manenberg avenue is where it's happening]

My work in Manenberg began at the end of 2001, as part of a follow-up to my book *Life in the liberated zone* (Cornerhouse, United Kingdom, 1995); eventually, I spent about six months over the next one and a half years taking photographs in and around Manenberg Avenue. I was welcomed, entertained, amused; I was also frightened, bewildered, often disoriented, and incredulous. The harshness of day-to-day life, lack of privacy, and attitudes to jail as well as life and death threatened everything I had been brought up to believe in. (I grew up only 20 minutes away by car from Manenberg.) At least 12 people I photographed died violently or were seriously injured during that period. And it will probably get worse before it gets any better.

Lurie's work on Manenberg has won the world understanding award in the 61st annual pictures of the year international competition. *Cape Town fringe: Manenberg Avenue is where it's happening* will be published by Double Storey Books, United Kingdom, in September 2004.

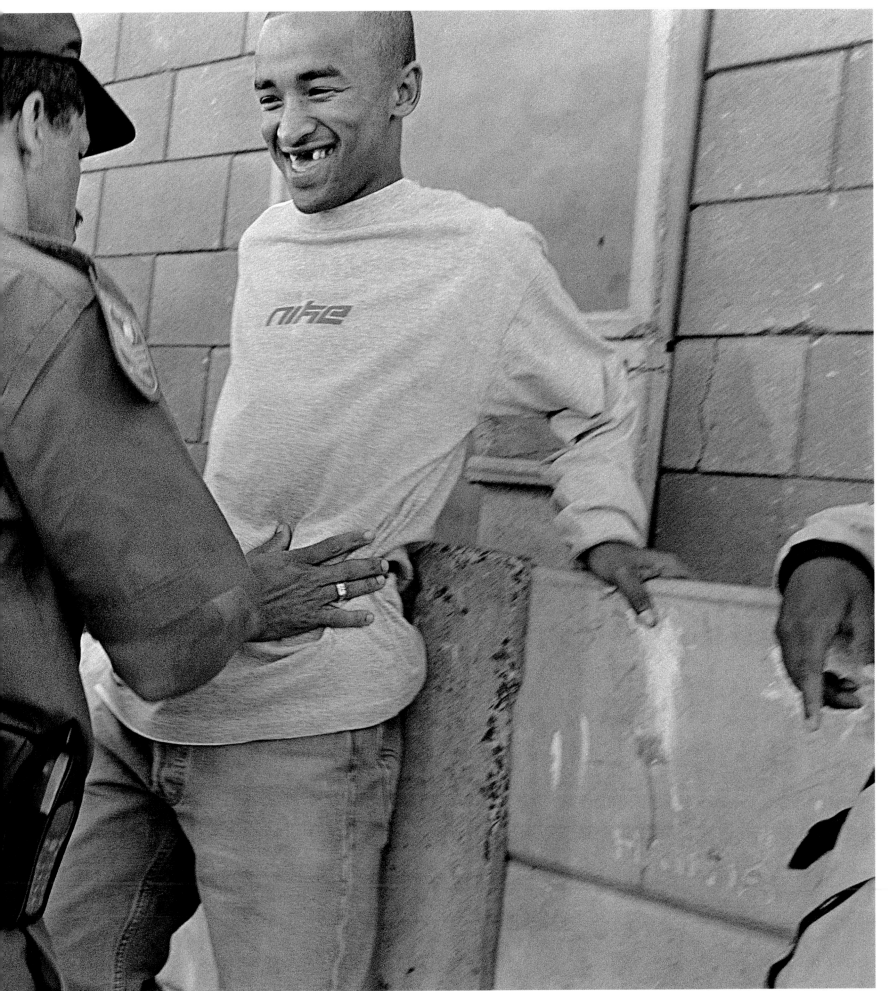

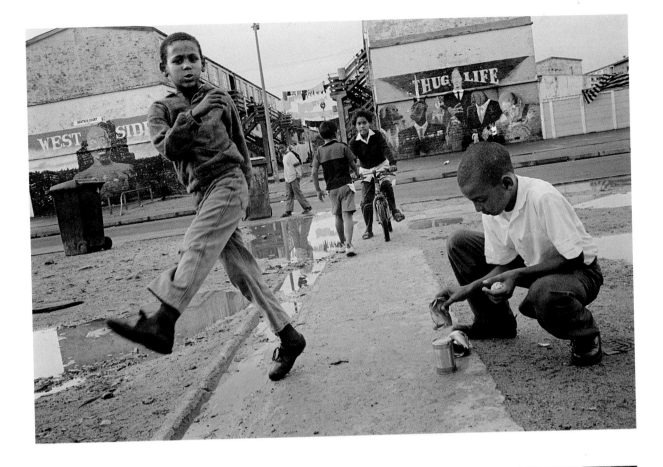

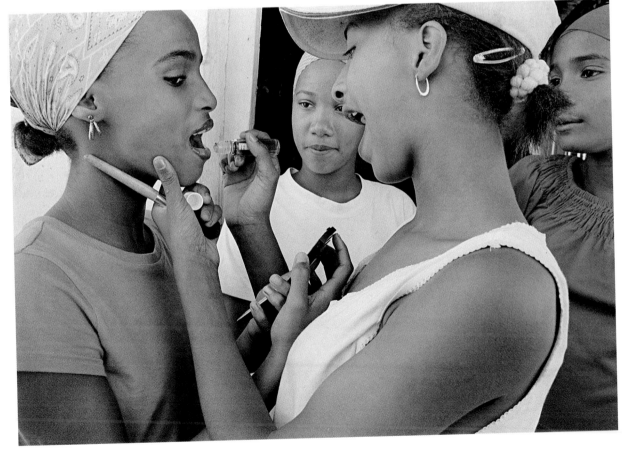

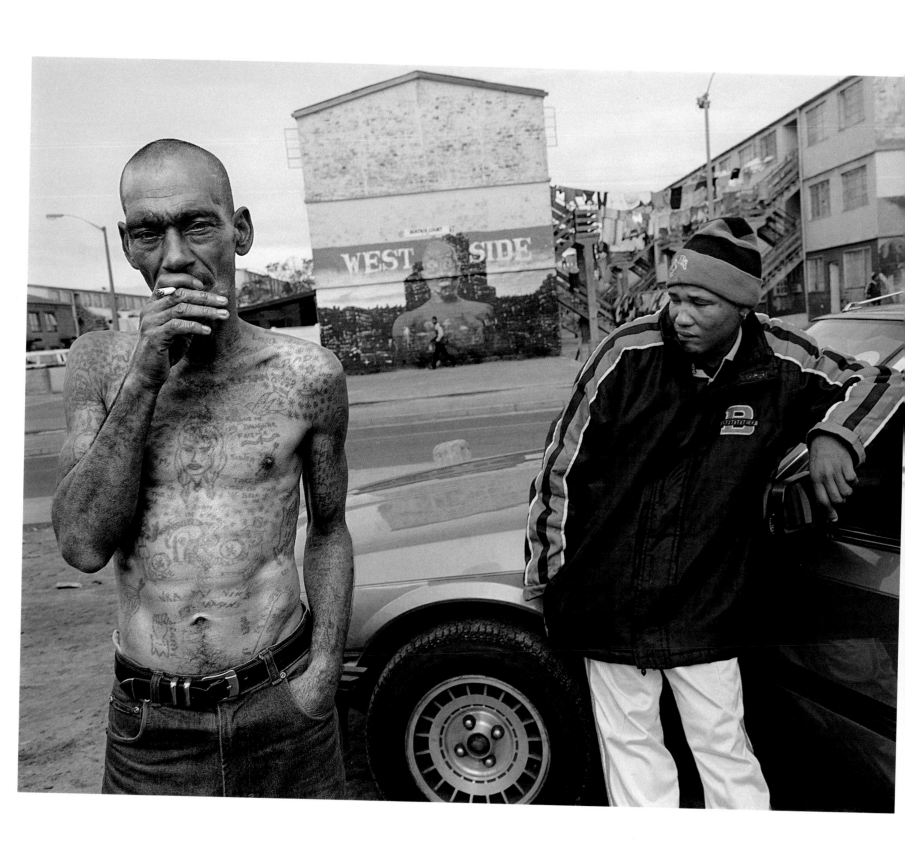

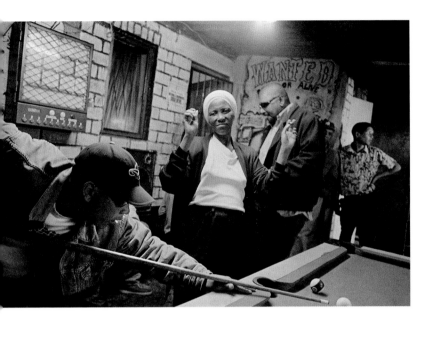

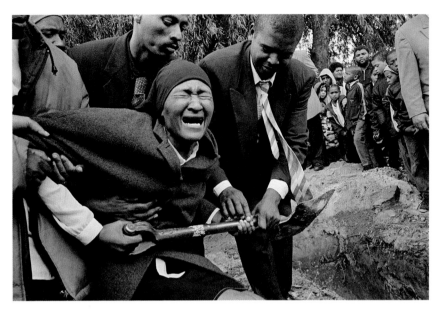

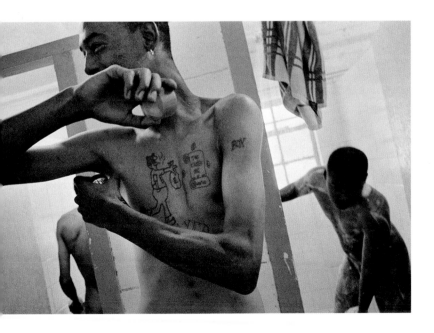

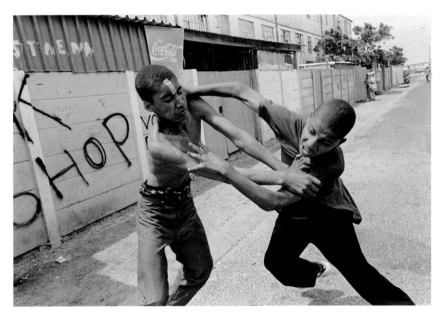

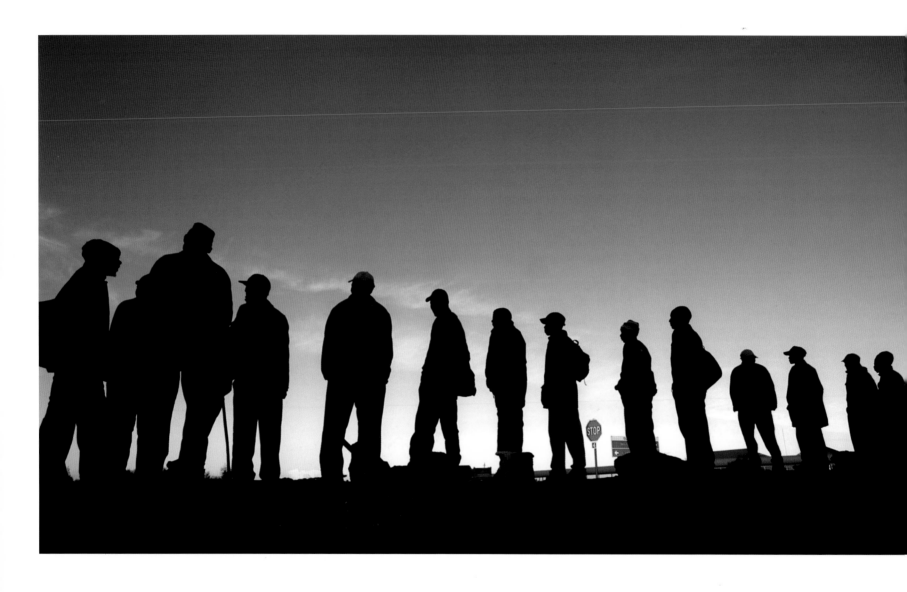

Men waiting to be picked up as casual labour, Khayelitsha, Cape Town. Some are picked up by builders and farmers, and work for about R60 a day. Others wait fruitlessly the whole day. [ **Mike** Hutchings / Reuters ]

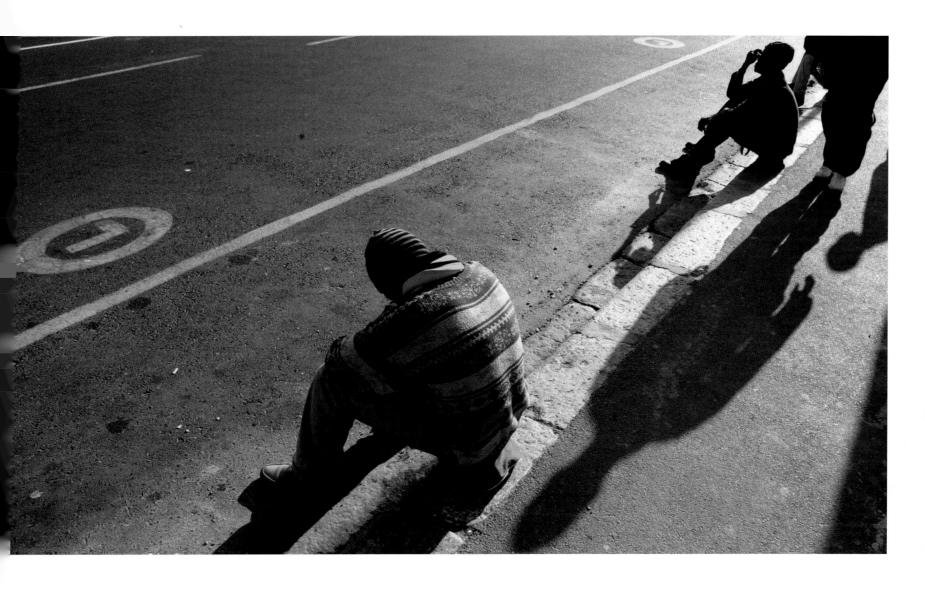

Despondent job-seeker, Buitenkant Street, Cape Town. 2003. [ **Mike** Hutchings / Reuters ]

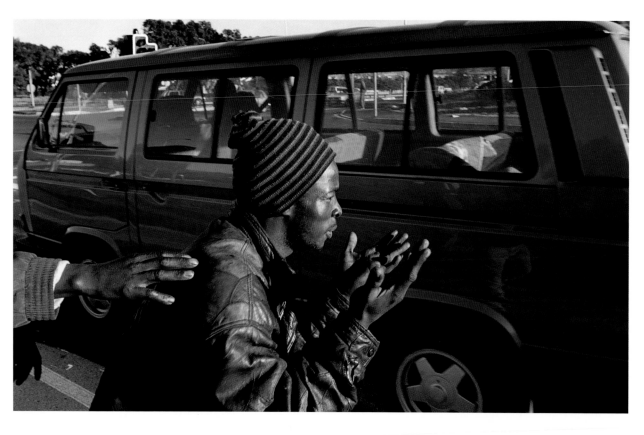

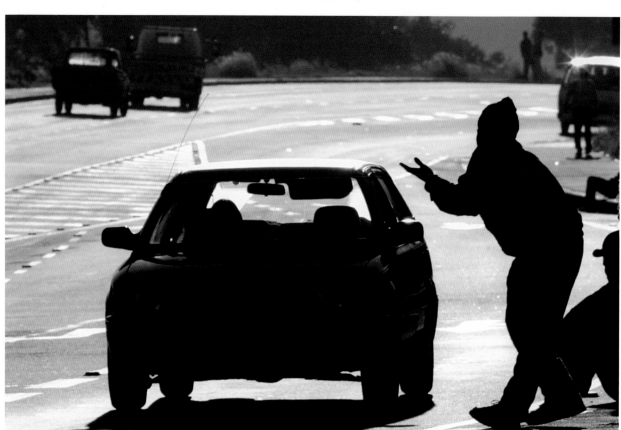

Asking passing motorists for work, Buitenkant Street, Cape Town.  [ **Mike Hutchings** / Reuters ]

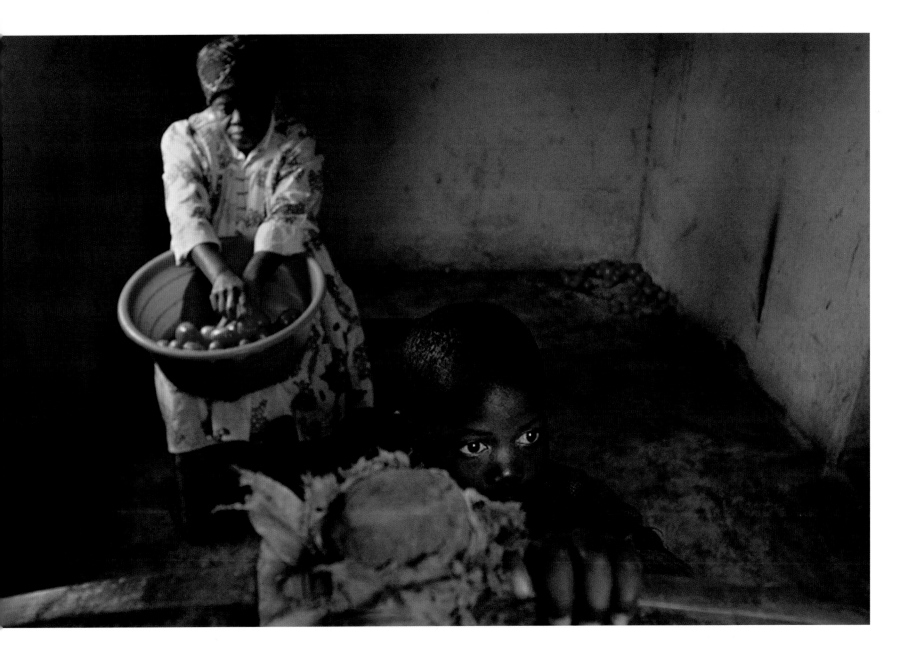

single mother sorts out tomatoes to sell on the street. Her son has stopped going to school. Messina, Limpopo.  [ **Mujahid** Safodien / Independent Newspapers ]

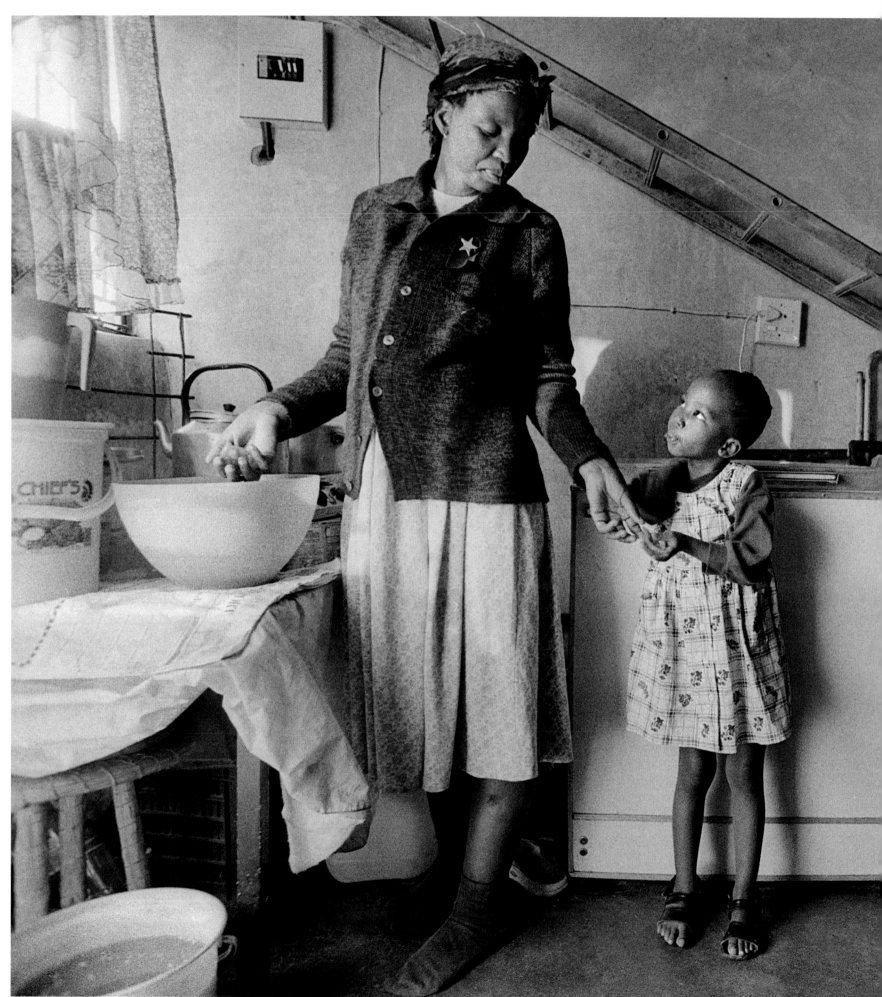

A mother and daughter prepare supper. Children are taught to cook and do house chores from an early age. Township kids grow up more quickly than those in other areas, since their parents are often out trying to find work; then the children have to take care of themselves.

# mujahid **safodien** [dark city]

Alexandra, the former black township in north east Johannesburg, embodies South Africa in microcosm: dilapidated brick houses, dating from freehold settlement in the early 1900s; single-sex hostels, from the apartheid era; and shacks and RDP houses, the counterpoint of post-apartheid South Africa. The Sandton business district glistens in the distance. Alex has been a site of political resistance, internal strife, and peace initiatives. Its residents have withstood forced removals, attempted expropriation, and failed renewal plans. Also known as 'the dark city', Alexandra is being redeveloped to the tune of R2 billion.

In the meantime, all its residents remain united in their struggle to survive.

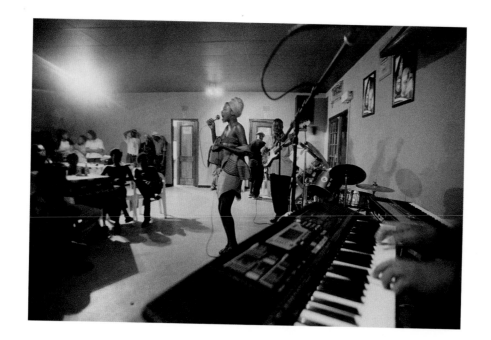

A Ghanaian singer at Jabu's Tavern. Alexandra comes to life at night – or at least it used to. Since police removed illegal immigrants from the township, the music has died, as most of the musicians were from other African countries. Jabu has since moved his tavern to Soweto.

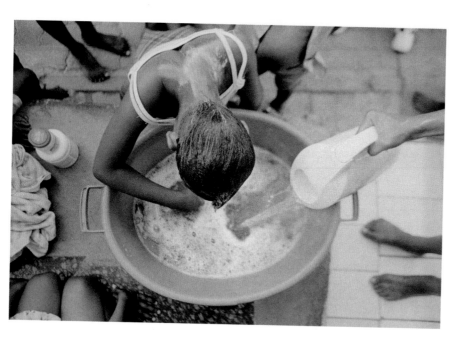

Queueing up for an outdoor wash. The bath is a plastic basin, and warm water comes from a kettle.

A young girl on a trampoline, costing 50 cents for five minutes. Long neglected by the authorities, Alexandra has recently received R2 billion for a thorough upgrade.

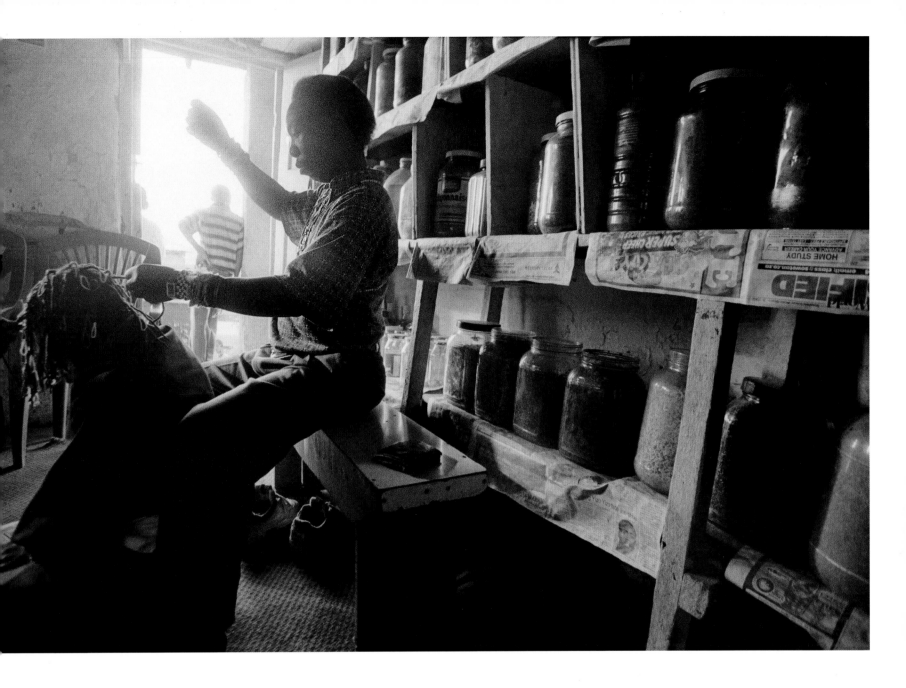

A spaza shop doubles as a hair care studio. Residents have to do the best they can with limited resources and amenities.

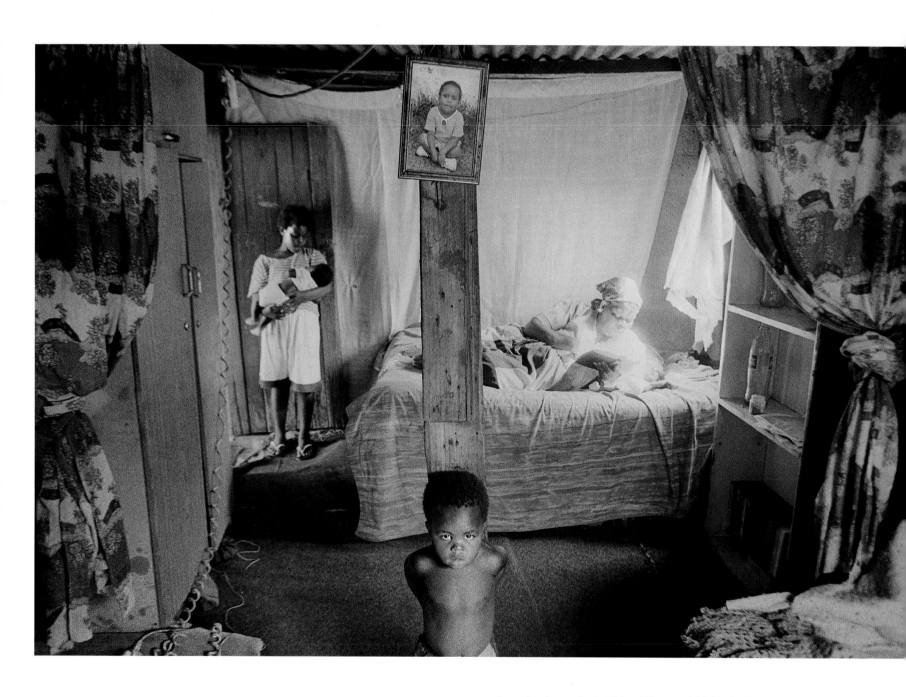

A grandmother reads the Bible, while a grandchild looks after a great-grandchild. The children's parents are out looking for work. They are all living off the grandmother's state pension

Three am, and time to go home. There's a shebeen in every flat block and on every street corner. Most people drink to forget their problems – but that's what usually causes the problems. Most people stay in the township for entertainment, because it's too expensive to go anywhere outside.

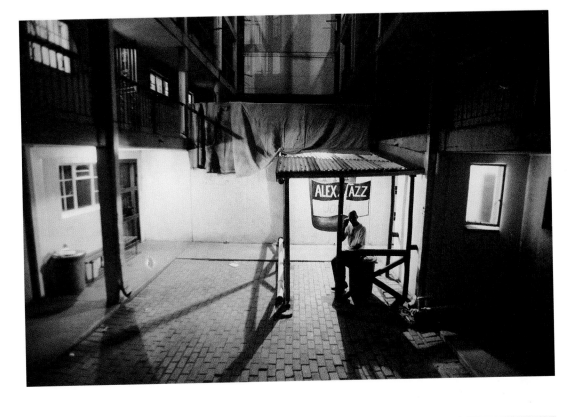

Bath time for Simpiwe, while others are still playing, waiting for nightfall. Home is only where you sleep; everything else is done outside.

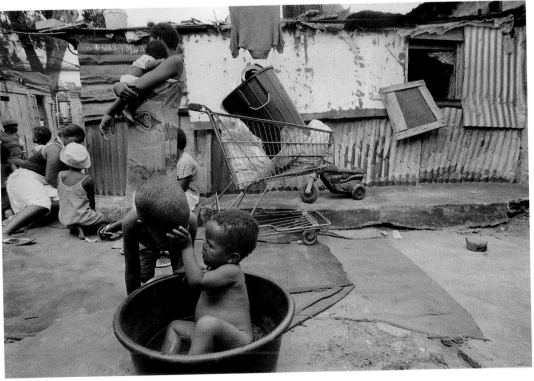

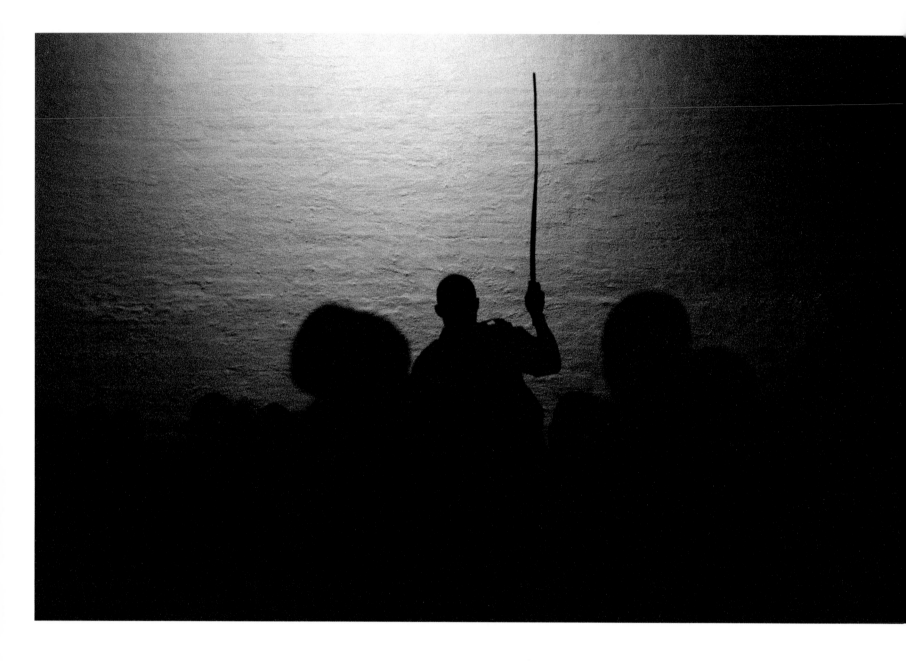

Policeman and illegal immigrants, Hillbrow police station, Johannesburg. [ **Nadine** Hutton

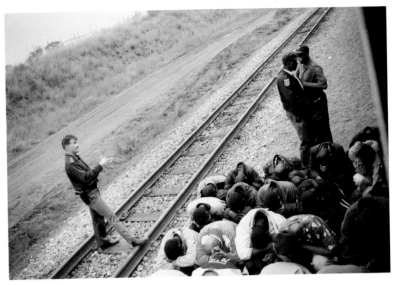

Illegal immigrants waiting to be deported. [ **Nadine** Hutton ]

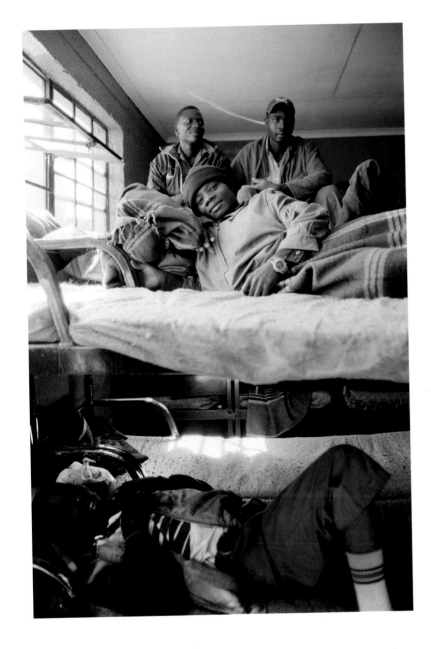

Illegal immigrants in the Lindela Detention Centre, Johannesburg. [ **Nadine** Hutton ]

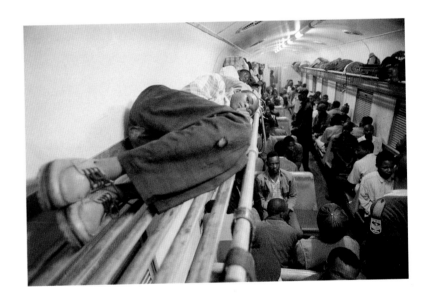

Illegal immigrants on a train back to Zimbabwe. [ **Nadine** Hutton ]

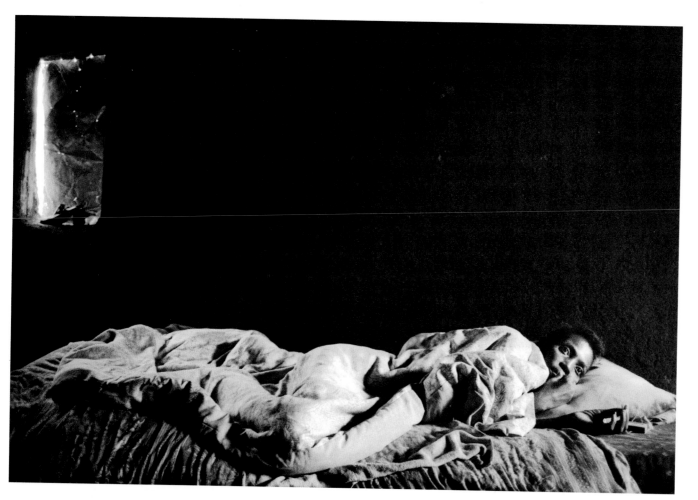

Ntombizonkhe Magoso, AIDS sufferer and mother of four, in a mud hut on a hill at Nyaywini in KwaZulu-Natal. Her mother could not handle the shame of her daughter's illness, and abandoned her on her grandmother's doorstep. [ Nadine Hutton ]

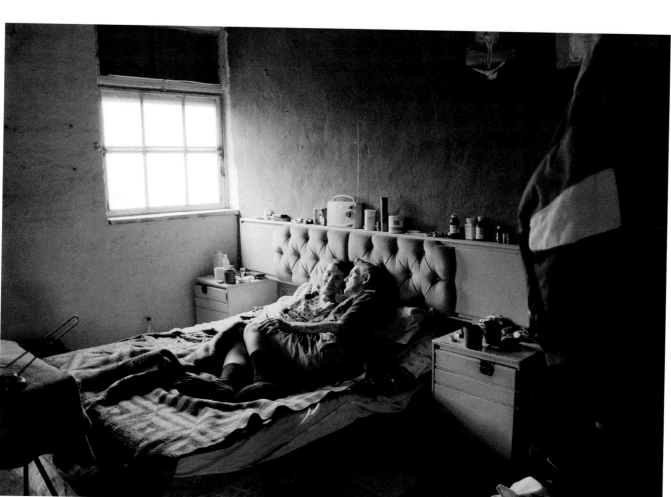

AIDS sufferers Wally and Kathy Hill in the Ark Christian Ministry shelter in Durban, where they met and got married. "I knew he was infected," she said, "but I prayed, "Lord, I love this man, show me the way."" [ Nadine Hutton ]

...ail Johnson in front of a portrait of her adopted son, Nkosi Johnson, shortly after his death at age 12 from AIDS. [ **Debbie** Yazbek / Independent Newspapers ]

A 12-year-old AIDS orphan, cared for by her grandmother.

An eight-month-old AIDS orphan with her sister.

These photographs were taken in the Hlabisa district in KwaZulu-Natal, where the Cotlands Baby Sanctuary and the Hlabisa Hospital operate a home-based care project for children affected by HIV/AIDS. A professional nurse and two home care workers visit children infected with HIV/AIDS, and attend to their needs. The workers also identify children who have lost their parents to AIDS, and relay this information to the welfare authorities. This service means a great deal to the Hlabisa community; however, most of KwaZulu-Natal and many other rural areas in South Africa are without home-based care.

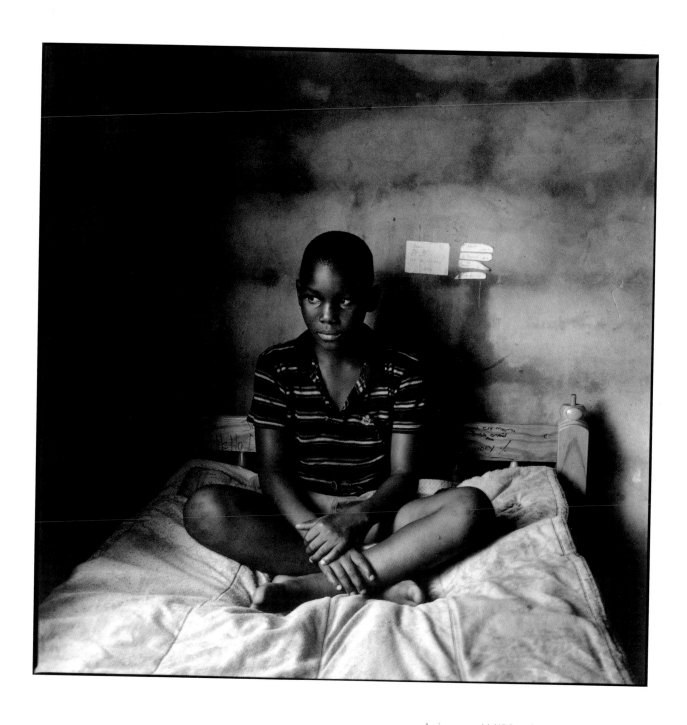

A nine-year-old AIDS orphan, cared for by his aunt.

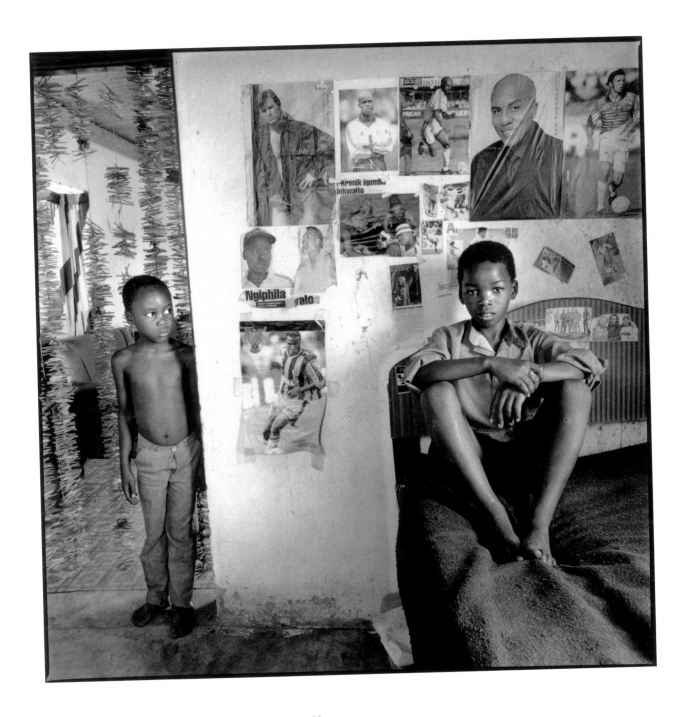

Two AIDS orphans, 12 and nine years old. Both are now cared for
by their grandparents.

Farmer during an eye test performed by a member of an airborne medical team, clinic at Niewoudtville, Northern Cape. [ **Andreas Vlachakis** ]

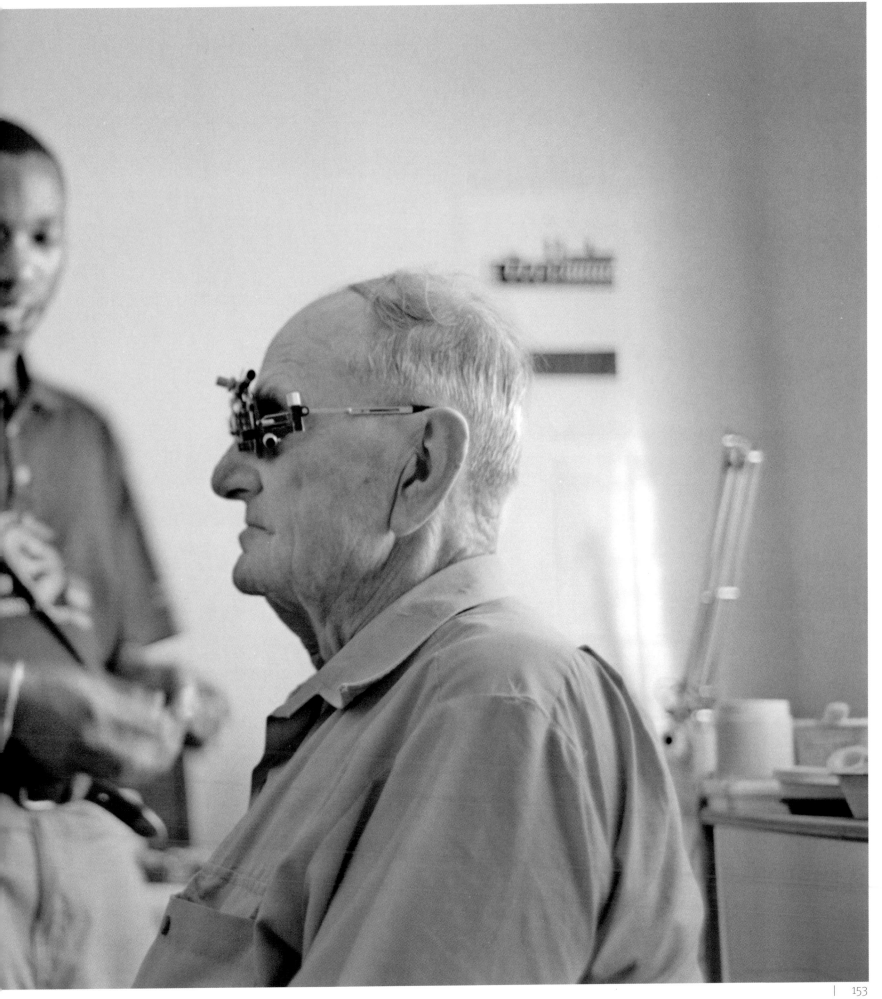

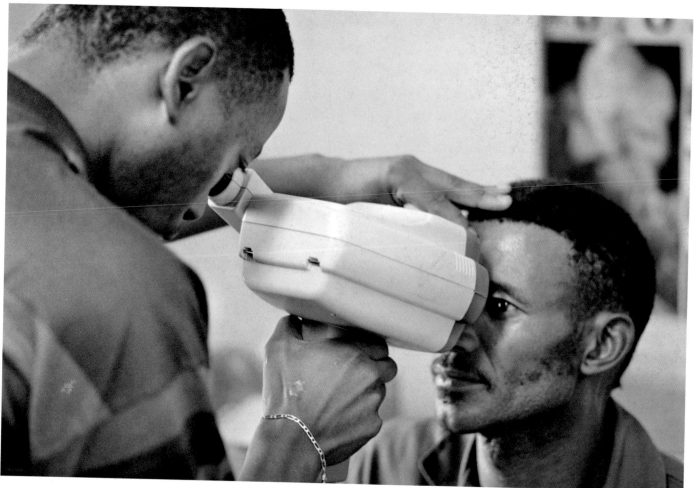

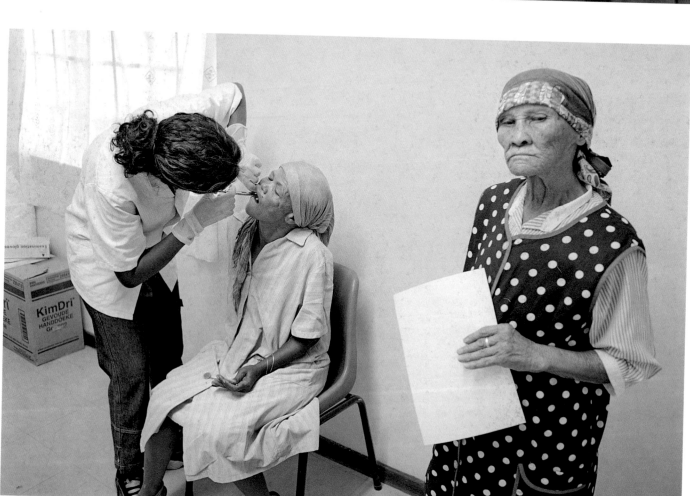

154

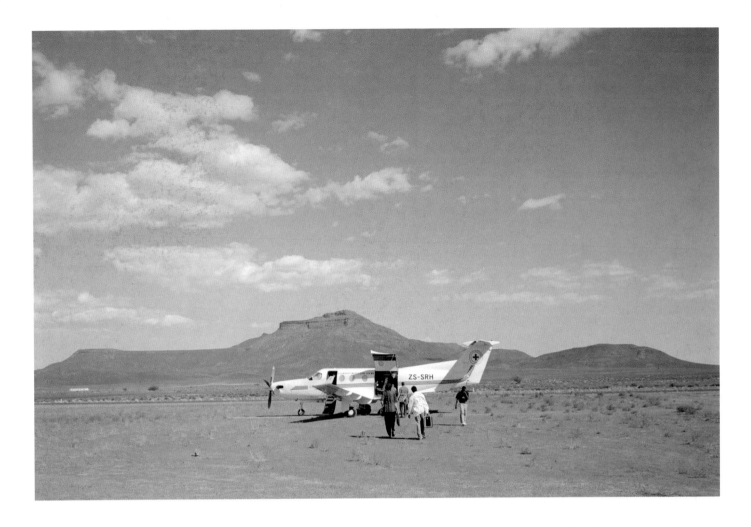

A medical team boards an aeroplane after visiting a village in the Northern Cape. [ Andreas Vlachakis ]

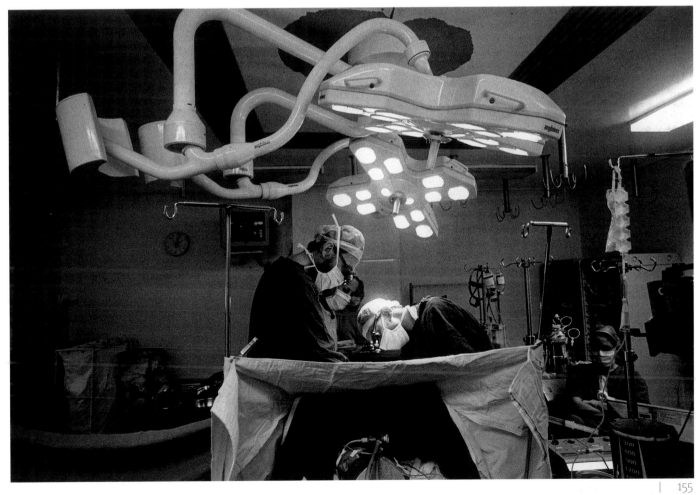

A surgical team performs an open-heart operation, Red Cross War Memorial Children's Hospital, Cape Town. [ George Hallett / South Photographs ]

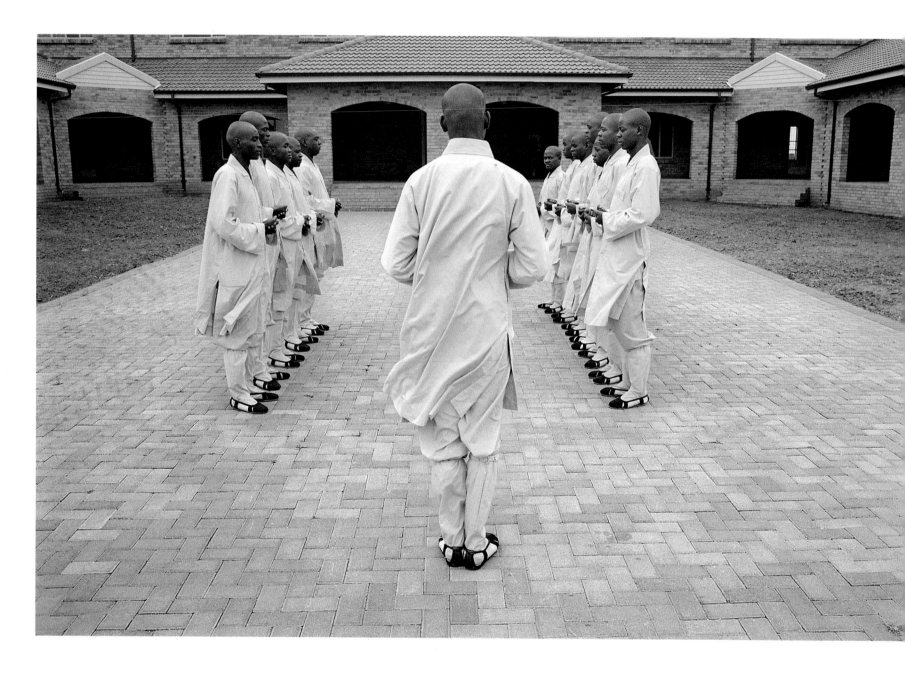

Monks at a Buddhist temple in Bronkhorstspruit, Mpumalanga. [ **Andreas** Vlachakis

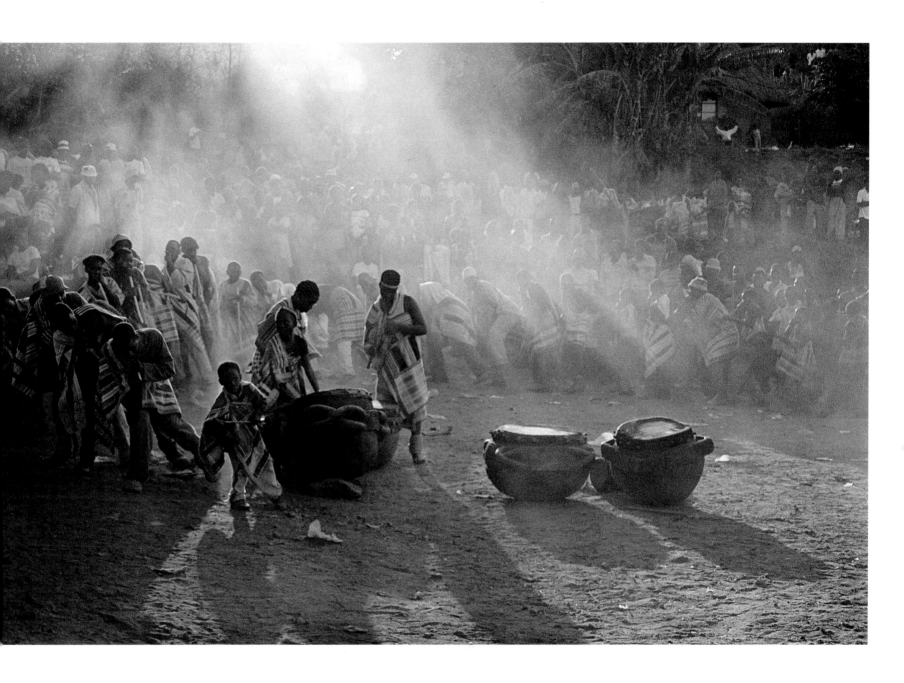

nda dance, Cibasa, Limpopo.  [ **Andrew** Tshabangu ]

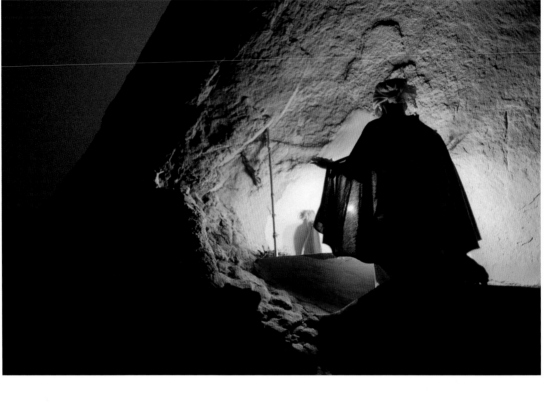

Mmatsepo, a traditional healer, prays at an altar she built in a cave at Mautse, eastern Free State. [ Lori Waselchuk ]

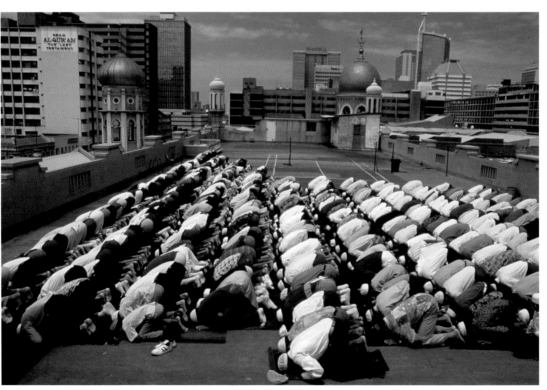

Muslims praying on rooftop, Durban. [ Gideon Mendel ]

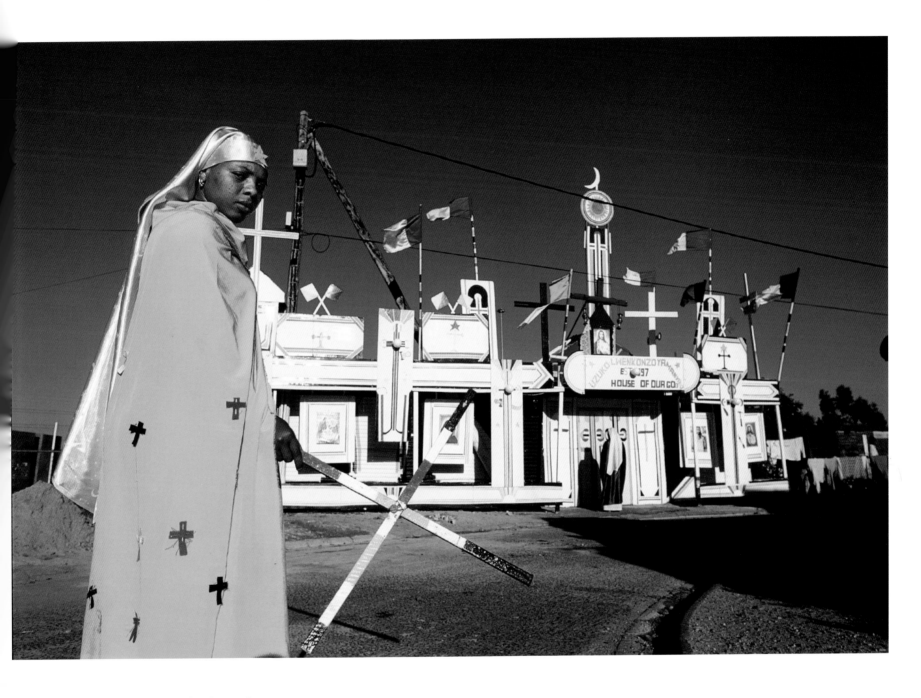

House of our God, Phillippi, Cape Town. [ **Fanie** Jason ]

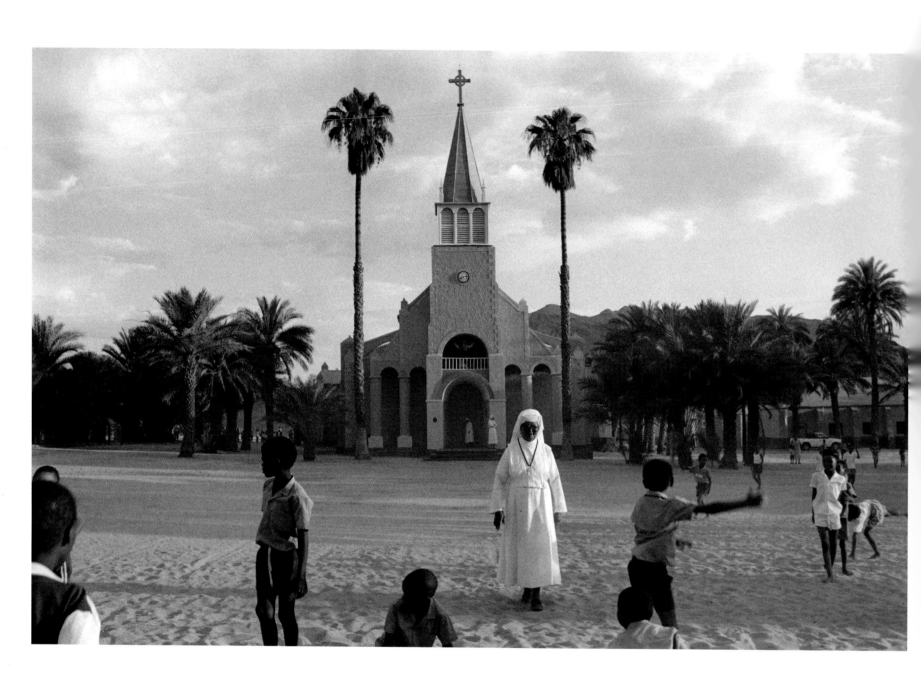

Roman Catholic Church, Pella, Northern Cape. [ **Jodi Bieber** ]

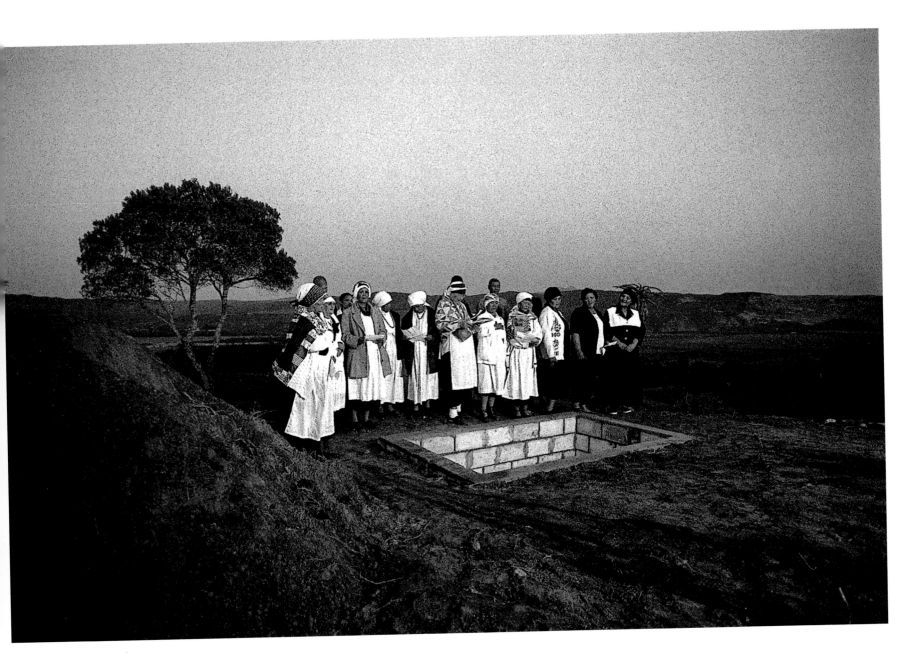

The funeral of Saartjie Baartman, Hankey, Eastern Cape, August 2002. Baartman, a Griqua woman, was publicly exhibited in England in the late 18th century. After her death in Paris in 1816, parts of her body were preserved and displayed in a museum. The French government returned her remains to South Africa in 2002. [ Paul Alberts]

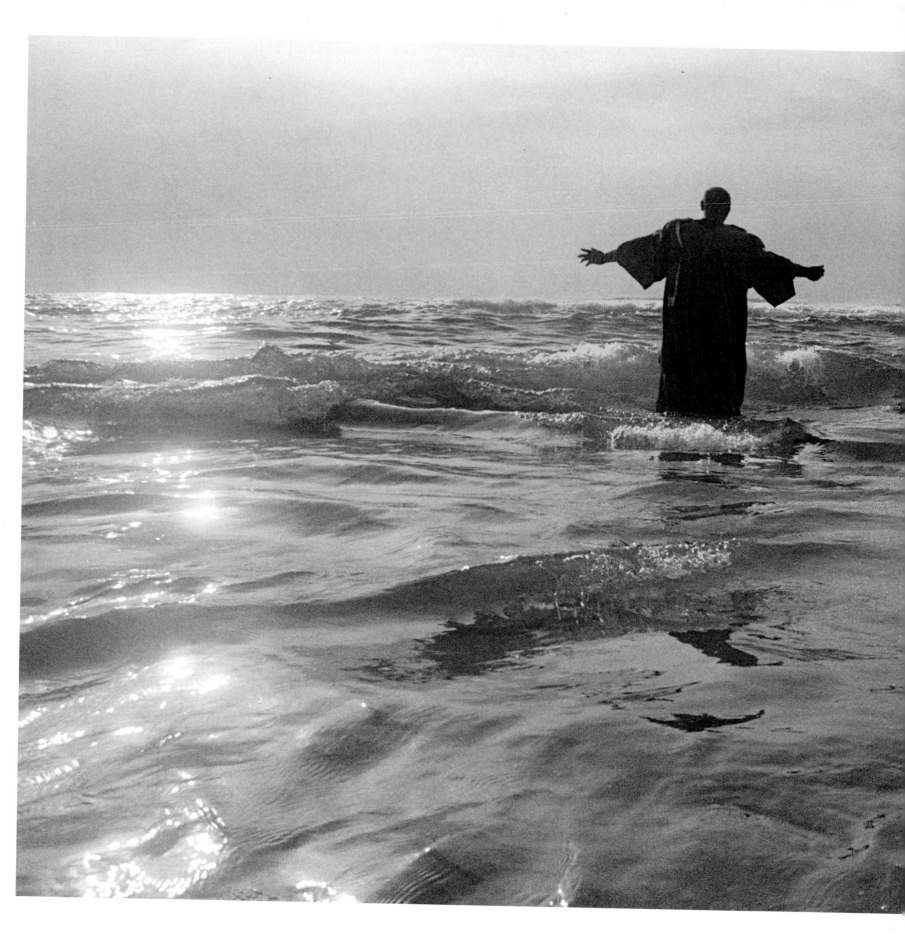

Early morning baptism, Durban beach, 1999.

# paul **weinberg** [the moving spirit]

South Africa is a new democracy, a country with high
hopes and expectations. Politically, we speak
eloquently and confidently. However, our birth has been
brutal and violent, and below the surface the past and
present coexist uneasily. We live in hope, we live in fear,
and too many live in abject poverty. In this context,
people continue to turn to faith and religion to help
them survive. Like our society, religious practice in
South Africa is enormously diverse. Successive waves
of settlers brought different forms of Christianity, to
which indigenous people have responded. Slaves and
indentured labourers brought with them Islam and
Hinduism. This essay, photographed in my home
province, KwaZulu-Natal, is a journey through the
events and rituals that mark our religious life, in search
of the moving spirit that may unite us all.

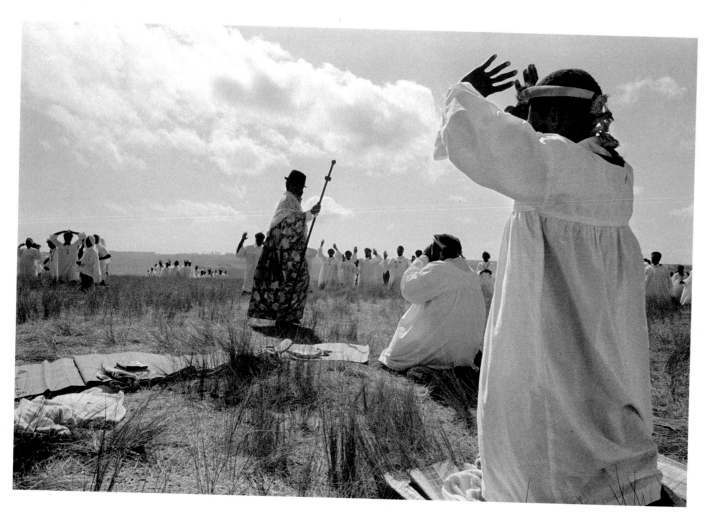

Shembe devotees pray during their annual pilgrimage to Mount Nhlangagazi, 1998.

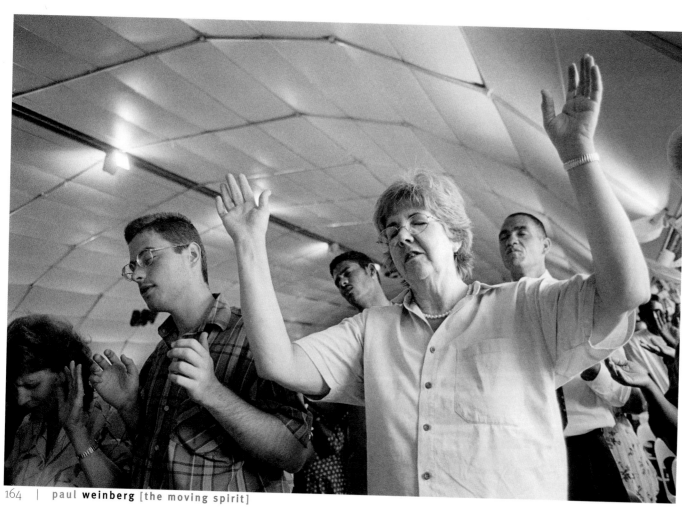

A prayer service at the Durban Christian Church, 1999.

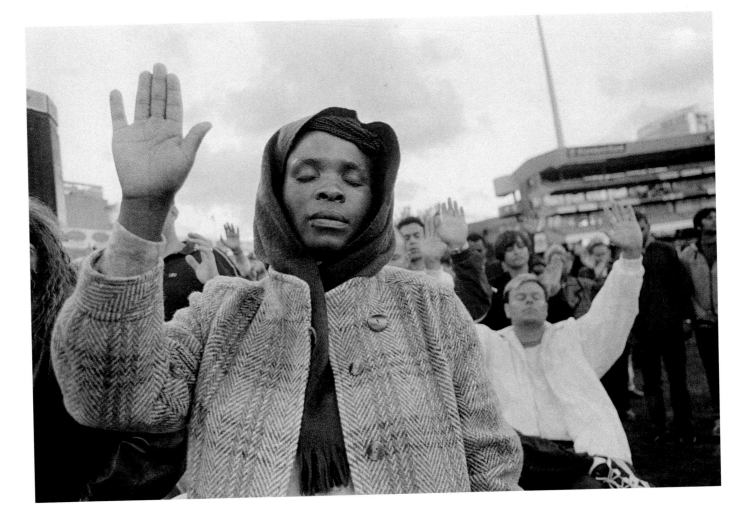

Mass service led by an evangelist, Kingsmead Cricket Stadium, Durban, 2000.

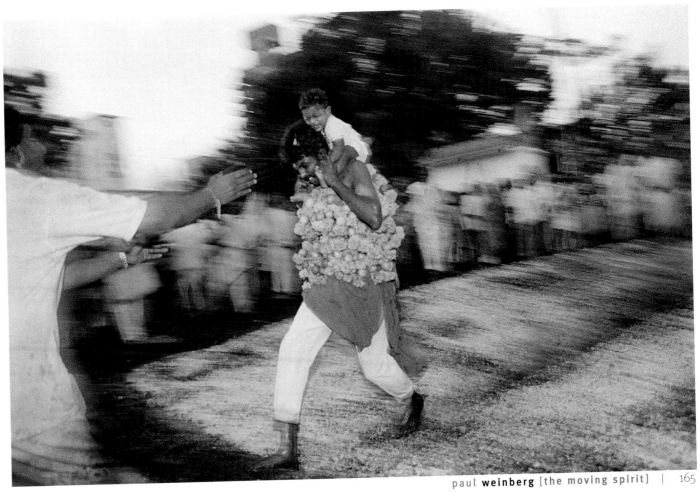

A Hindu devotee walks on fire, Pietermaritzburg, 1998.

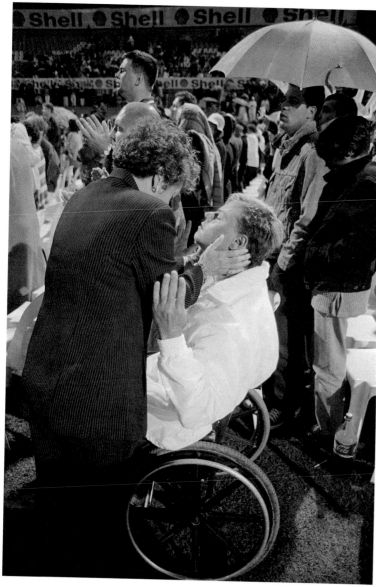

Audience prays for miracles, mass service led by an evangelist,
Kingsmead Cricket Stadium, 2000

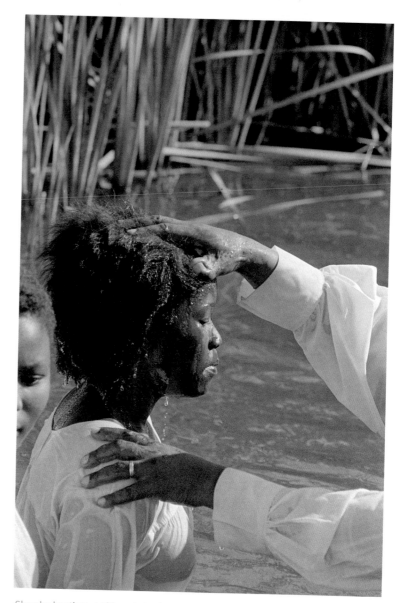

Shembe baptism at Ekhuvokeheni, Inanda, Durban, 1999.

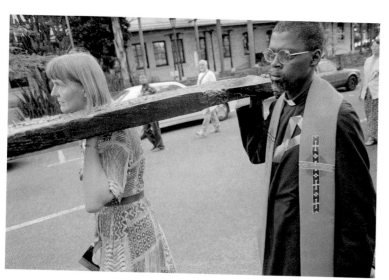

Annual Easter parade organised by Diakonia, Durban, 1998.

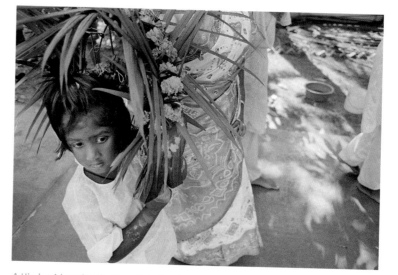

A Hindu girl carries the Kavadi during the Kavadi festival, Durban,
1999.

Shembe worshippers inhale holy smoke on the last day of their pilgrimage to Mount Nhlangagazi, 1998.

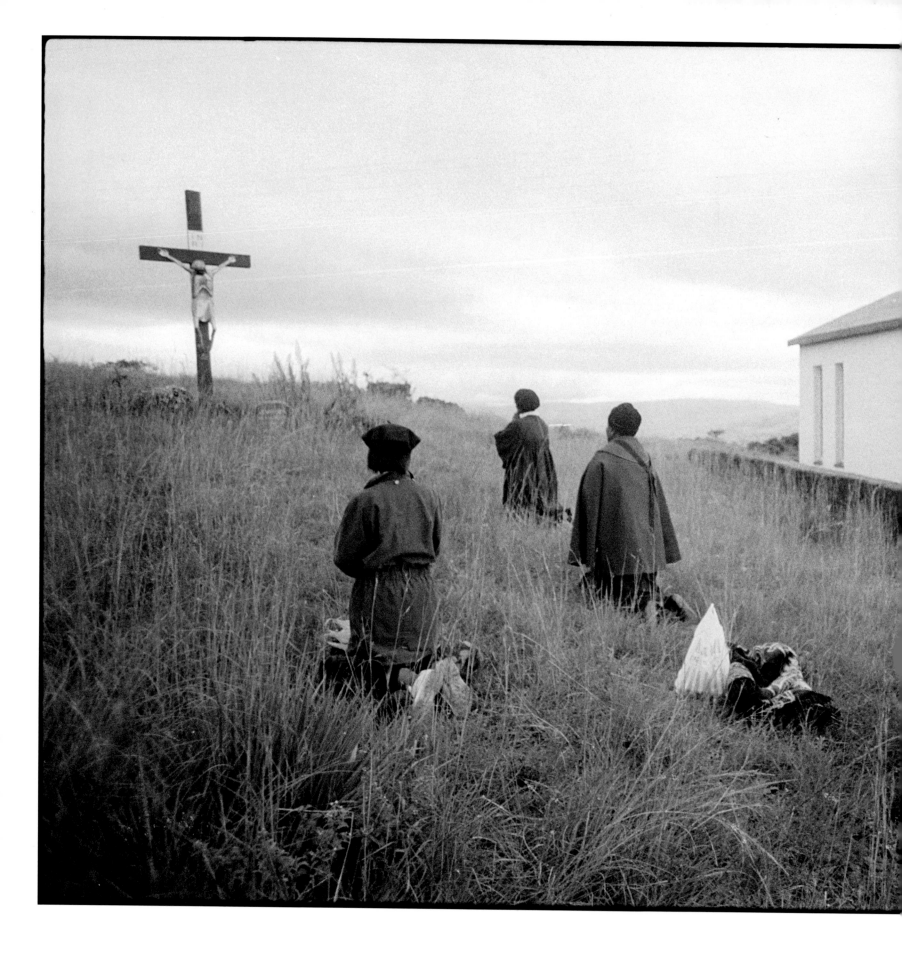

## andrew **tshabangu** [pilgrims at ngome]

In 1995, Sister Renalde May, a Benedictine nun, declared that the Mother of Christ had appeared to her at Ngome, near Eshowe in KwaZulu-Natal. The Roman Catholic Church is still investigating the sighting. In the meantime, thousands of pilgrims from all over southern Africa visit the site every year.

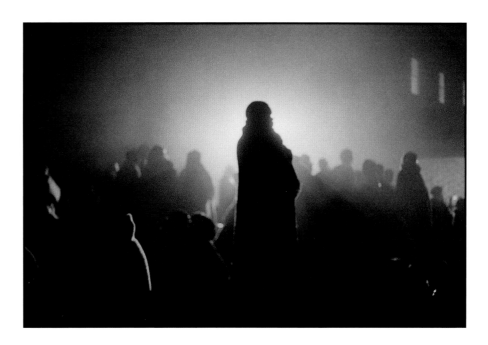

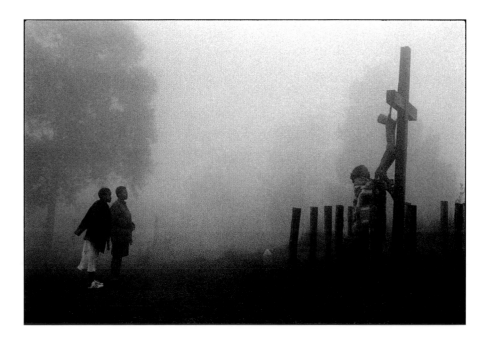

# graeme **williams**
## [industrial landscapes]

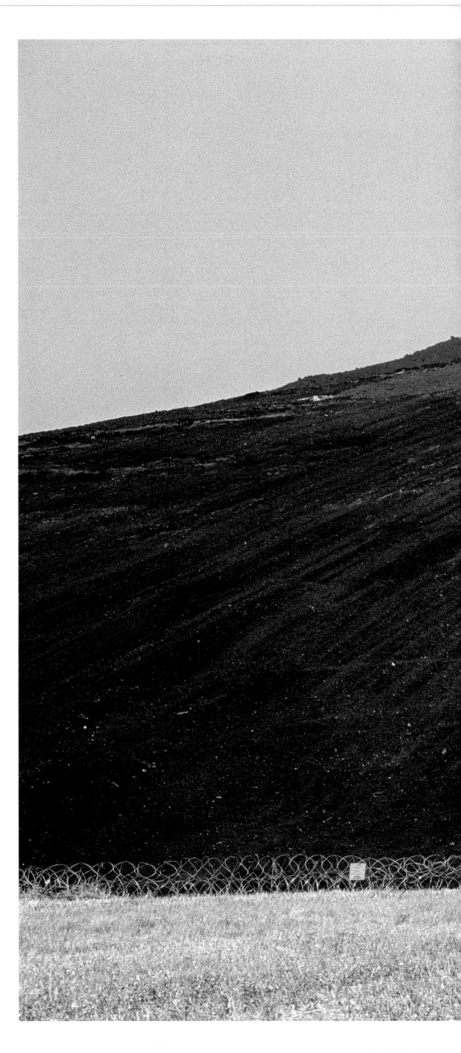

Coal dump rehabilitation, Ogies, Mpumalanga, 2002.

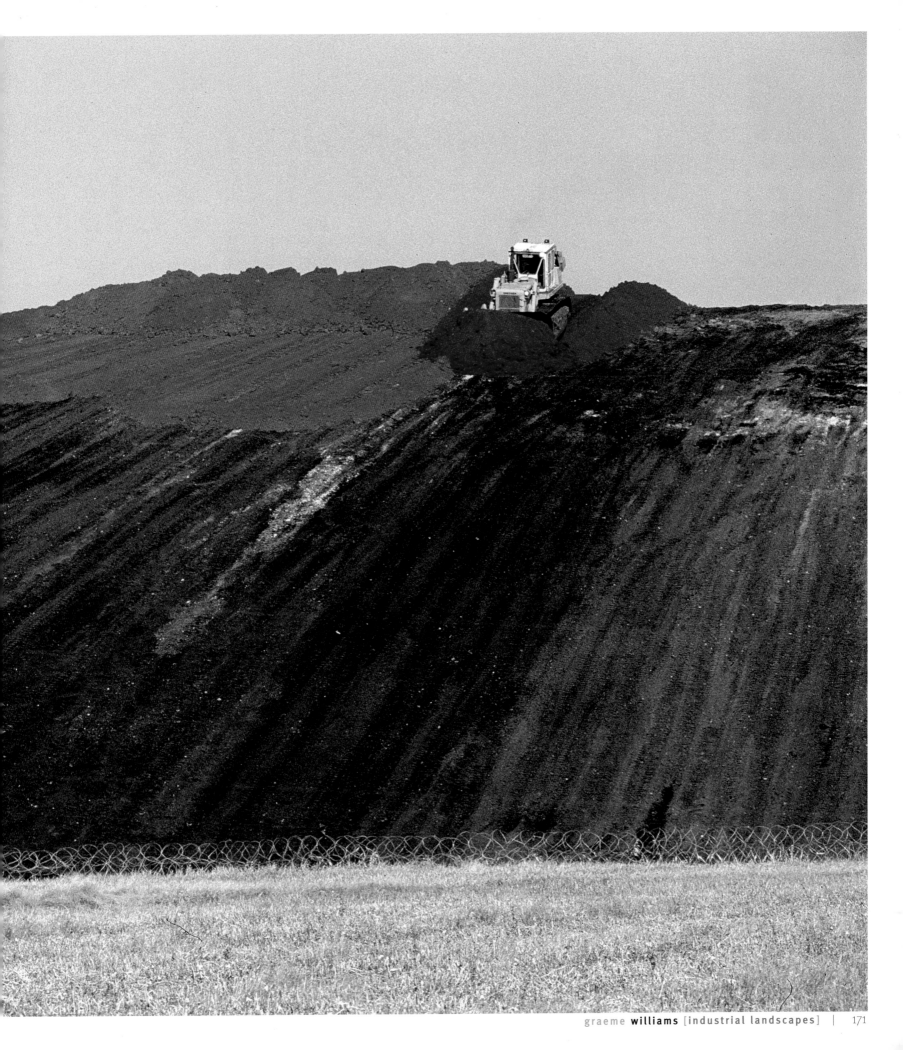

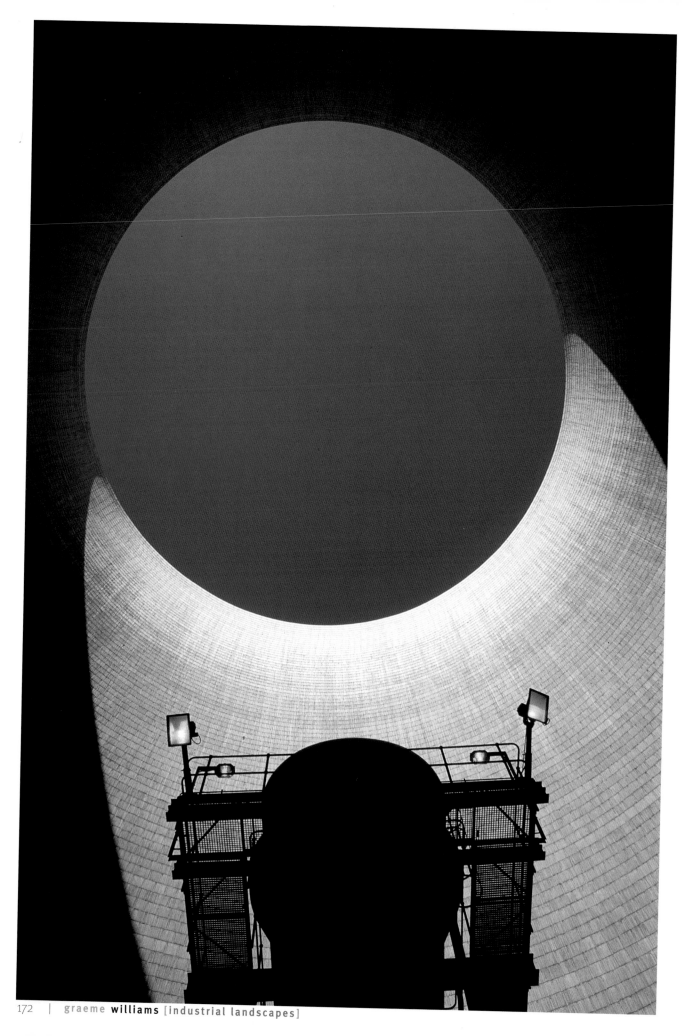

Inside the cooling tower at Kendal, the world's largest coal-fired power station. Witbank, Mpumalanga, 1995.

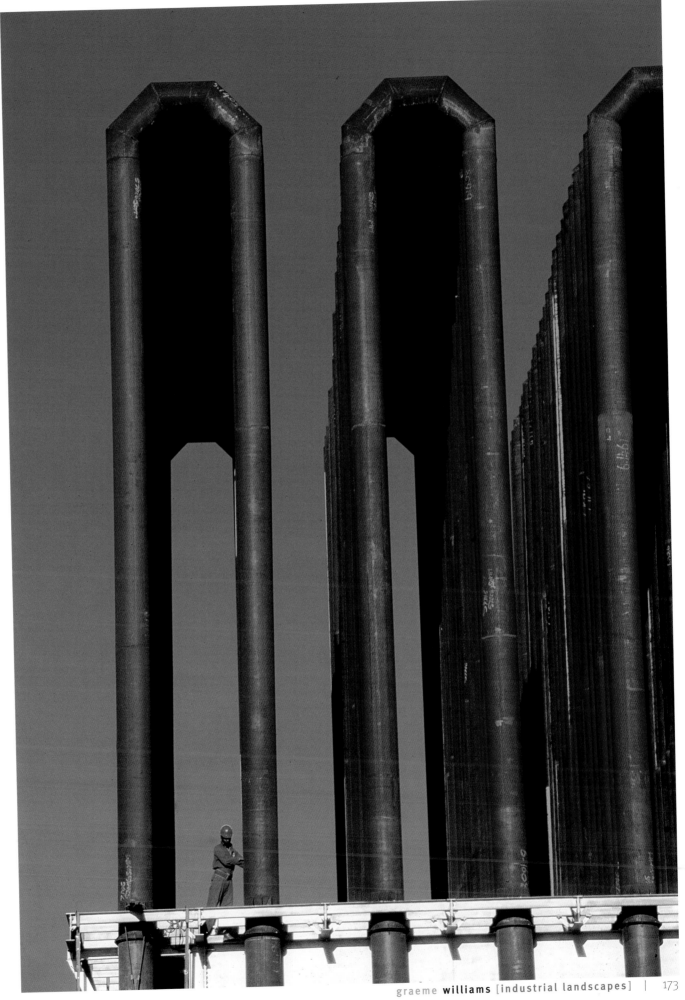

Trombone coolers being installed at a ferrochrome plant. Lydenburg, Mpumalanga, 1997.

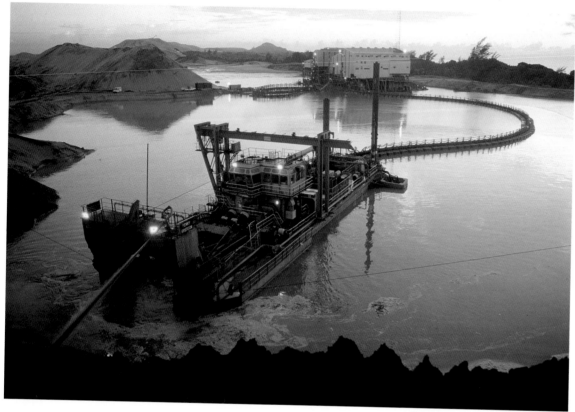

Richards Bay Minerals dredging operation in the sand dunes north of Richards Bay, KwaZulu-Natal, 1997.

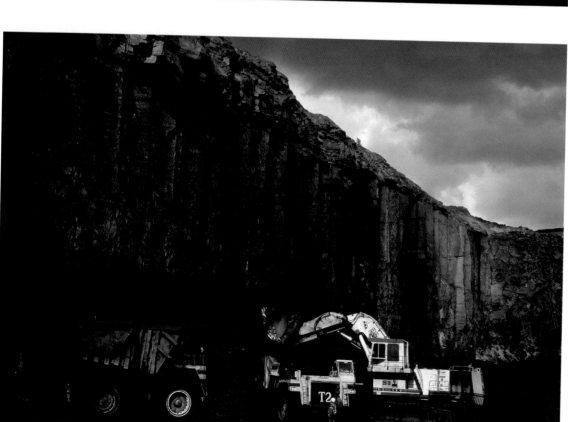

Haulage trucks in an open-cast coal mine. Witbank, Mpumalanga, 1995.

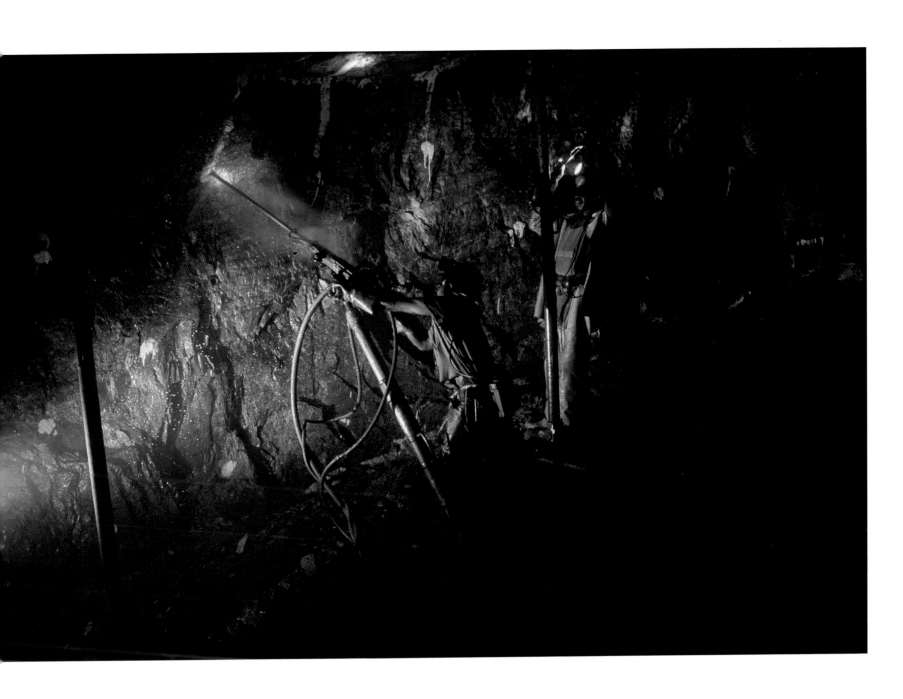

ine workers drilling blast holes, gold mine, Randfontein, Gauteng.

Telephone pole cut for firewood, near Umtata, Eastern Cape. [ **Oscar G** ]

tronomical observatory at Sutherland, Northern Cape. [ **Rodger** Bosch ]

Bridge over the N2 near Khayelitsha, Cape Town. [ **Rodger** Bosch

...sty road, Tugela Ferry, KwaZulu-Natal. [ **T J Lemon** / Independent Newspapers ]

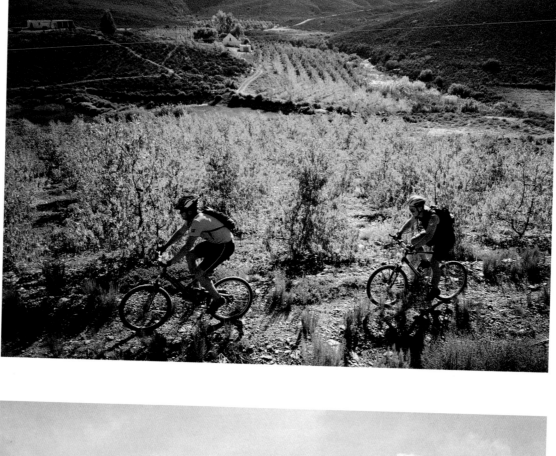

Mountain bikers near Montagu, Little Karoo.
[ **Andrew** Ingram / Independent Newspapers ]

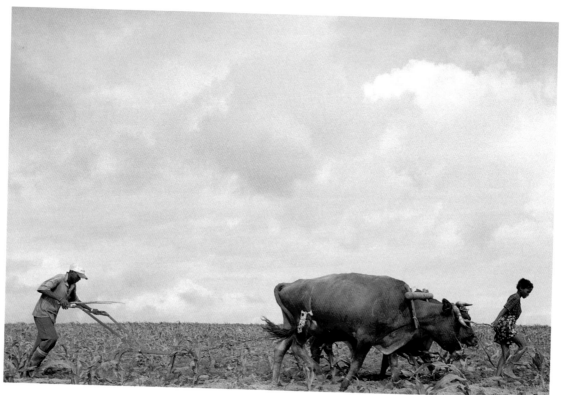

Children ploughing, Qunu, eastern Cape. [ **Lori Waselchuk** ]

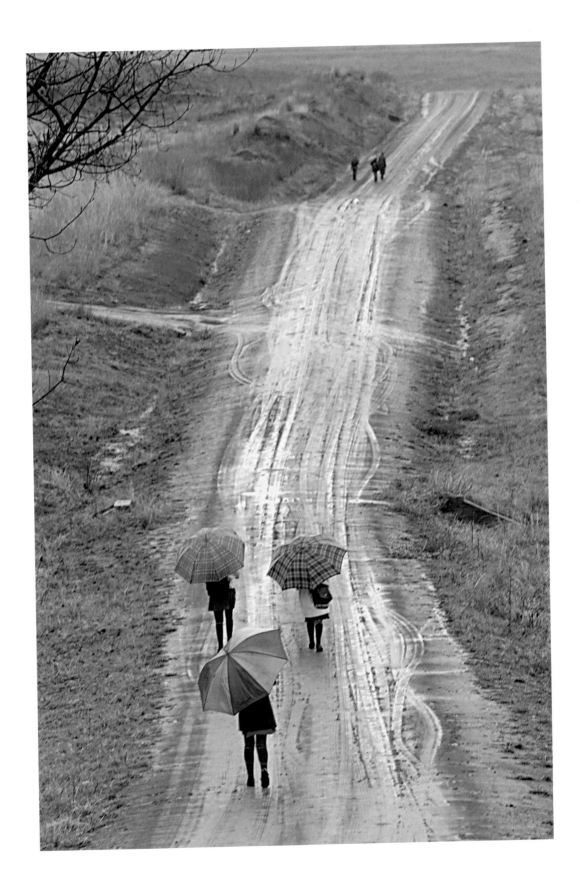

Youths at Qumbu in the Eastern Cape brave the rain on their way to shool. [ Siphiwe Sibeko / Independent Newspapers ]

Shack under construction, Bredell, Gauteng, 2002. [ **Lori Waselchuk** ]

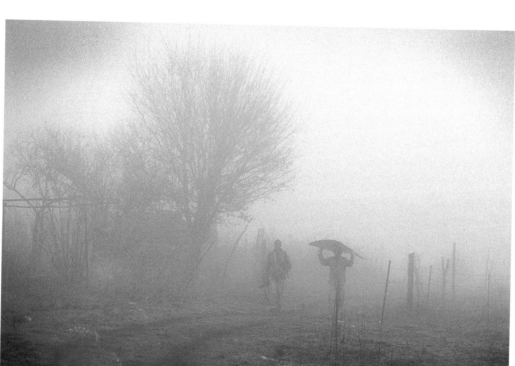

Homeless people on their way to erect a shack during a mass land occupation at Bredell, East Rand, winter 2002.
[ **Steve Lawrence** / Independent Newspapers ]

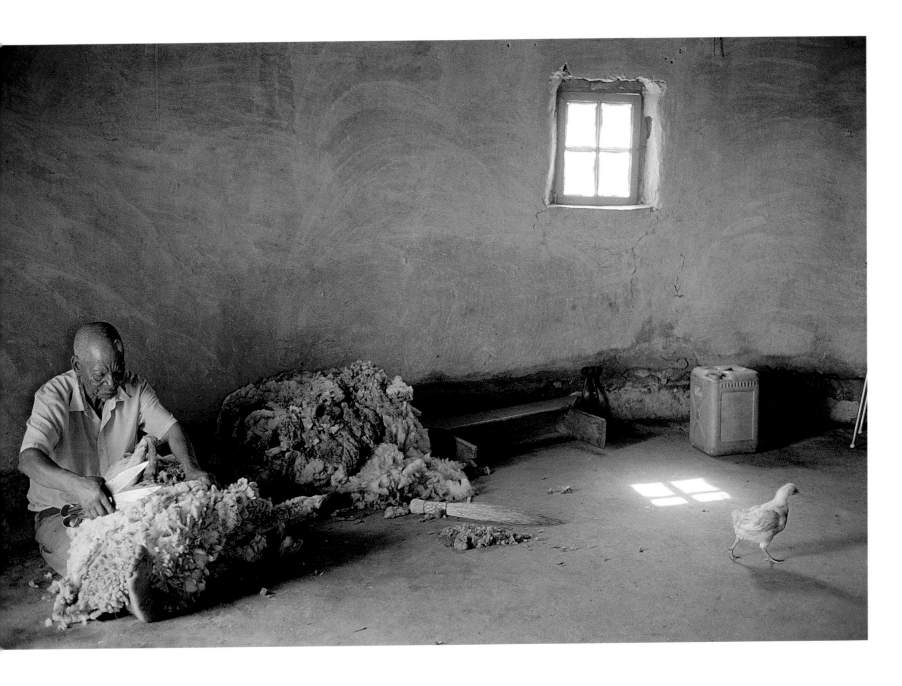

heep shearer, Qunu, Eastern Cape. [ **Lori** Waselchuk ]

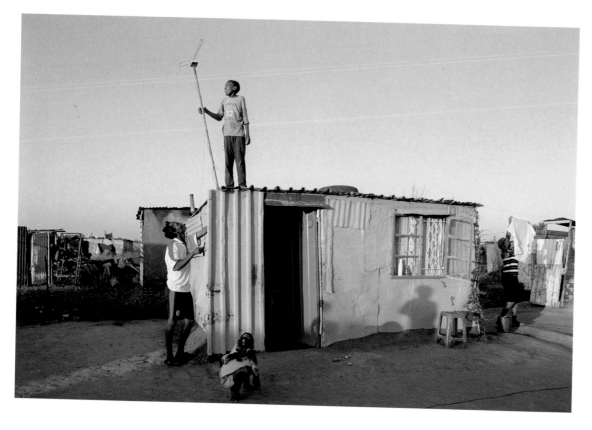

Shack-dwellers erect a TV aerial, Gabon informal settlement, Gauteng. [ **Lori Waselchuk** ]

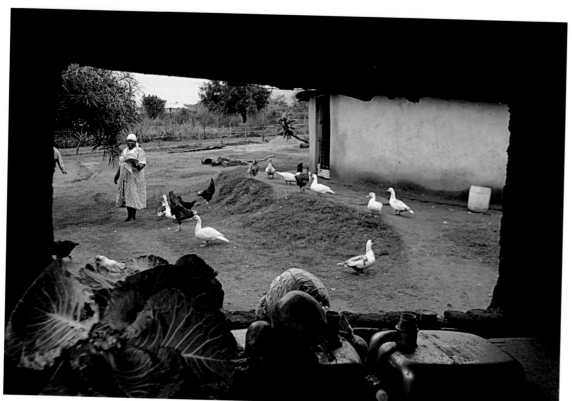

Sustainable living, Valley of a Thousand Hills, KwaZulu-Natal.
[ **Mujahid Safodien** / Independent Newspapers ]

An Eskom employee connects power cables in a new RDP housing project. Tembisa, East Rand. [ **Shaun Harris** / Afrika Moves ]

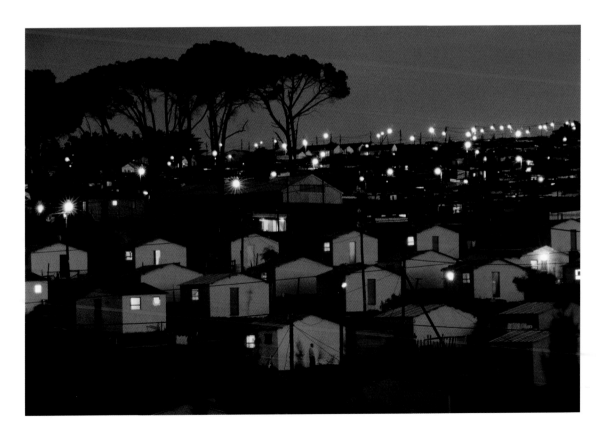

Electric lights in a new RDP housing project at Khayamandi, Stellenbosch.
[ **Louise Gubb** / Trace Images ]

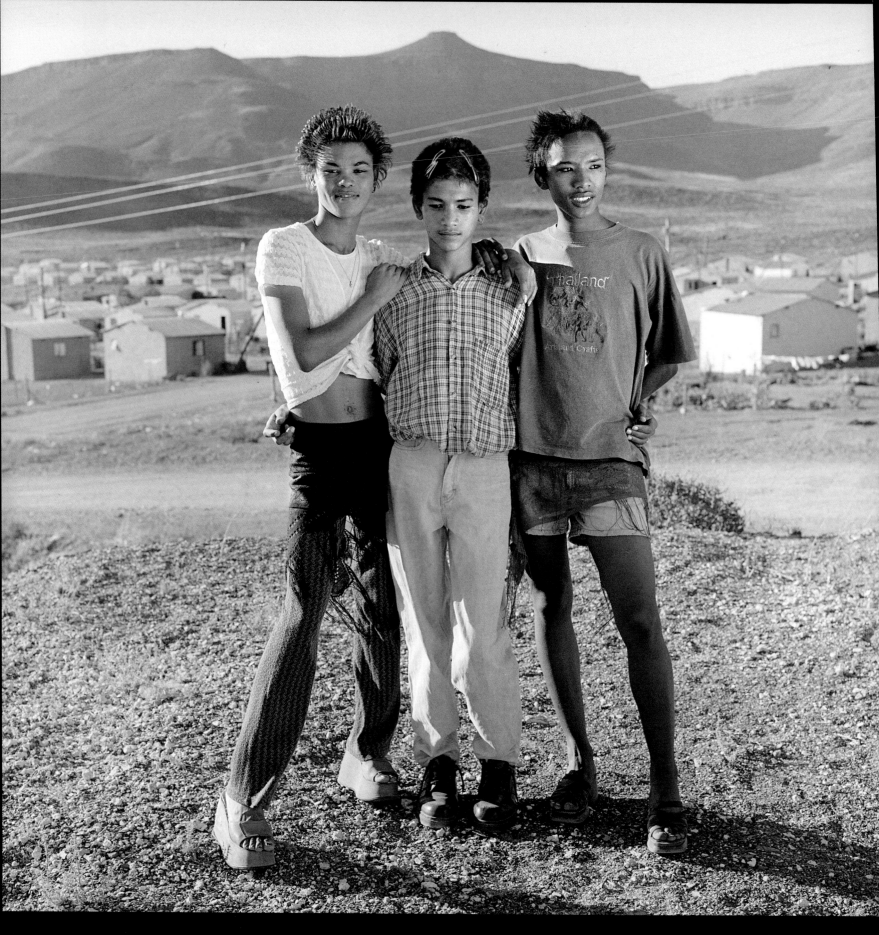

Roderick Swartz, Heinrich Smith, and Melvin Jacobs.

# andreas vlachakis [calvinia]

The town of Calvinia lies deep in the Karoo, four or five hours' travel by car north of Cape Town, surrounded by the Hantam mountains. Hantam was the name the San gave the area; it means 'the place where the red flowers grow'. The town itself was later renamed after the austere religious reformer John Calvin. I paid several visits to the town over a period of two years, starting in 2001. Photographing mainly in the township of Calvinia Wes and surrounds, this lonely, stark place spoke to me of marginalisation but also of a graceful endurance.

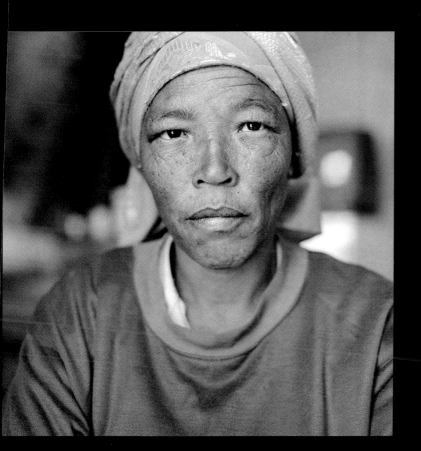

Lena van Wyk.

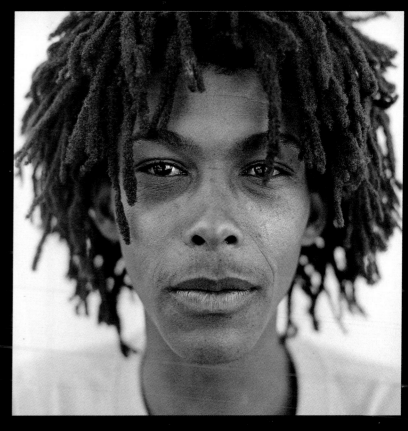

Asher Tafari.

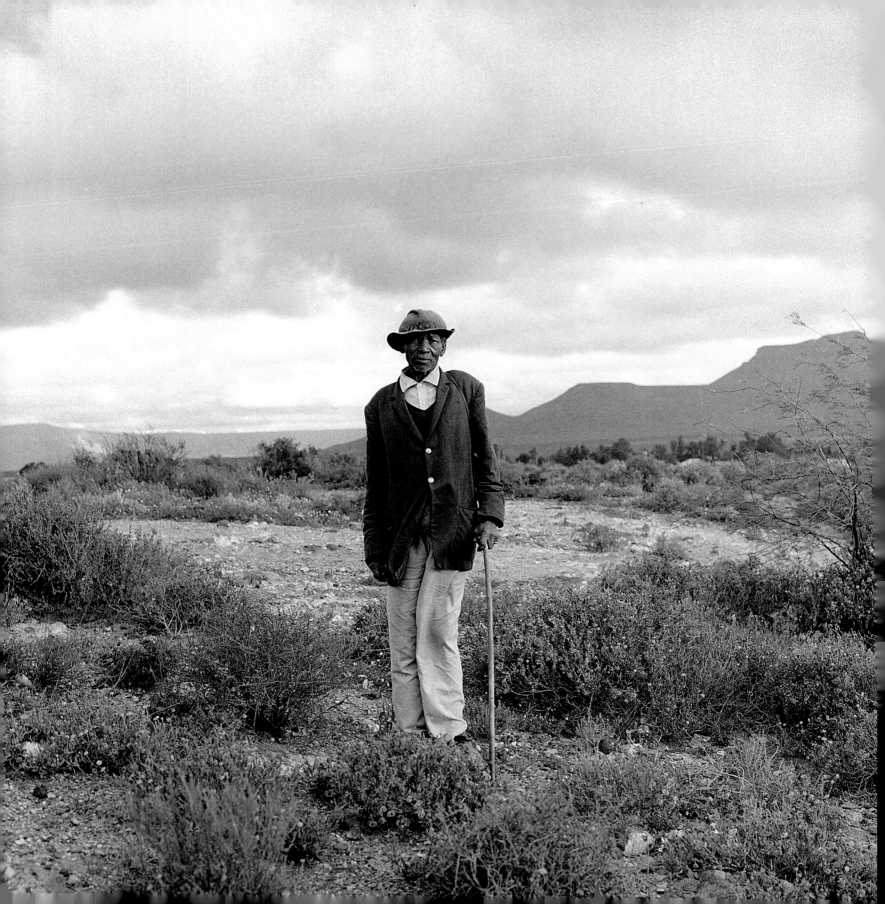

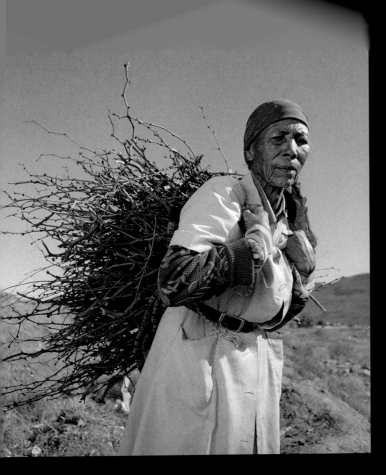

na Moors going home.

Late afternoon at the dump.

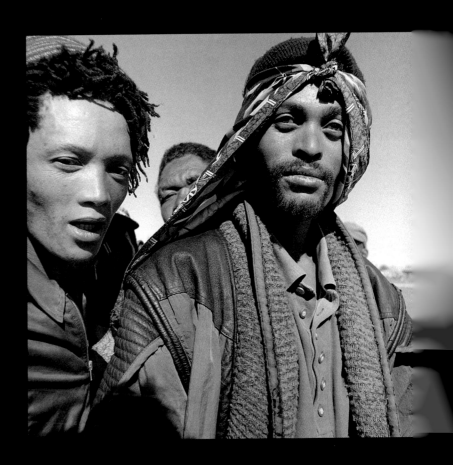

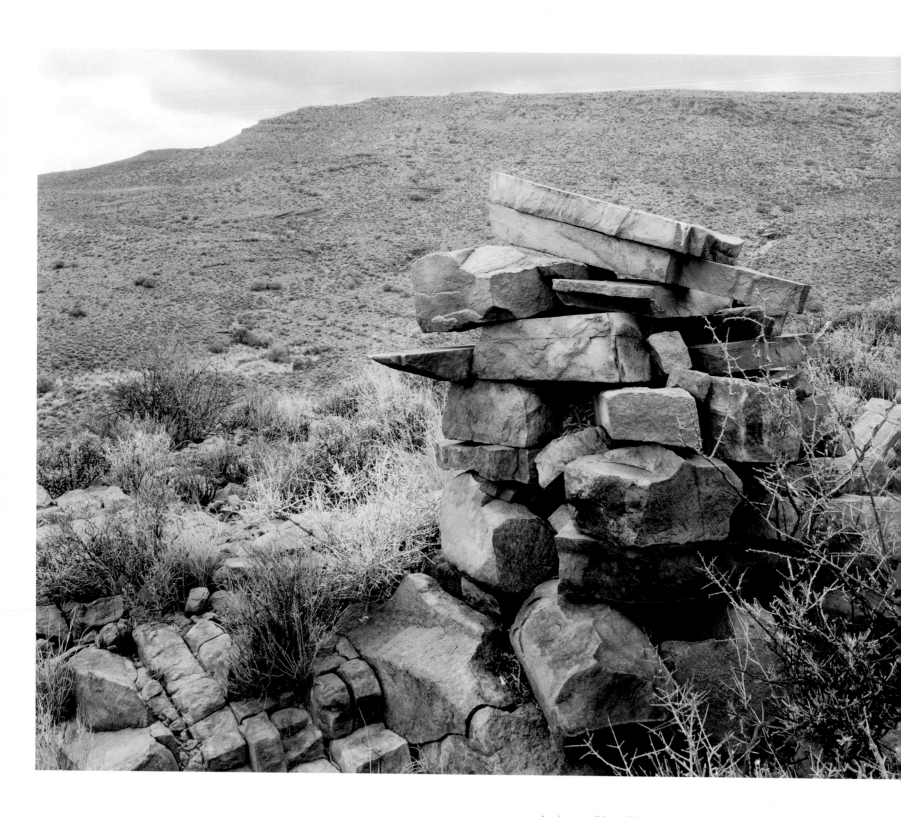

A cairn, possibly marking a grave, Leeuwenvalley, Moordenaar's Karoo. 24 April 200.

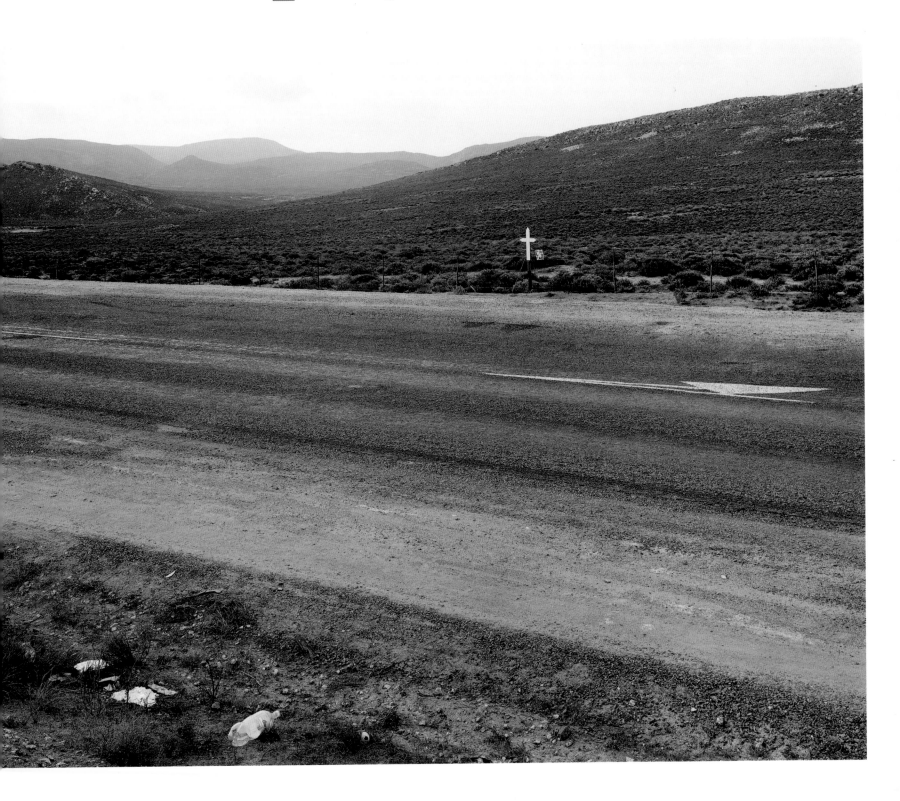

ad kill at S31º 12.586', E18º 29.67', on the N7 between Vanrhynsdorp and Nuwerus. 19 September 2003.

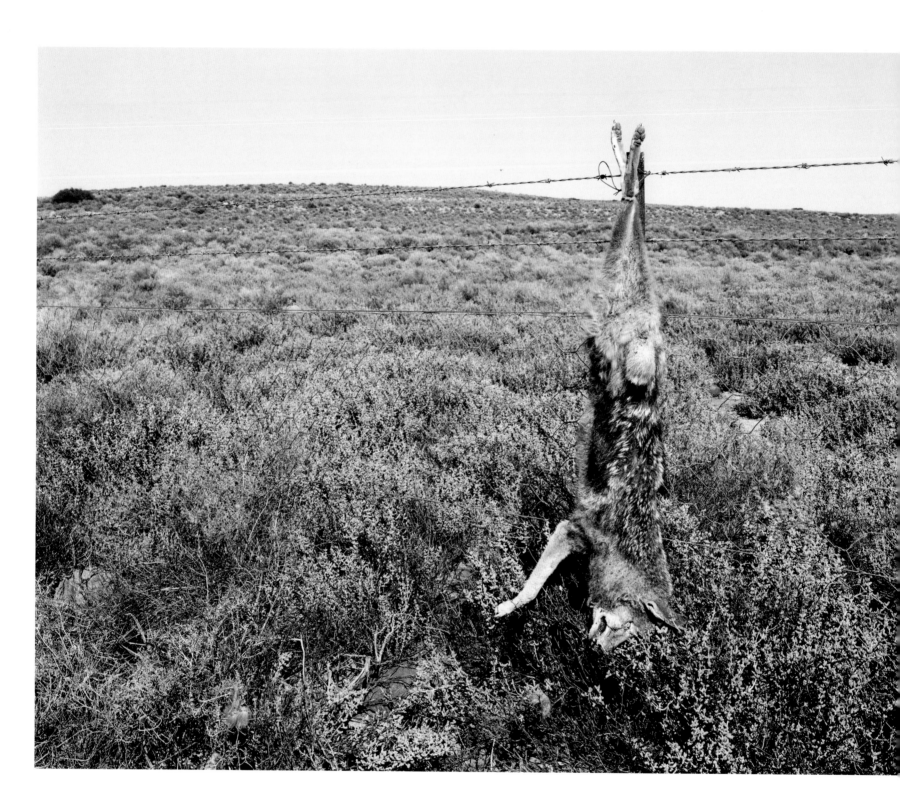

Jackal on a fence of the farm Kraairivier, between Laingsburg and Sutherland, Northern Cape. 16 August 200

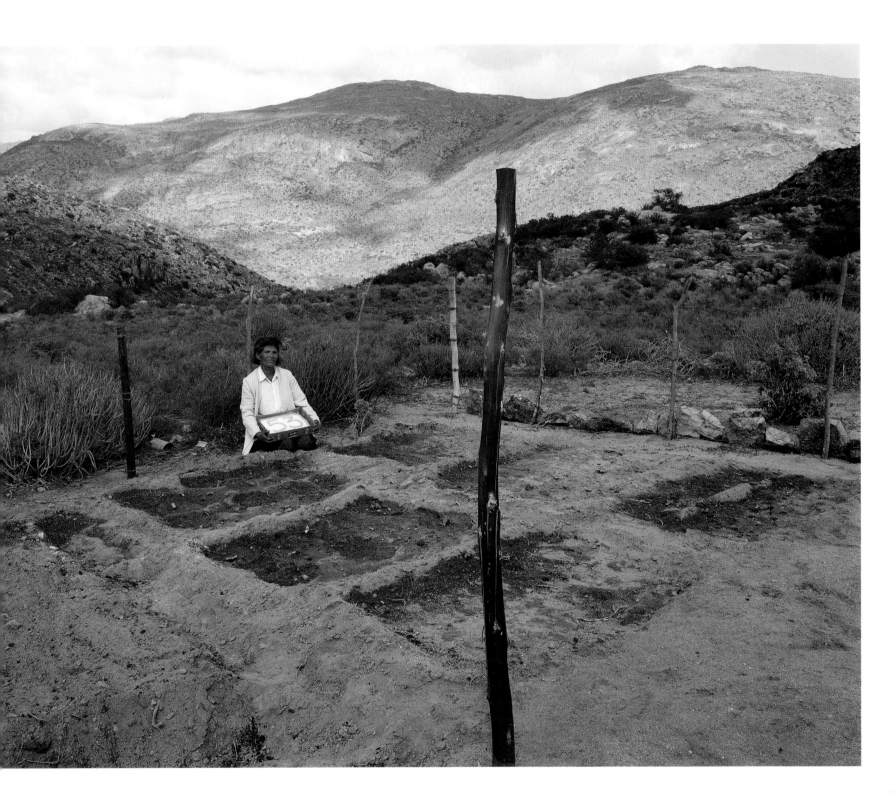

na Boois with her birthday cake and vegetable garden on her farm Klein Karoo in the Kamiesberge, Namaqualand. 20 September 2003.

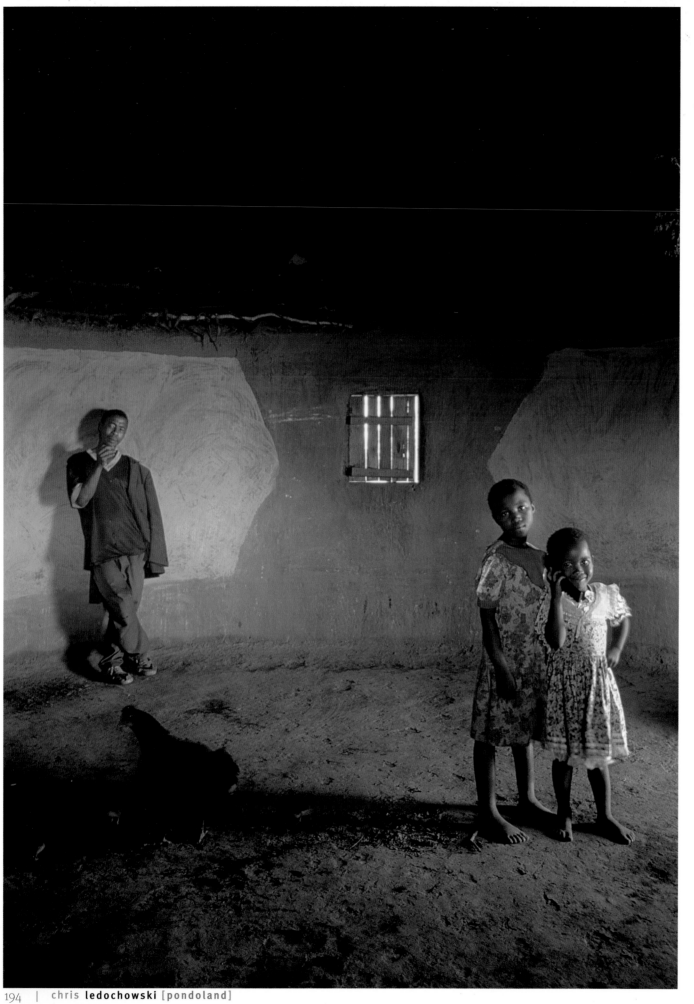

# chris **ledochowski** [pondoland]

Pondoland is a remote rural area edging on to the Wild Coast in the
Eastern Cape. Its economy centres on two agricultural products:
subsistence crops of maize, and cash crops of dagga.

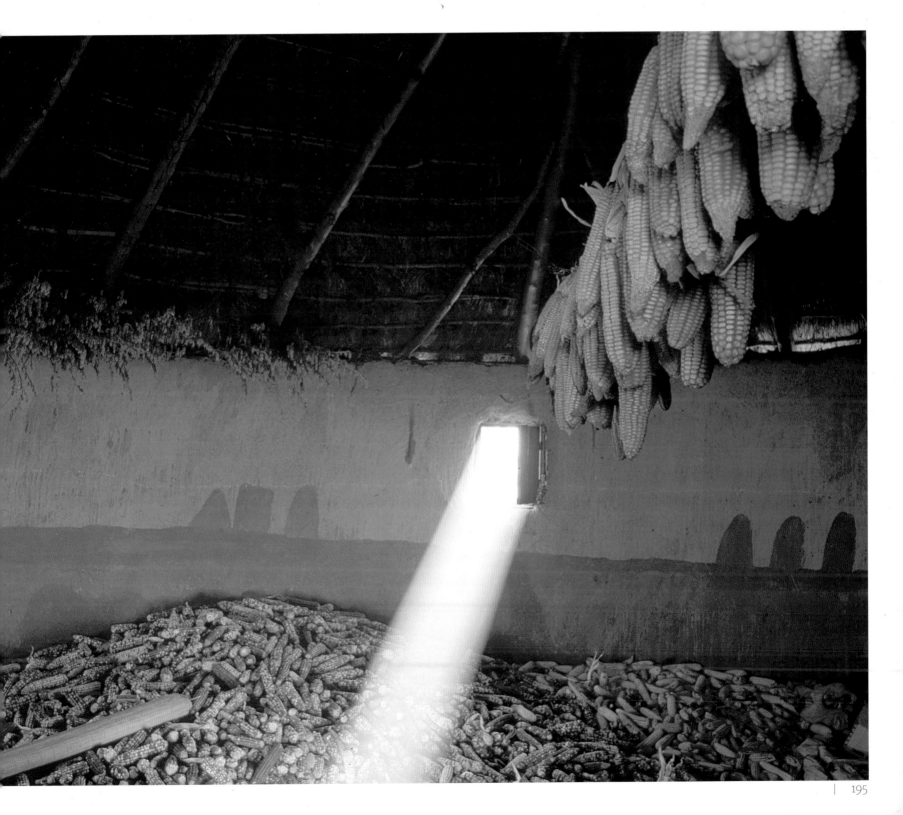

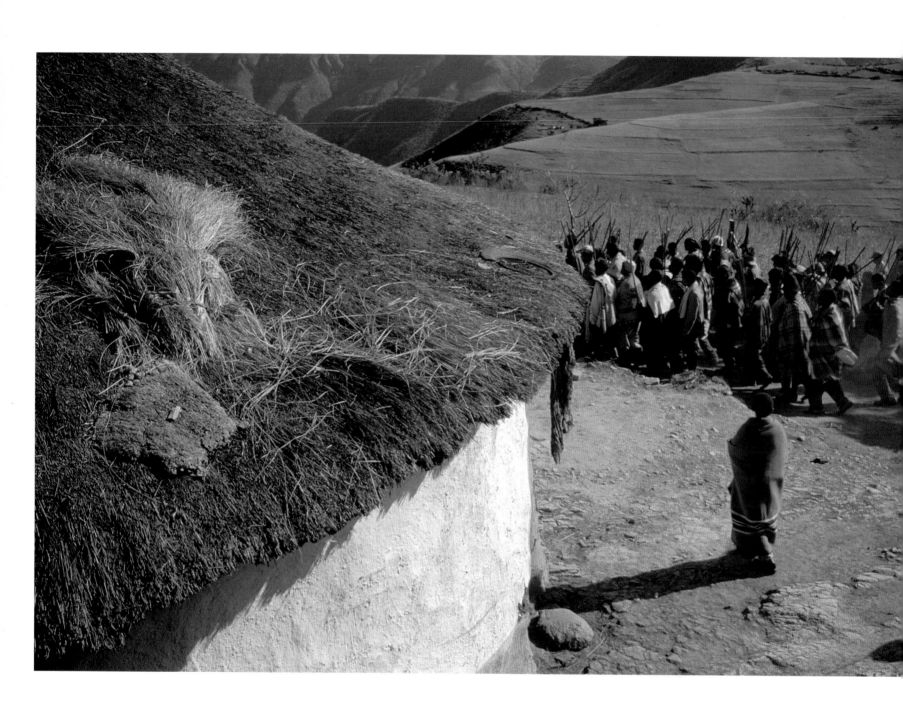

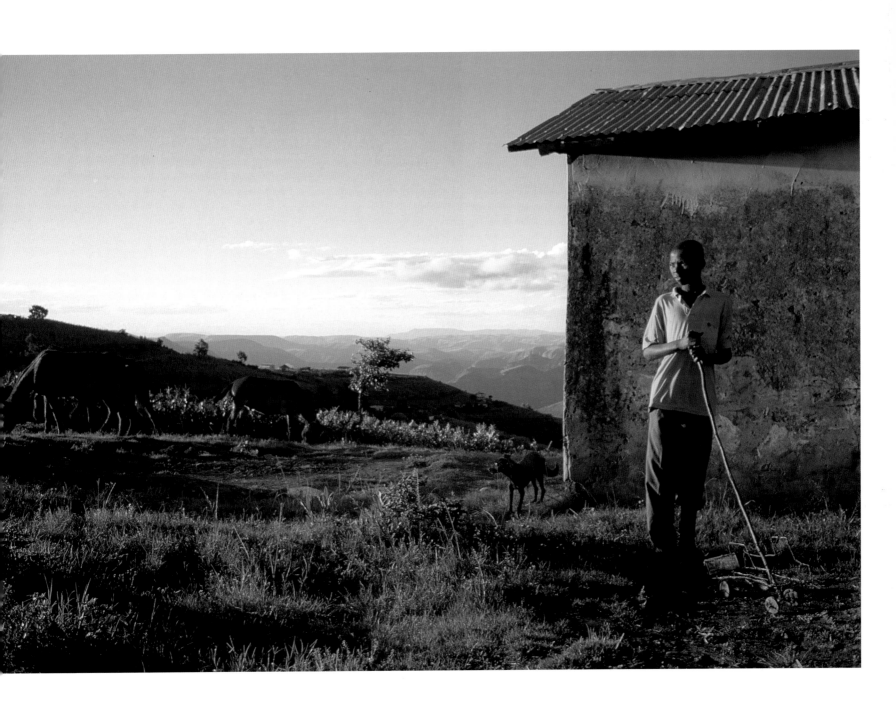

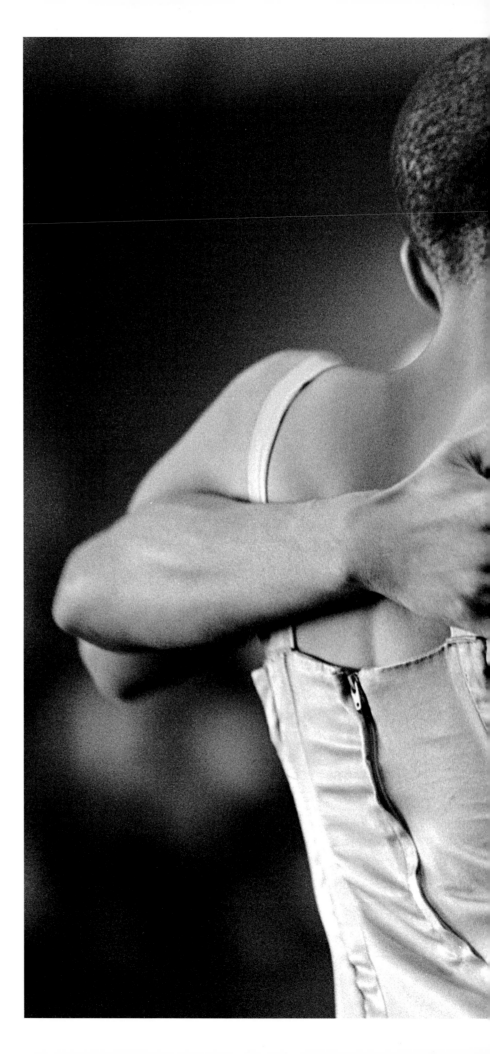

Jazzart dancers Gordon Andries and Jackie Manyaapelo in 'The full-blown story – the story of AIDS in SA', Cape Town, 2003. [ **Garth Stead** ]

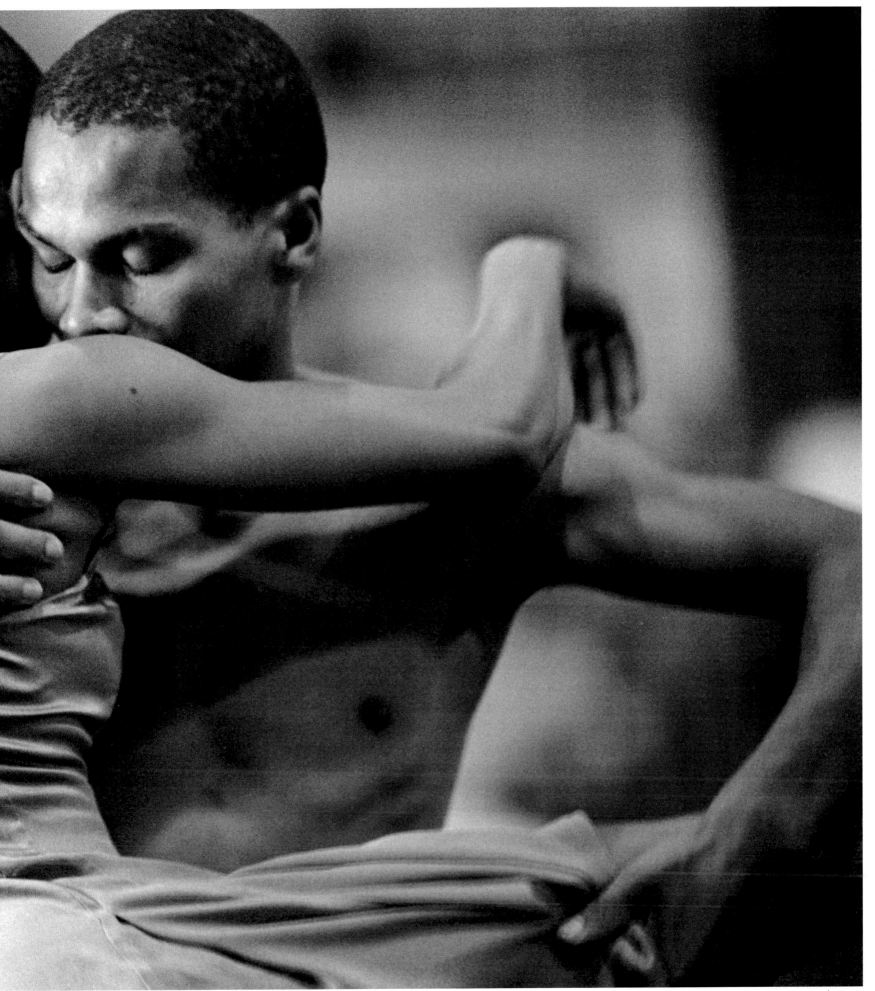

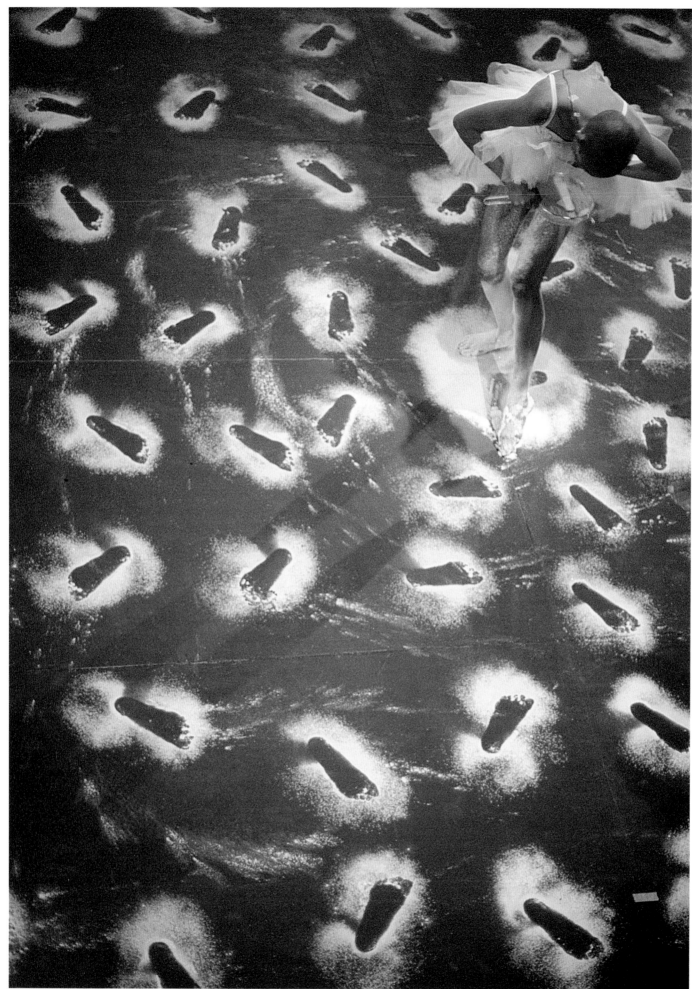

Nelisiwe Zaba, FNB Dance Umbrella, Wits Threatre, Johannesburg, 2002. [ John Hogg ]

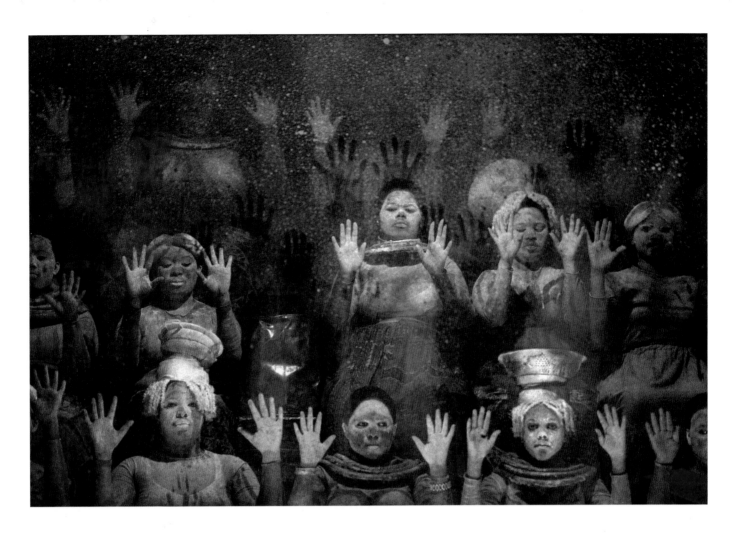

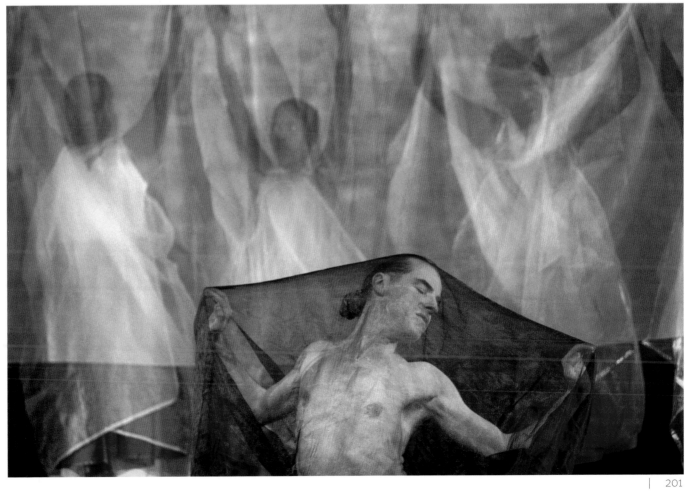

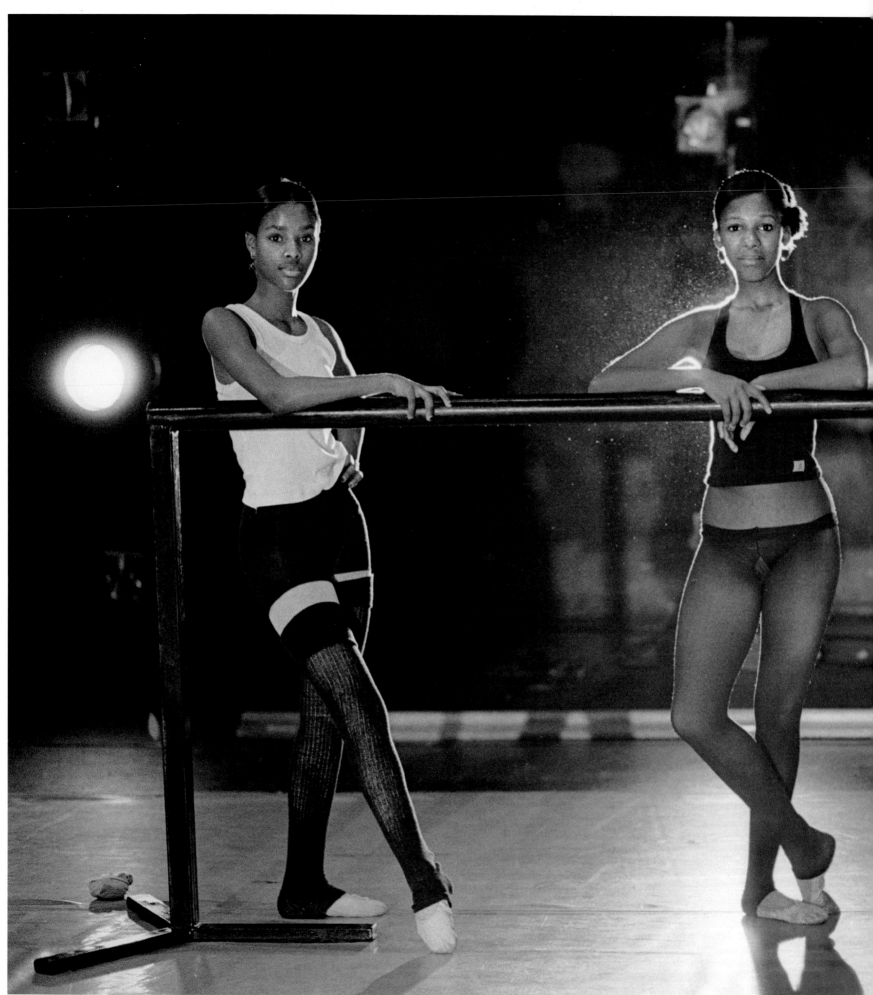

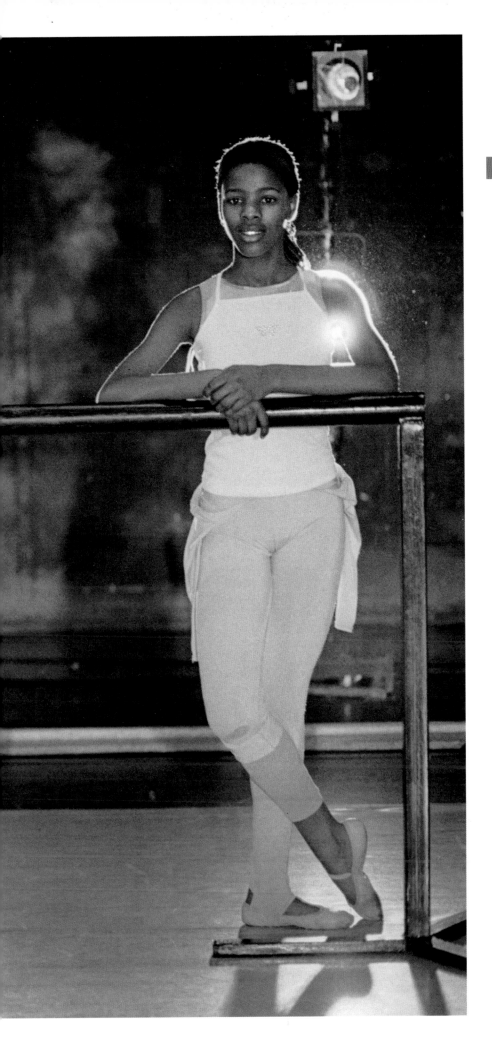

## george **hallett** [dance for all]

I first visited Philip Boyd's Dance for All school in Guguletu in 1999. I was so impressed by the vitality, exuberance, and commitment of both teachers and students that I am still photographing them today. Over the years I have watched these young people grow into confident and sophisticated dancers. Art can certainly change lives.

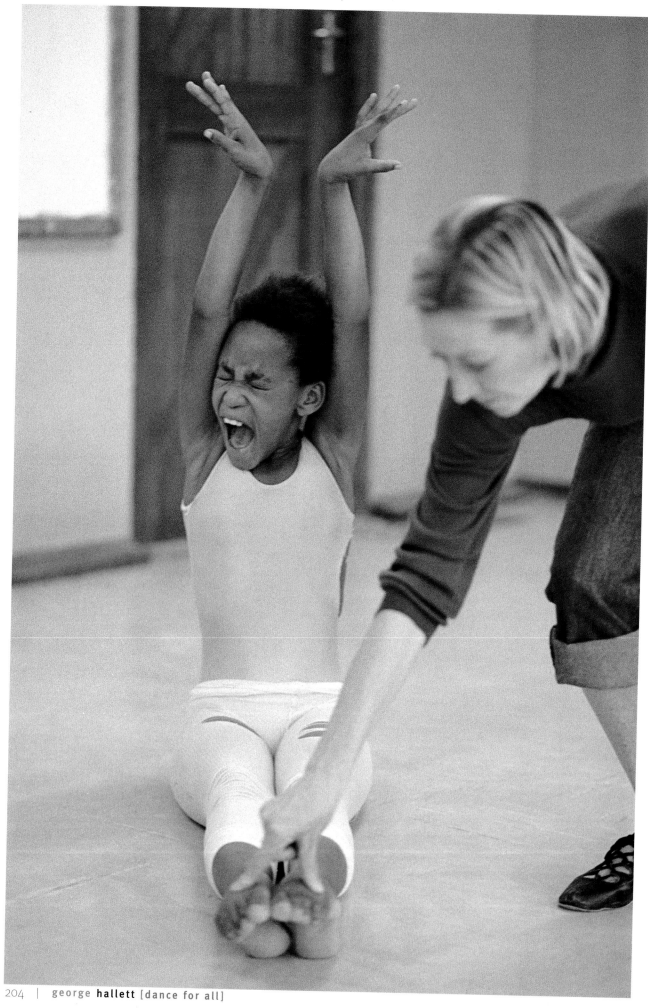

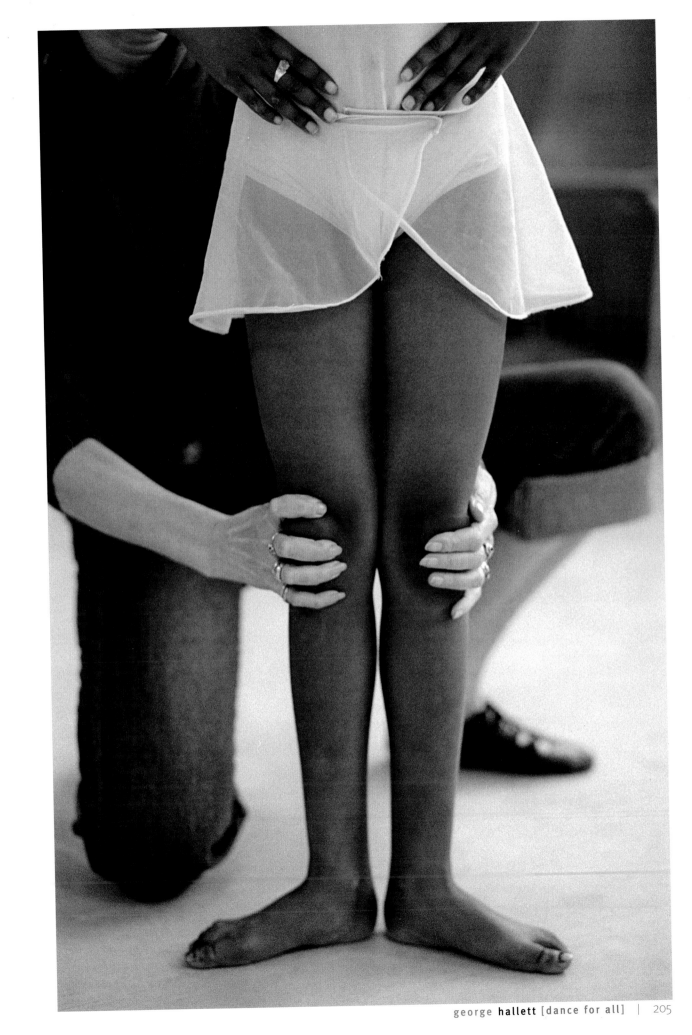

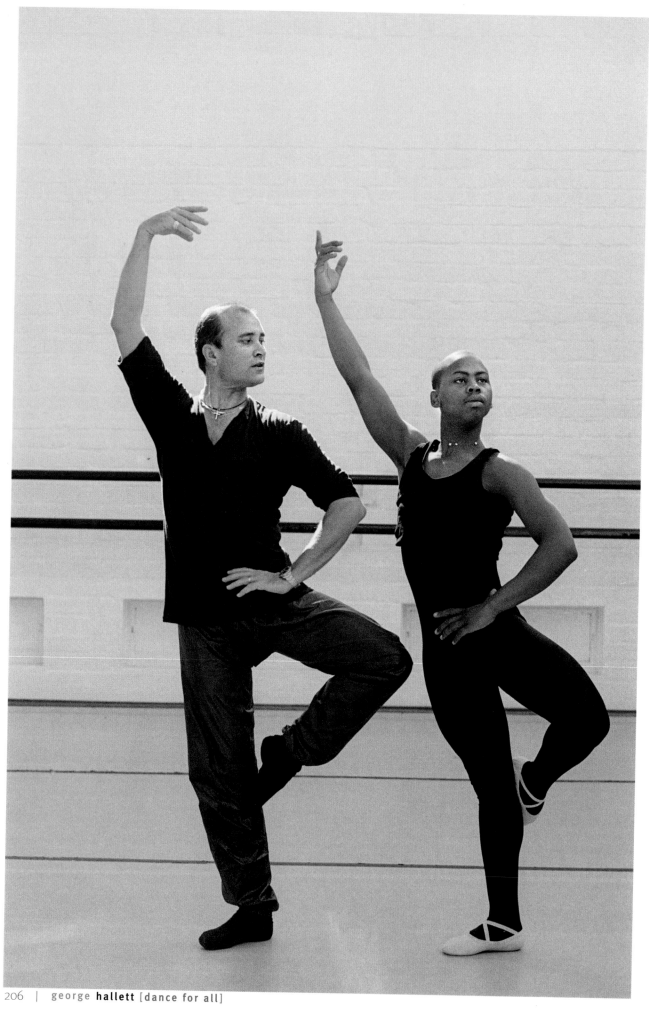

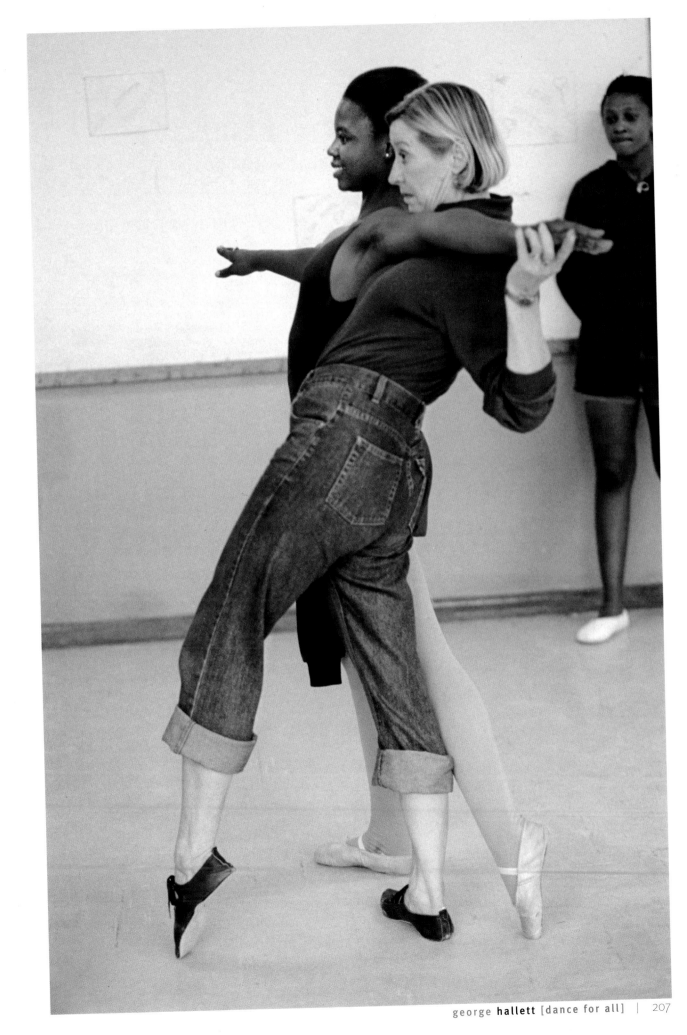

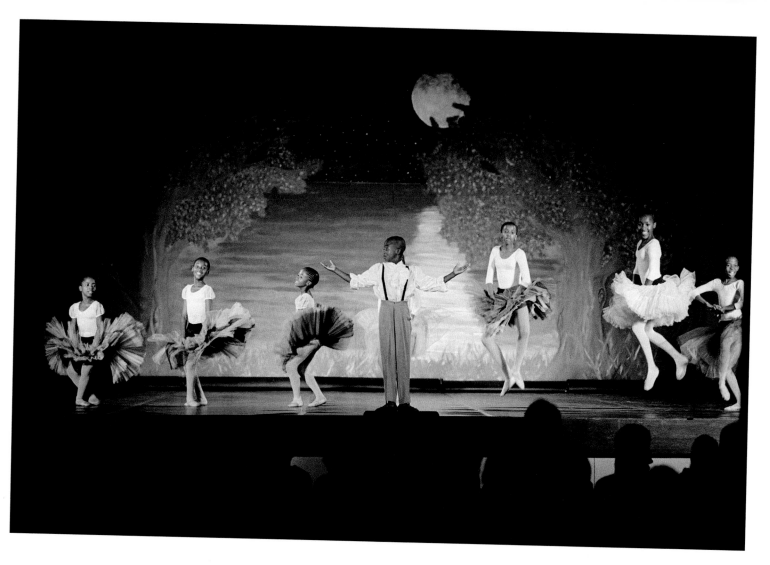

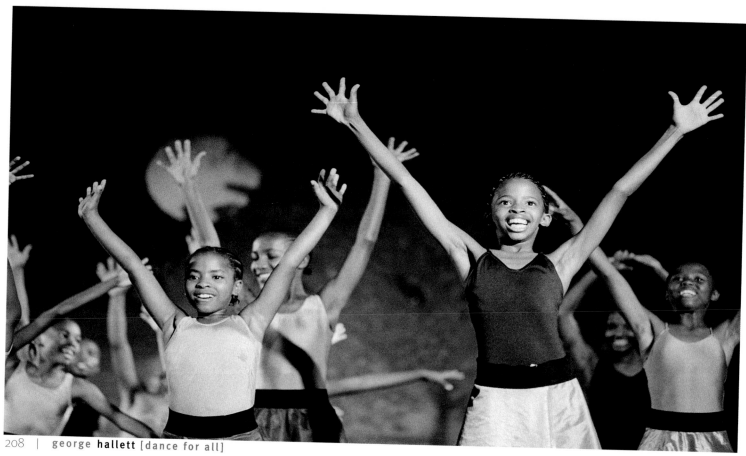

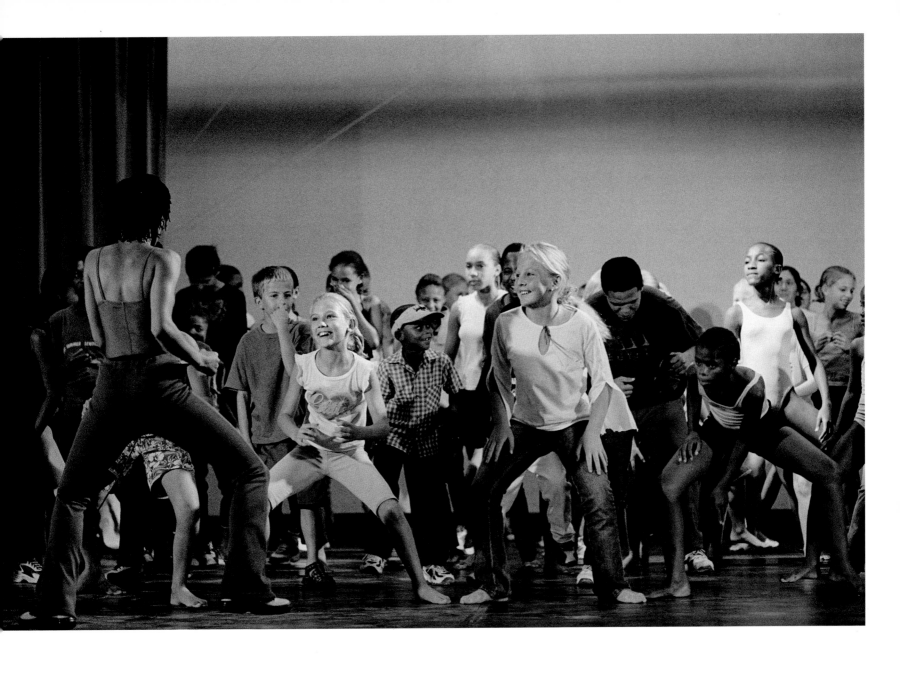

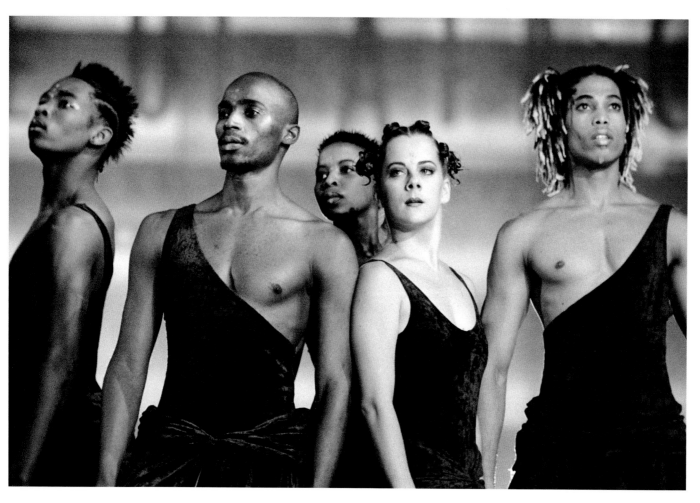

Jazzart dancers Luthando Ntsodo, Sifiso Kweyama, Jackie Manyaapelo, Ondine Bello, and Angelo Collins in 'Face of Africa', Cape Town, 2000. [ Garth Stead ]

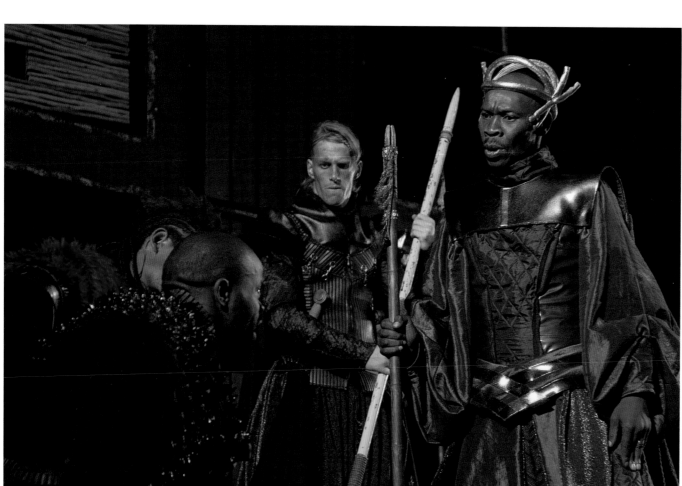

Joko Scott plays Duncan in Shakespeare's 'Macbeth' at Maynardville, Cape Town, 2003. [ Garth Stead ]

Lorcia Cooper dancing, Women's Arts Festival, The Playhouse, Durban, 2002. [ Mothlalefi Mahlabe ]

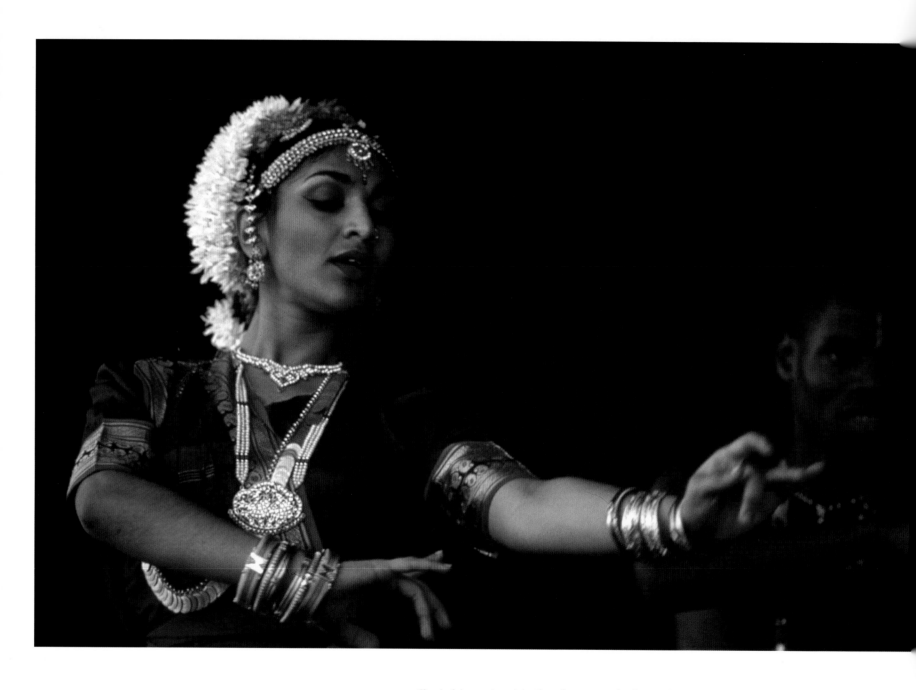

Classical dance at a celebration of 140 years of Indian settlement, Durban. [ **Paul Weinberg** / South Photographs ]

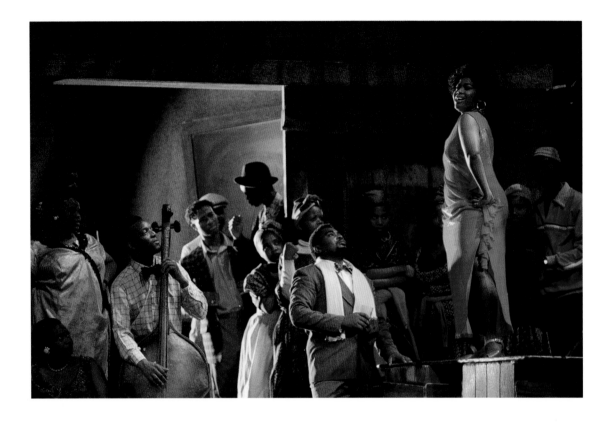

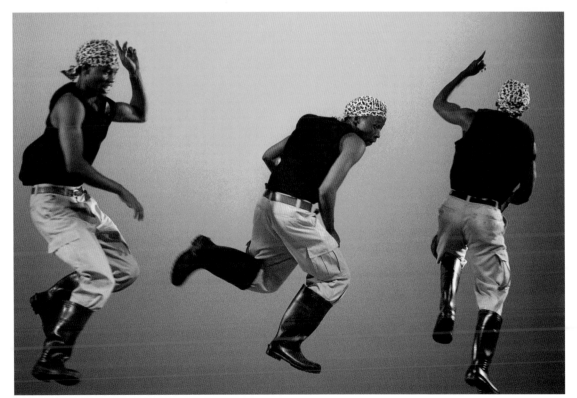

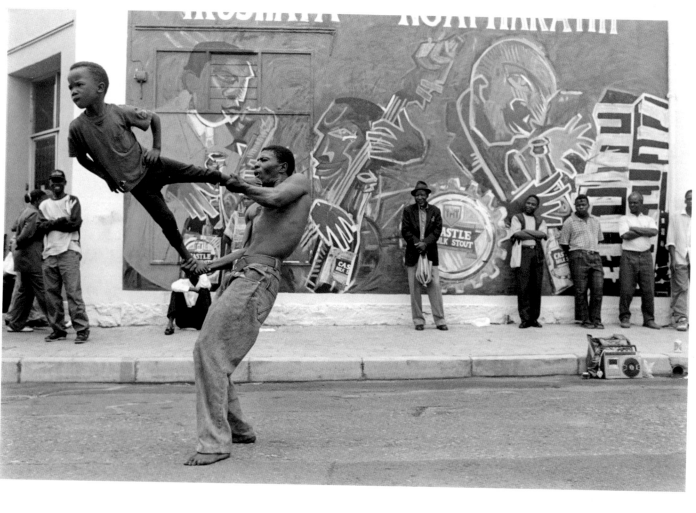

Street act, Newtown, Johannesburg. [ Jodi Bieber ]

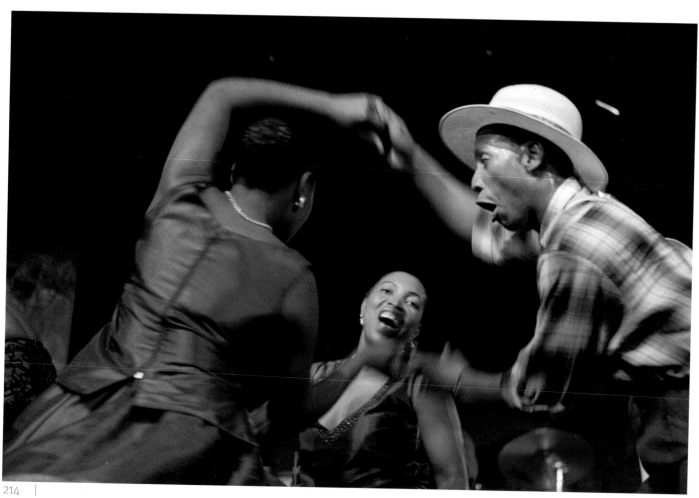

'Tribute to the 1950s', Agfa Theatre on the Square, Sandton, 2001. [ Mothlalefi Mahlabe ]

for the feature film 'Charlie', Observatory, Cape Town. [ **Garth** Stead ]

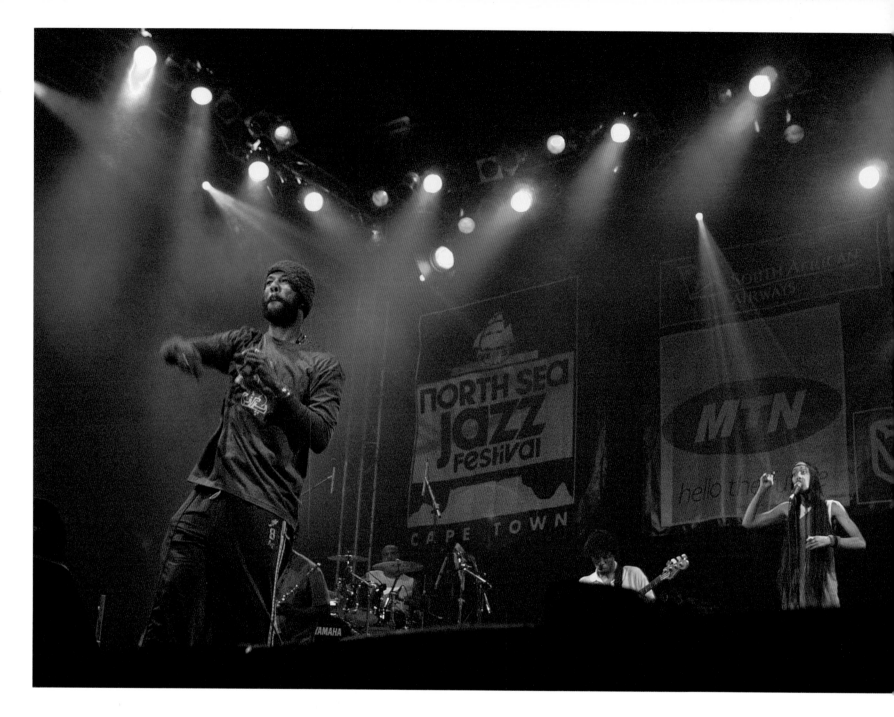

# benny **gool**
## [north sea jazz festival]

Within a few years, the North Sea Jazz Festival – Cape Town has become one of the premier events on South Africa's cultural calendar. Pioneered locally by Rashid Lombard, below right, it is a joint venture between a local and a Dutch entertainment company. Having travelled to various jazz festivals worldwide, Lombard found the North Sea Jazz Festival – Den Haag to be the most intriguing because of its concept of staging multiple performances under one roof. Following long deliberations and negotiations, Rashid realised his vision of bring this concept to South Africa in 2000. Utilising five stages, the local festival features more than 30 artists over two evenings. Another key feature is its even split between African and international artists. The festival has won numerous awards.

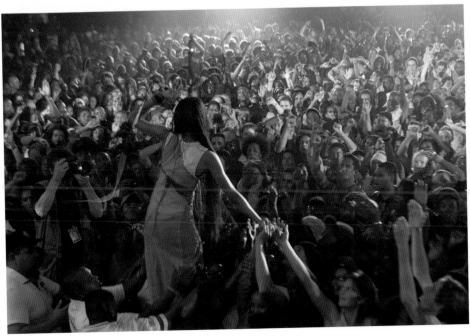

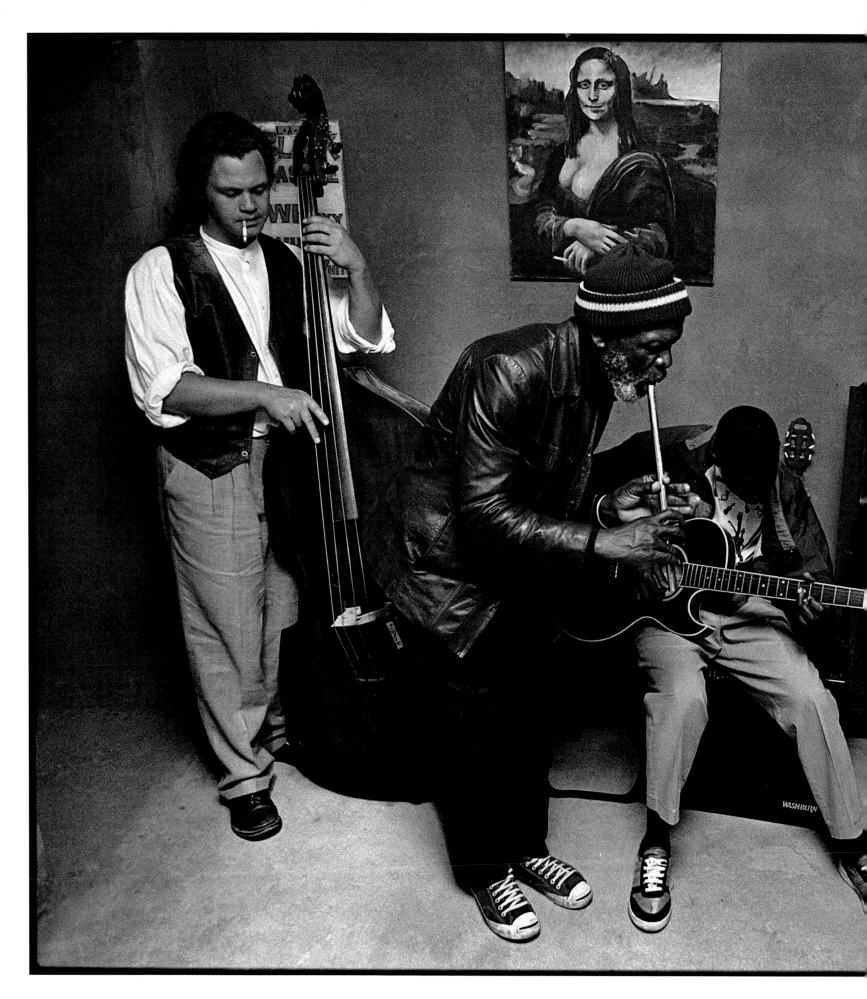

A groom (left) plays with Nelson and Mike at his wedding. [ **Duif du Toit** ]

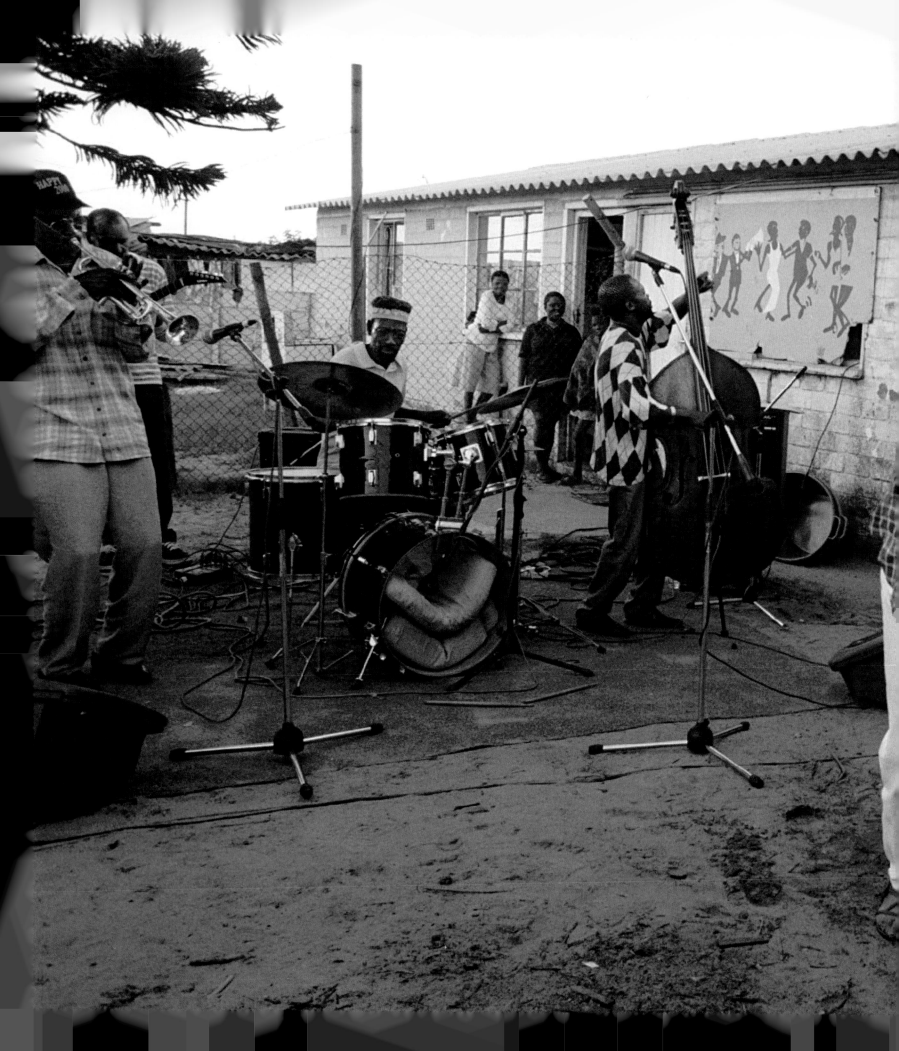

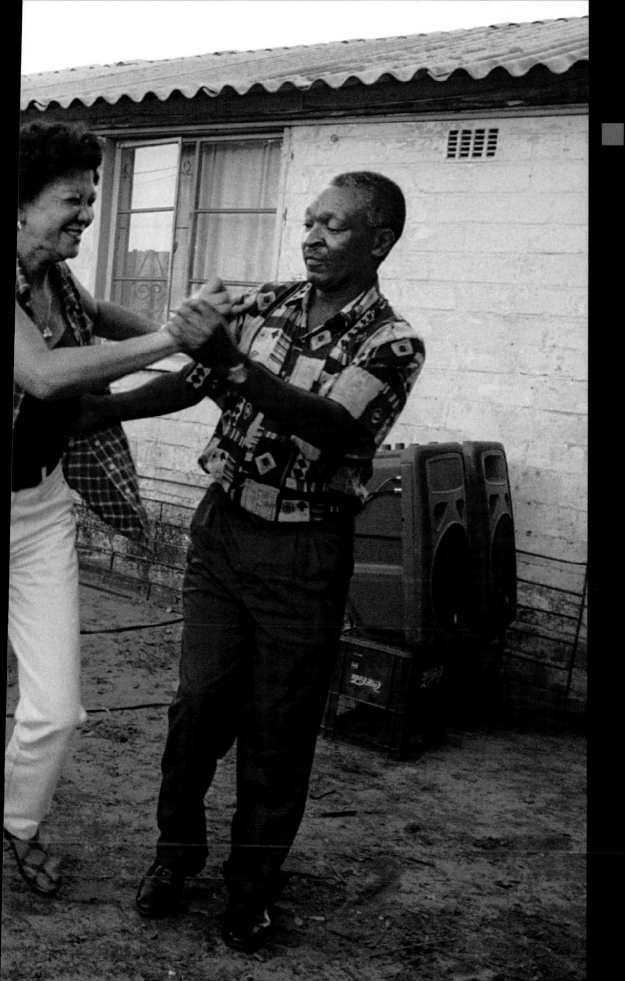

# fanie jason
## [porgy's house of jazz]

Every day at Porgy's house in Guguletu, Cape Town, jazz musicians – some trained, some not – come to jam. This motley group of guitarists, saxophonists, trumpet players, and drummers often play until the early hours. Porgy's house is on one of the roughest streets in Guguletu. Here, most men are unemployed, out on bail, or on the run from the police. Porgy is trying to transform his home into a jazz house, where players can also learn to read and write music.

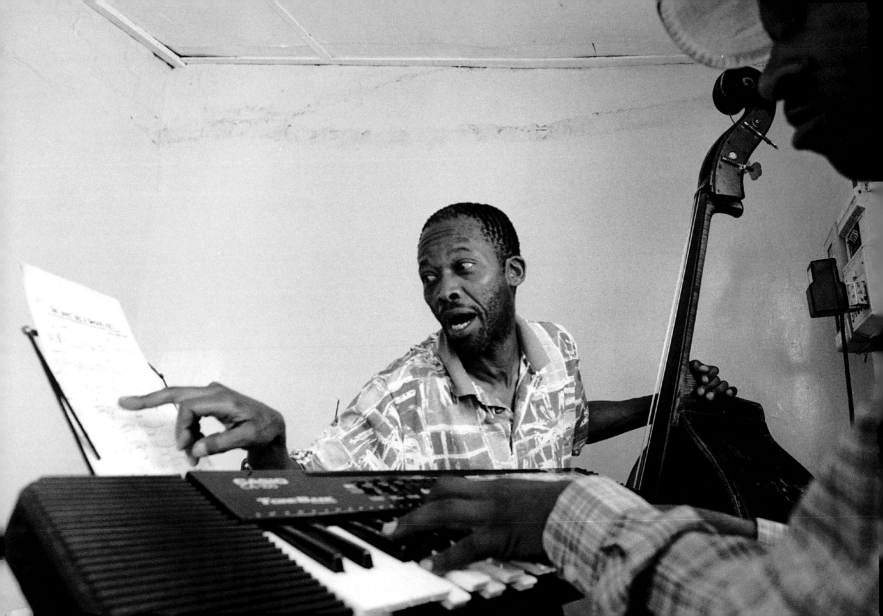

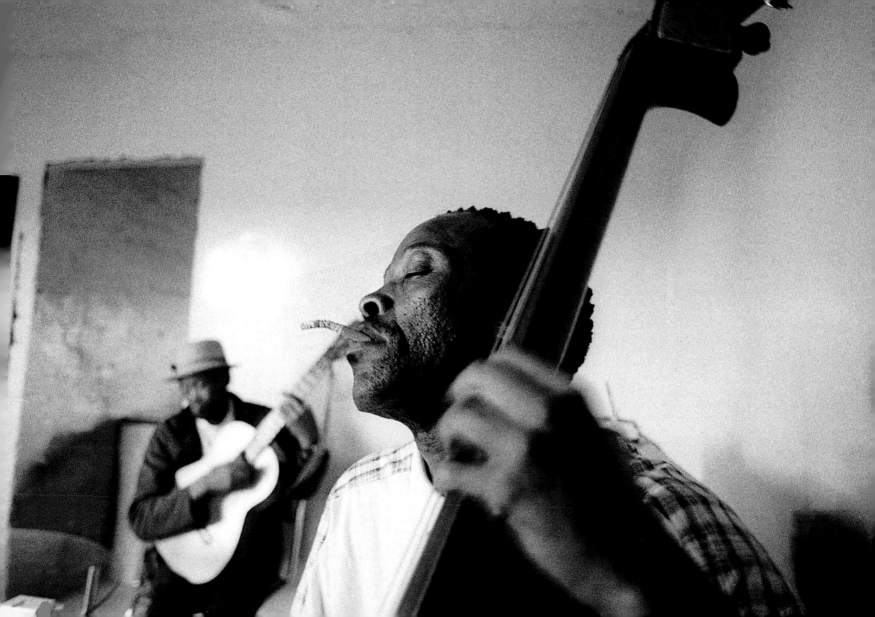

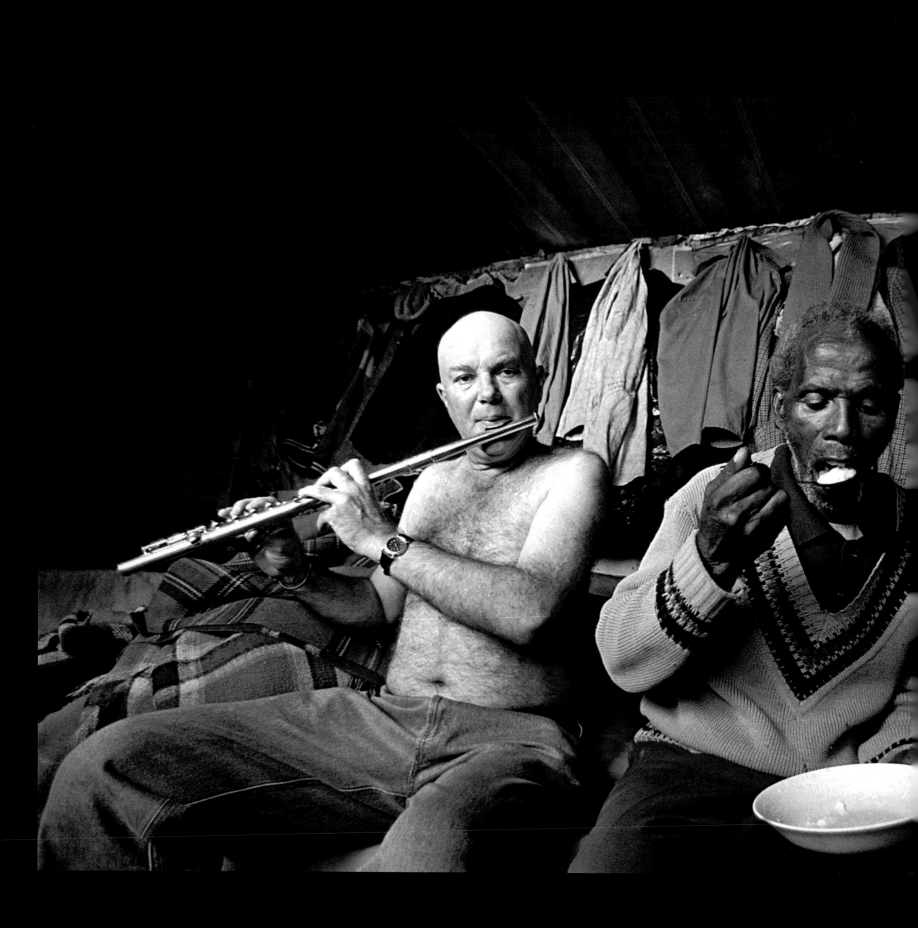

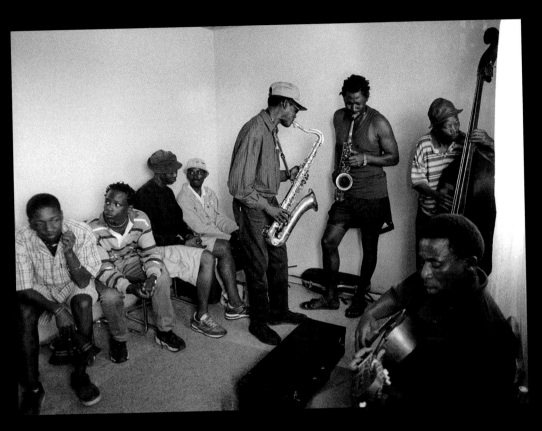

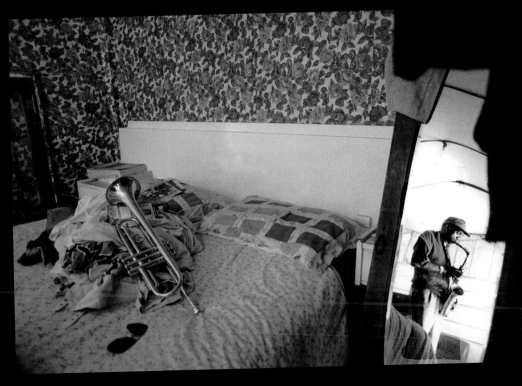

Ken H Simmons II, president of the event management company Jake Productions, formed with his sweetheart, Jessica Motaung, daughter of Kaizer Motaung, legendary founder of the Kaizer Chiefs Football Club.

Queen 'Iyaya' Sisoko of the group Abashante, one of few women who have made their mark in kwaito.

Mduduzi 'Mandoza' Tshabalala, an icon in the kwaito movement, which has changed the world view of young black South Africans.

Nathi Masika, football player and model.

The jazz pianist Abdullah Ibrahim, Cape Town. [ **George** Hallett / South Photographs ]

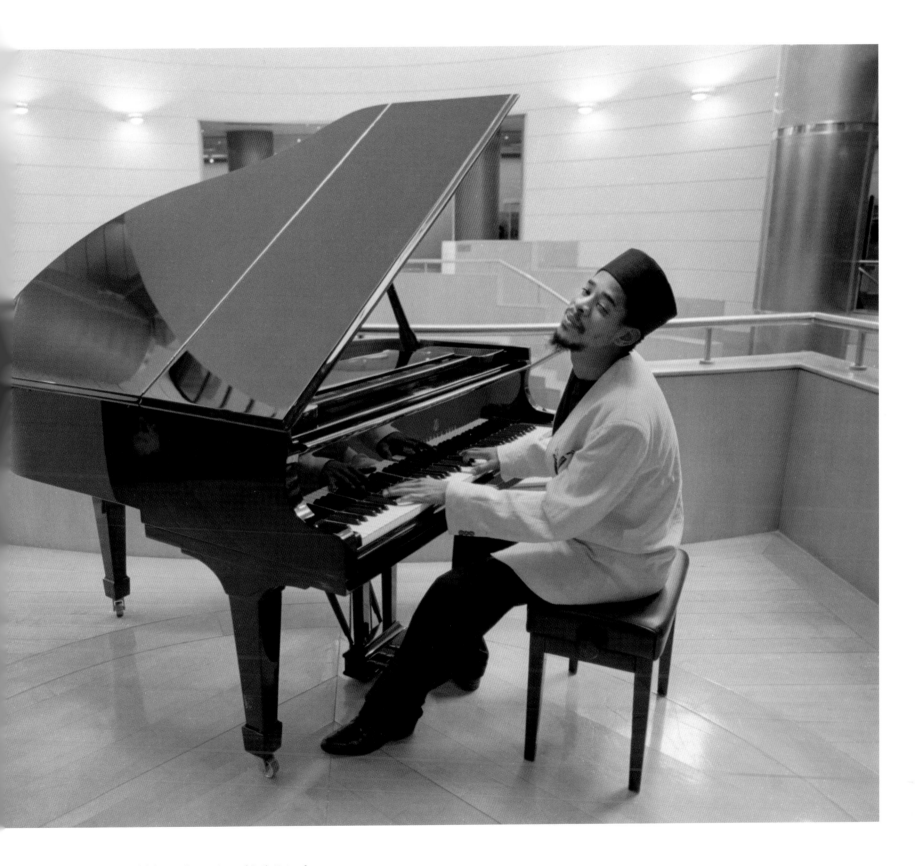

The late jazz pianist Moses Molelekwa, Johannesburg. [ Ruth Motau ]

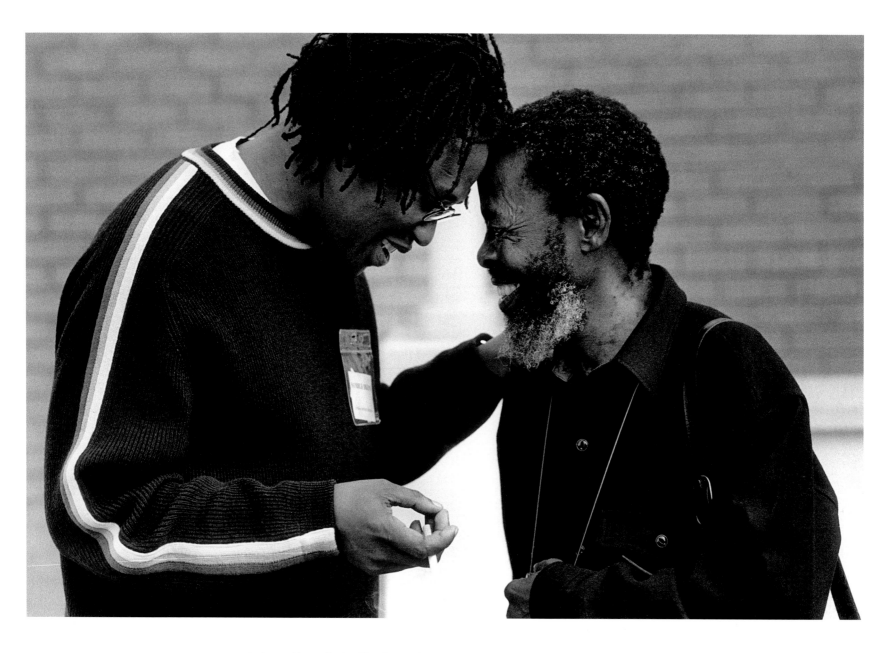

Author and journalist Sandile Dikeni, left, with the author Keorapetse Kgotsitsile, University of Pretoria. [ **George** Hallett / South Photographs ]

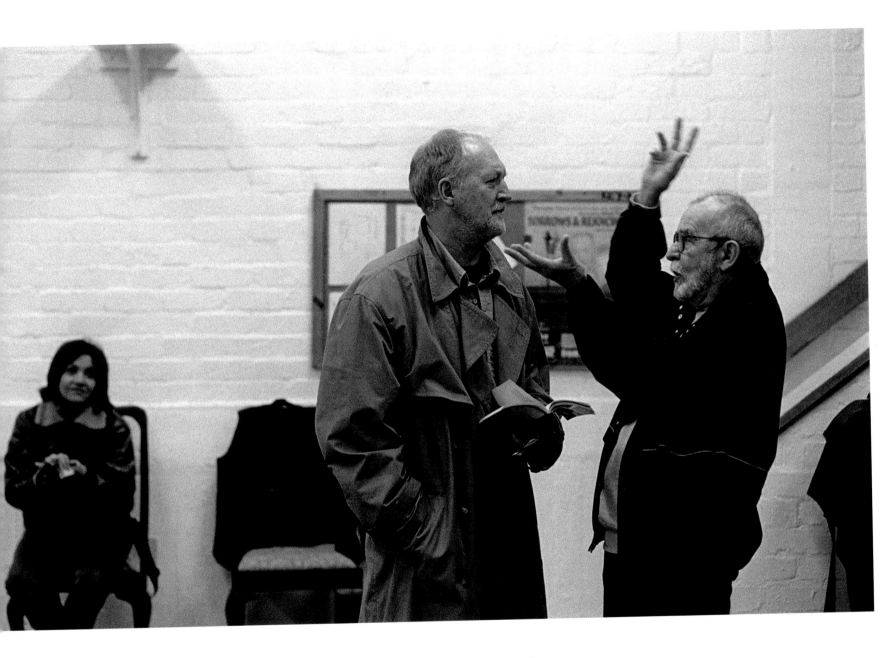

Actor Marius Weyers, left, with playwright Athol Fugard, Baxter Theatre, Cape Town. [ **George** Hallett / South Photographs ]

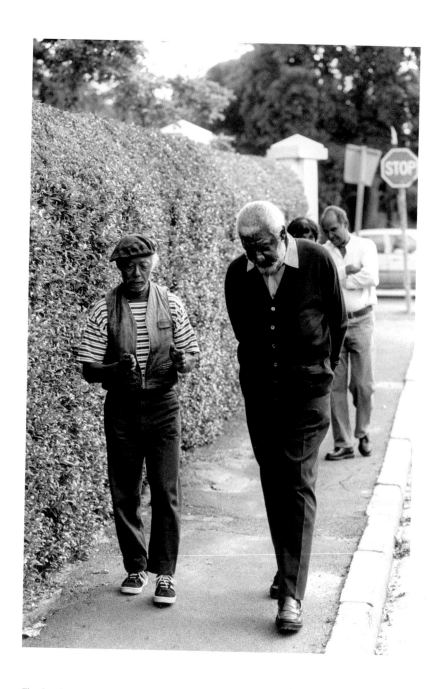

The South African author James Matthews, left, with the Gambian author Lenrie Peters,
Cape Town. In the background is the Somalian author Nuruddin Farah.
[ **George** Hallett / South Photographs ]

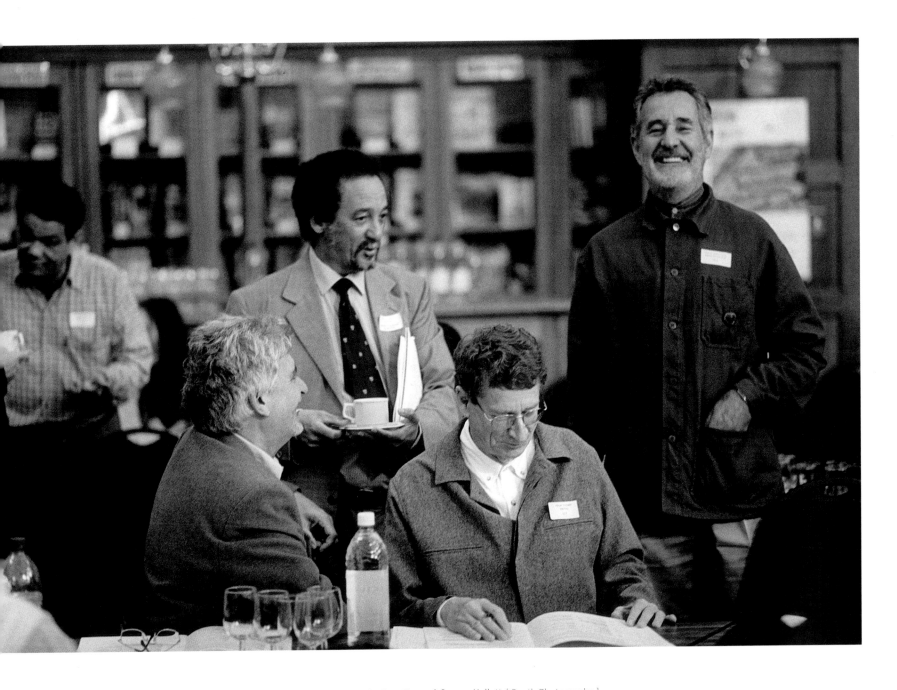

pie Coetzee, Jakes Gerwel, André Brink, and Breyten Breytenbach, Centre for the Book, Cape Town. [ **George** Hallett / South Photographs ]

The cartoonist Zapiro and the photographer Karina Tarouk.

The fine art photographer Lien Botha.

The theatre director Marthinus Basson.

The artist Tracy Payne.

sculptor Brett Murray.

The talk show host Dali Tambo.

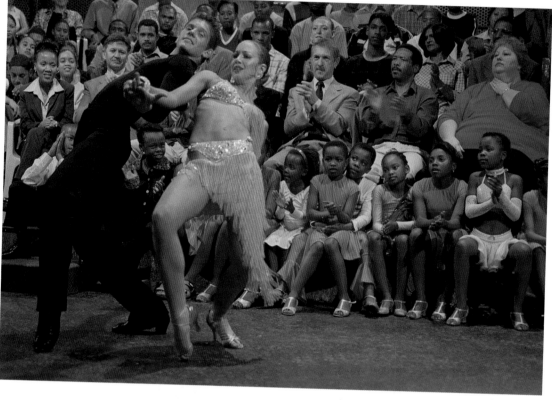

Ballroom dancers at the Henley Studios, Johannesburg, during a television show hosted by Felicia Mabuza-Suttle, 2002. [ **Mothlalefi Mahlabe** ]

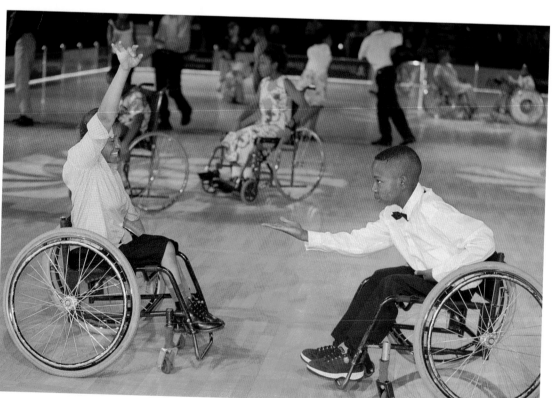

Disabled ballroom dancers at Sun City, North West. [ **Mothlalefi Mahlabe** ]

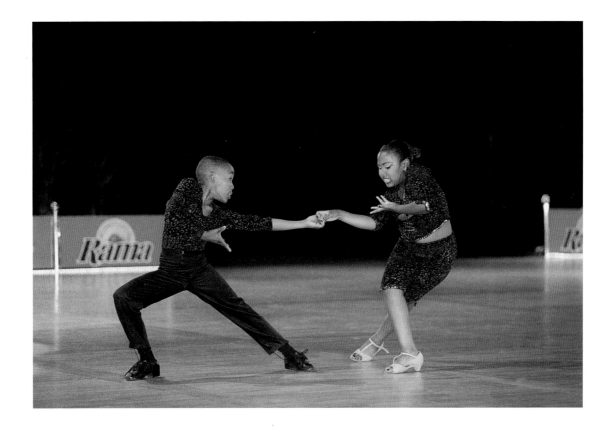

Sun City, North West. [ **Mothlalefi Mahlabe** ]

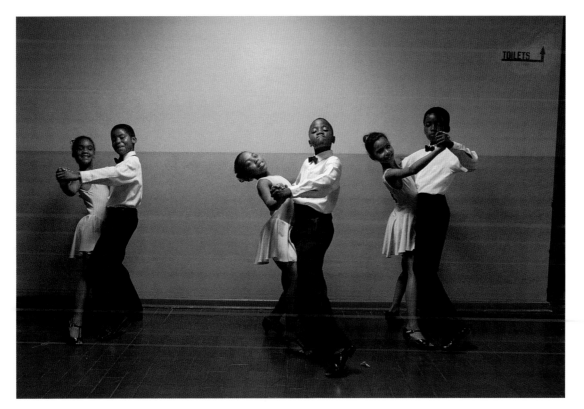

Ennerdale, Gauteng. [ Jodi Bieber ]

# ivan naudé
## [fashion for a new age]

At the finals, Catherine Award for Fashion Design, Johannesburg, 2003.

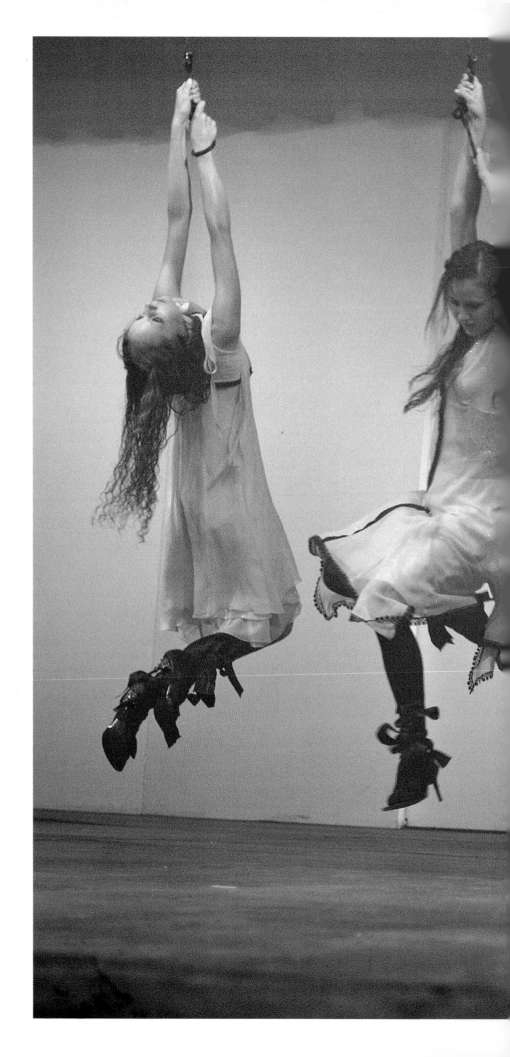

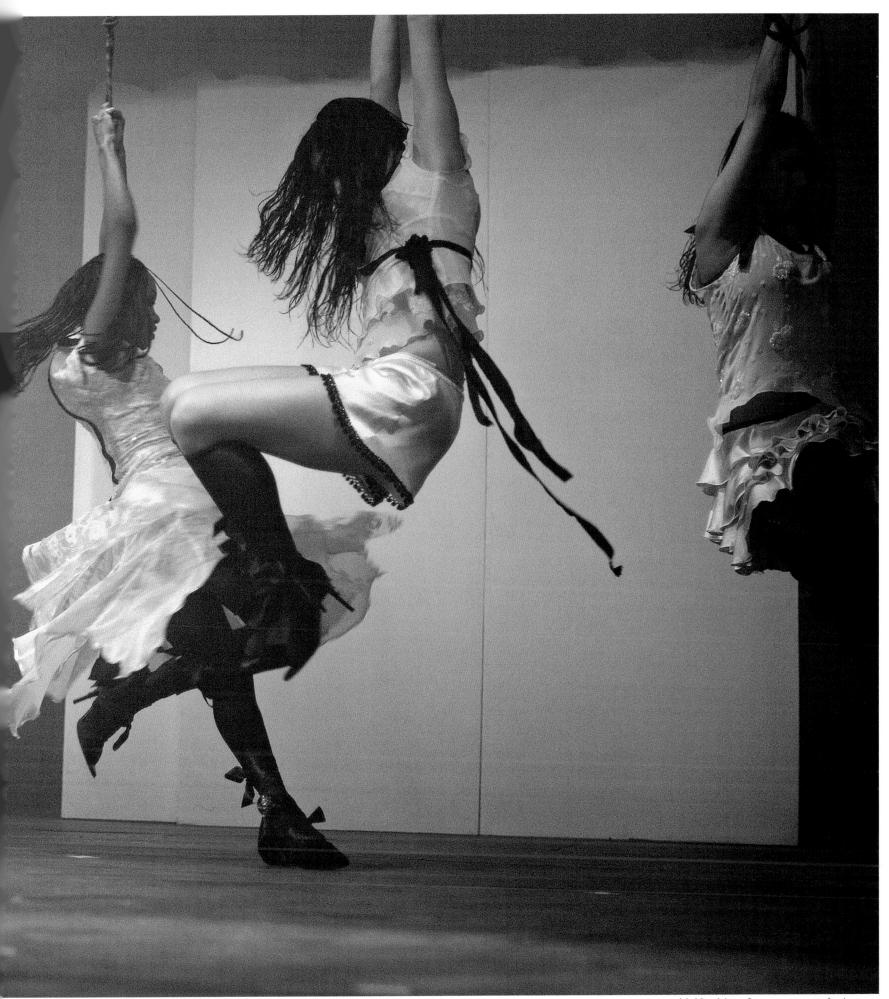

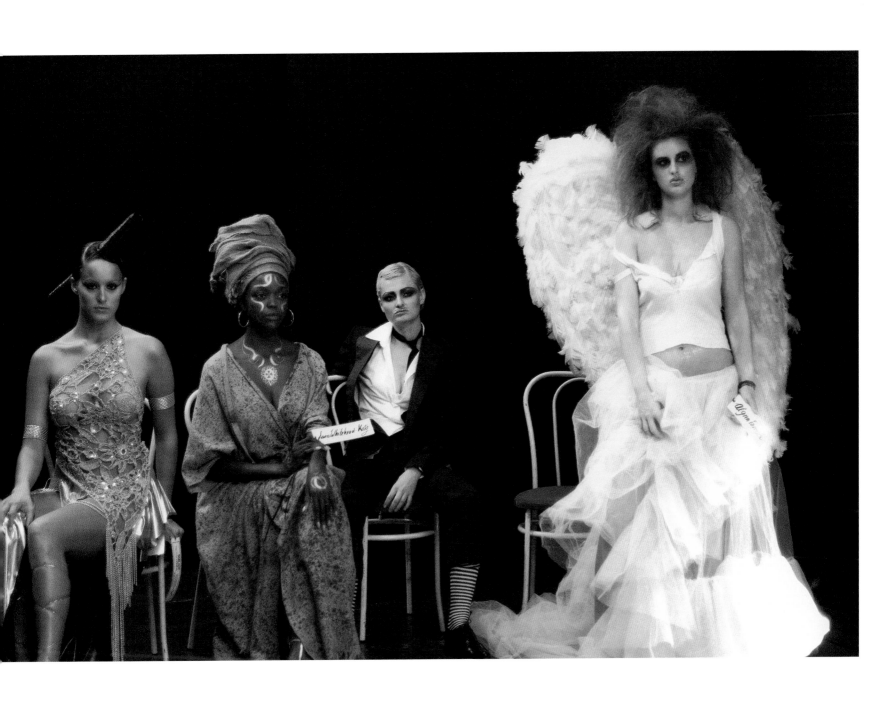

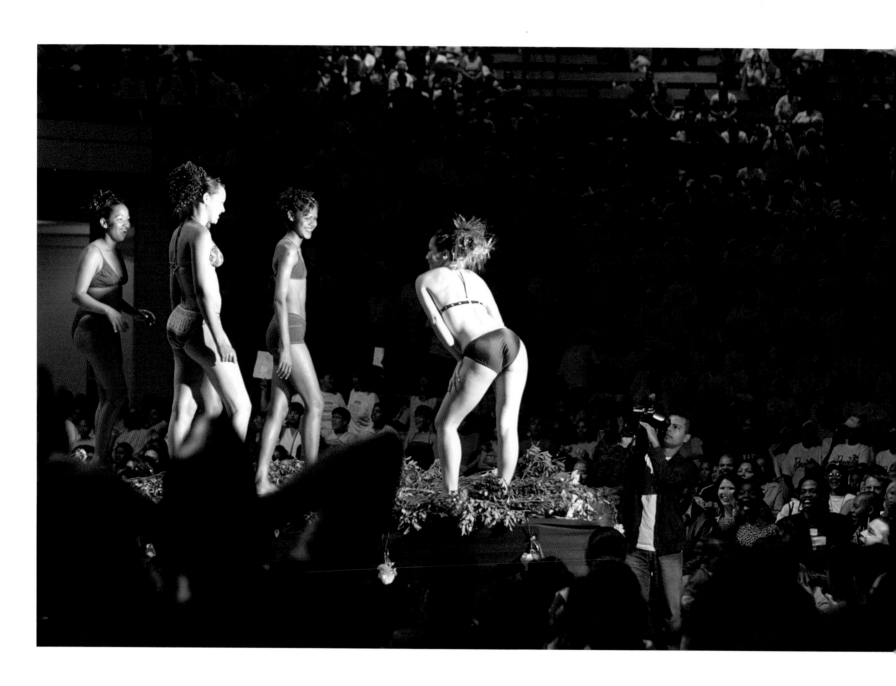

Factory workers participating in the Spring Queen Fashion Show, Good Hope Centre, Cape Town, 2002. [ **Benny** G●

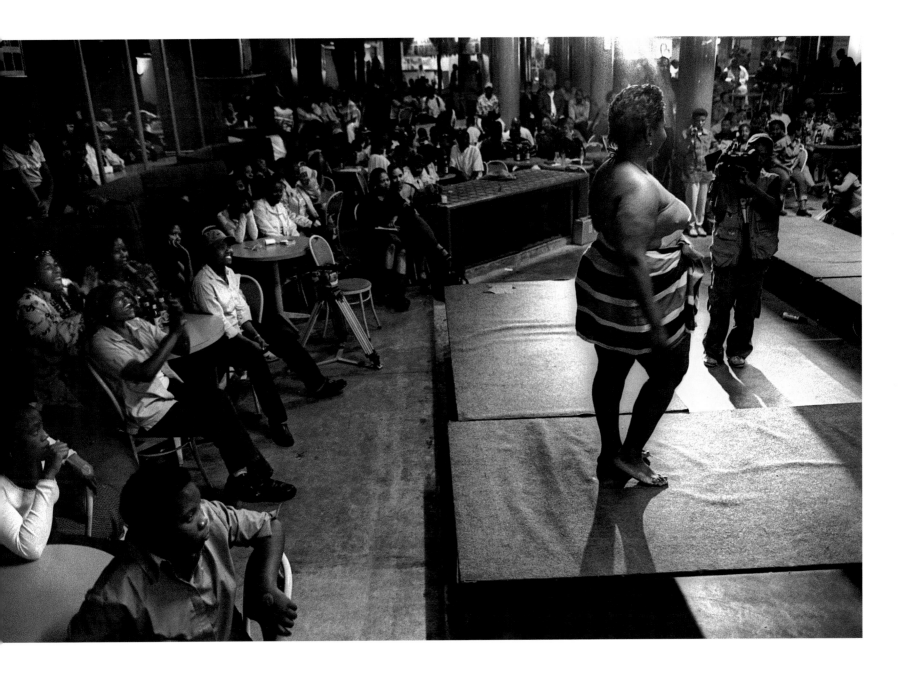

s Fats competition, night club, Soweto.  [ **Debbie** Yazbek / Independent Newspapers ]

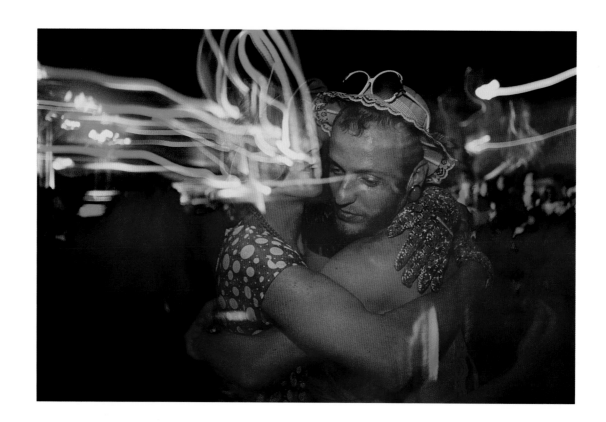

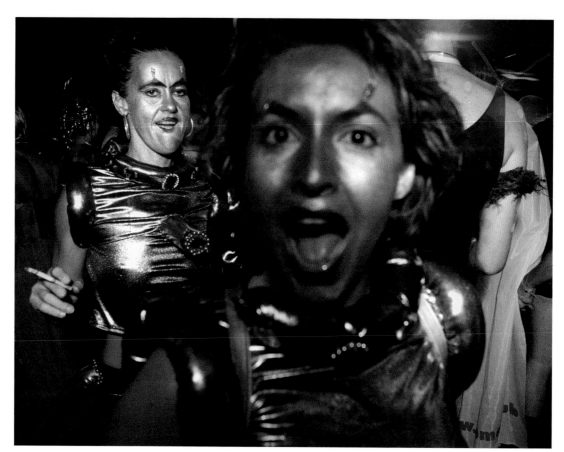

Mother City Queer Party, Cape Town. [ **Rodger Bosch** ]

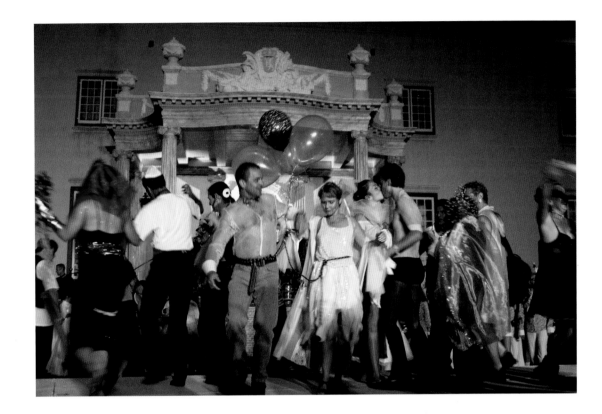

Mother City Queer Party in progress at The Castle headquarters of the Dutch settlers at the Cape. [ Jeremy Jowell ]

Gay pride march, Johannesburg. [ John Hogg ]

The lonely bride, Mother City Queer Party, Cape Town. [ Jeremy Jowell ]

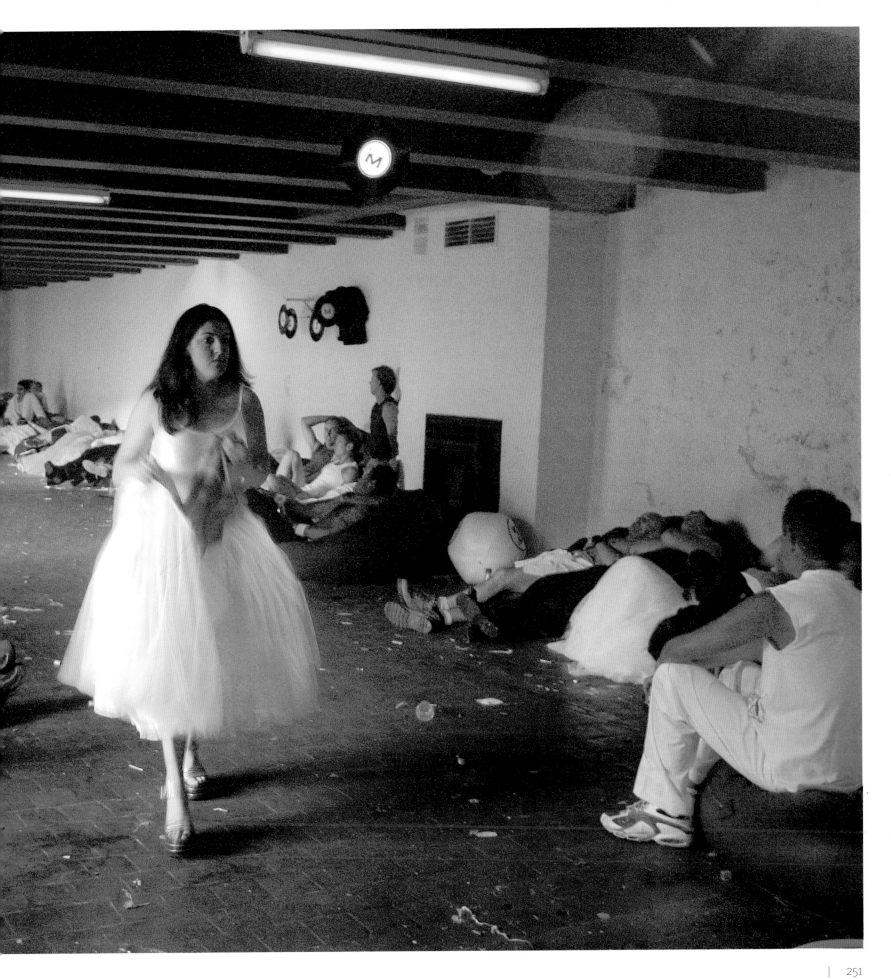

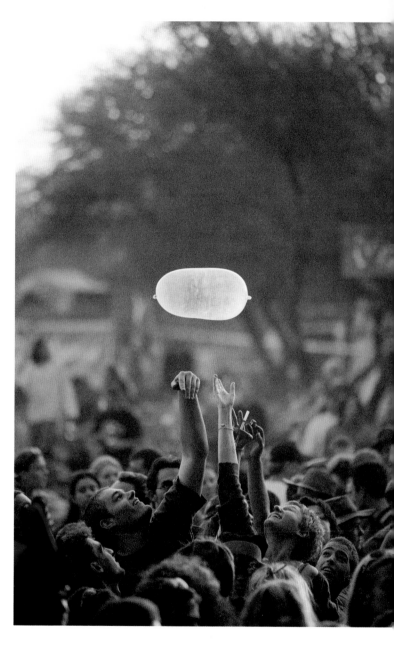

Oppikoppi Music Festival, Fountains Valley, Pretoria. [ **John** Hogg ]

Crowd with condom, Opikoppie Music Festival. [ **John** Hogg ]

n pit at the mainstage, Oppikoppi Music Festival.  [ John Hogg ]

Ravers at a hip-hop concert, Michell's Plain, Cape Town. [ **George** Hallett / South Photographs ]

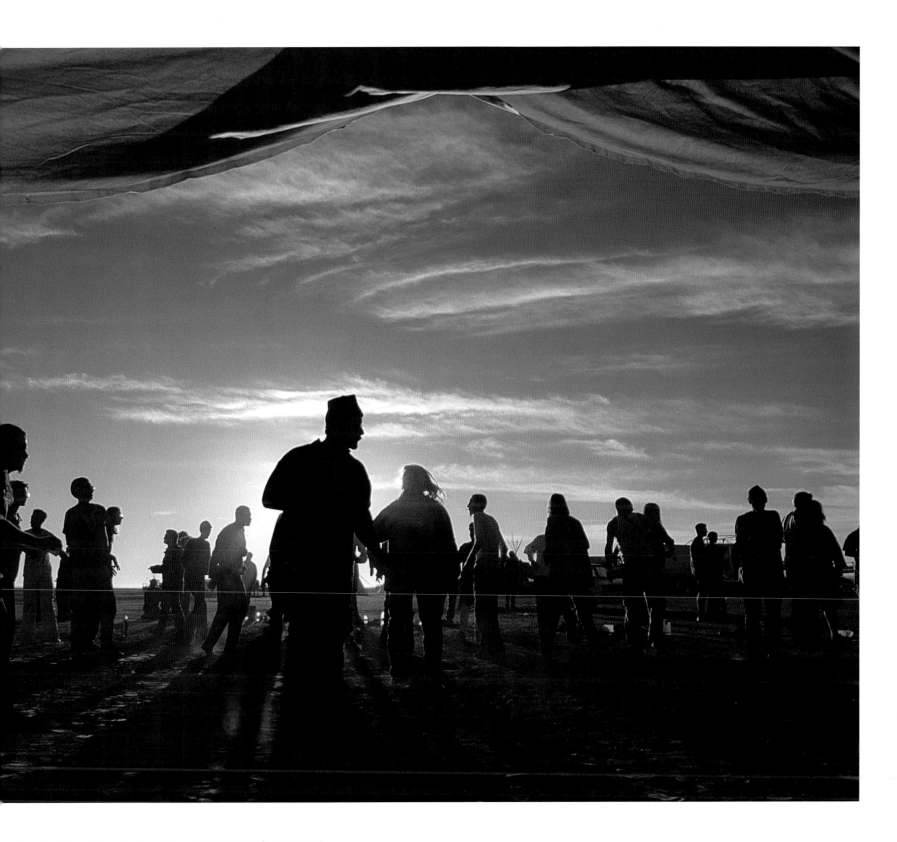

...ers at sunrise, Verneukpan, Northern Cape. [ **Kim** Ludbrook / EPA Photos ]

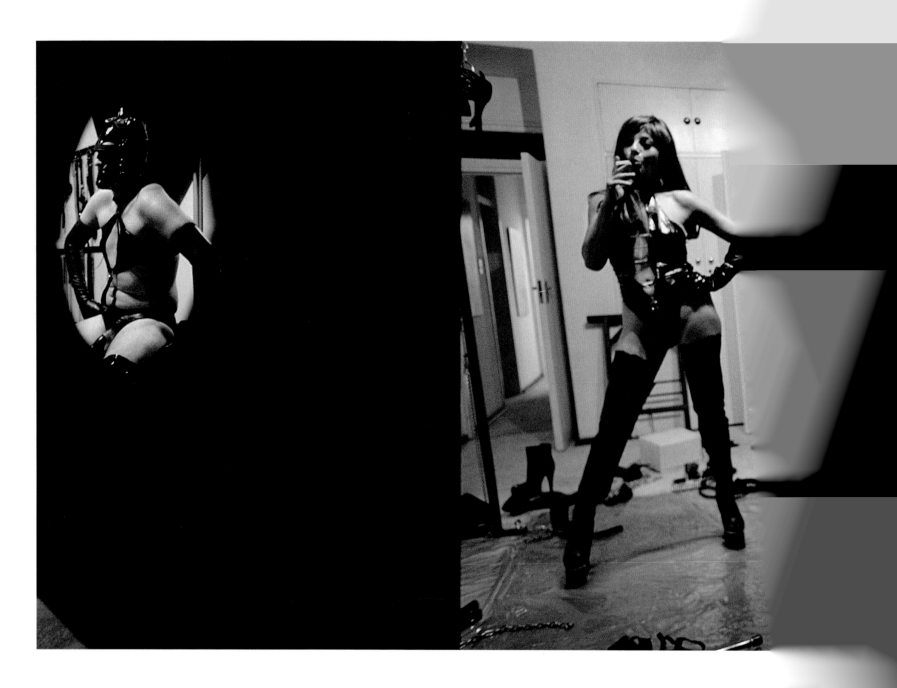

Mistress at a sex club, Johannesburg

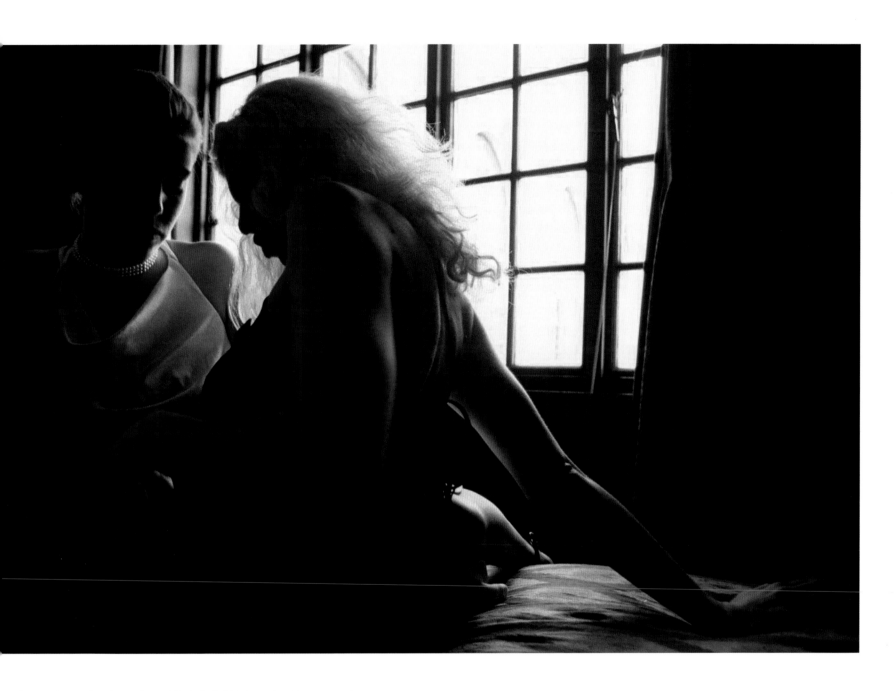

workers at The Ranch, Johannesburg.  [ **Karin** Retief / Independent Newspapers ]

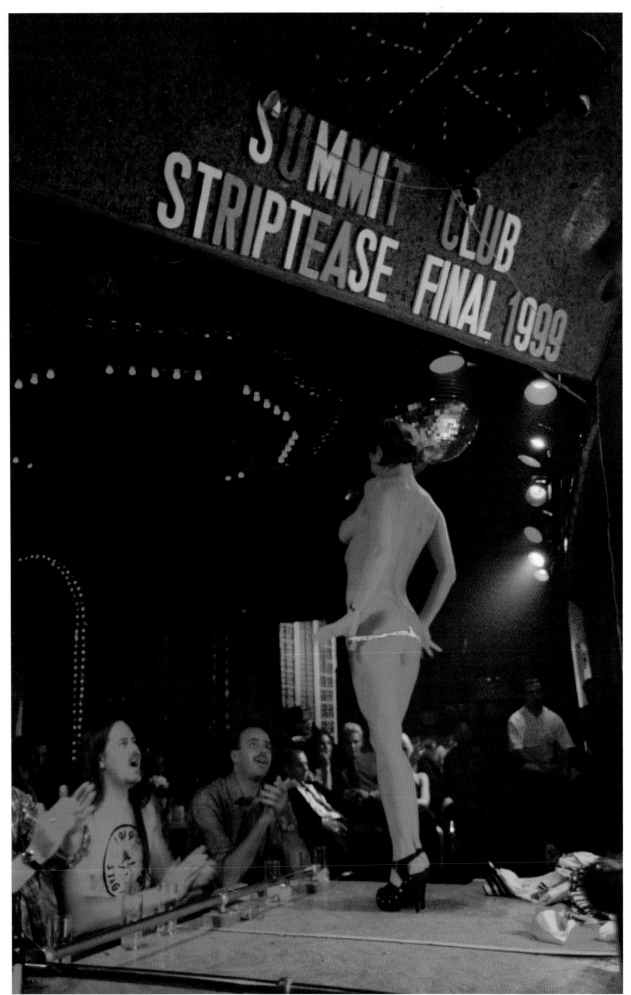

Striptease competition at the Summit Club, Johannesburg. [Nadine Hutton]

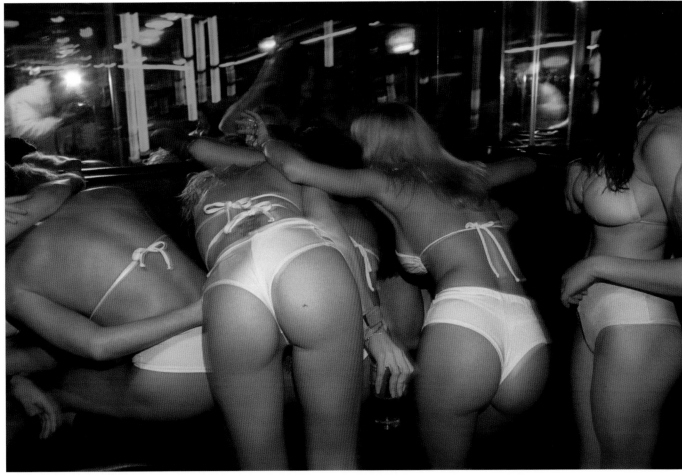

Strippers hide their faces during a police raid on a night club, Johannesburg.
[ Steve Lawrence / Independent Newspapers ]

Sex workers at a truck stop, Durban. [ Karin Retief / Independent Newspapers ]

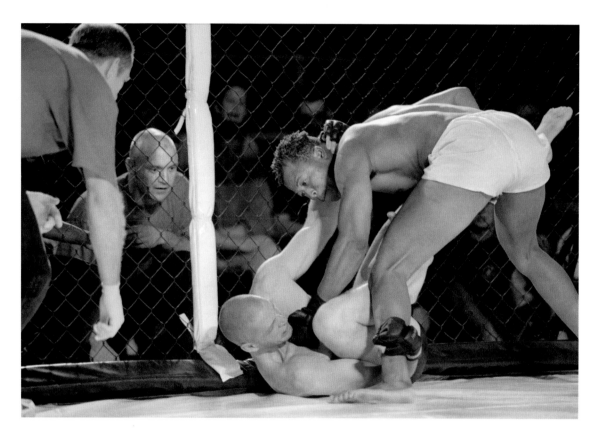

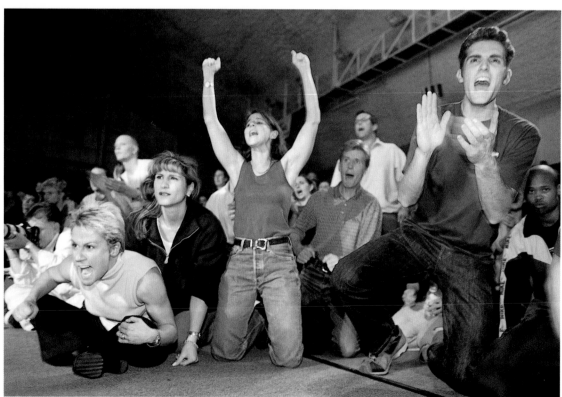

'Ultimate fighting' in a wire cage, Turffontein, Johannesburg. [ **Andreas Vlachakis** / South Photographs ]

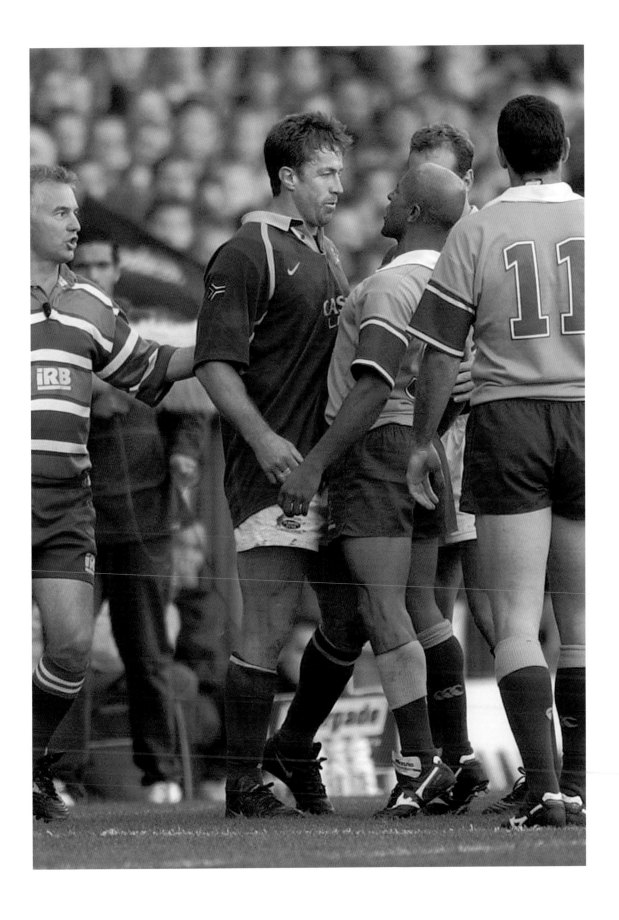

Face-off between Springbok captain Corné Krige and Wallabies captain George Gregan, Newlands, July 2003. [ Andrew Ingram / Independent Newspapers ]

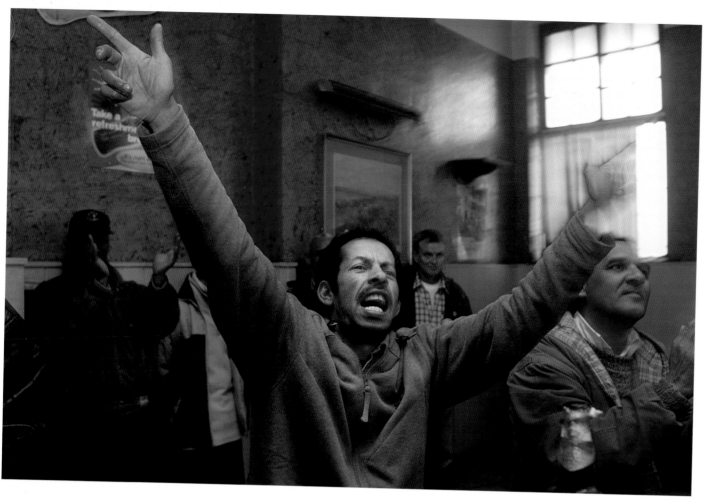

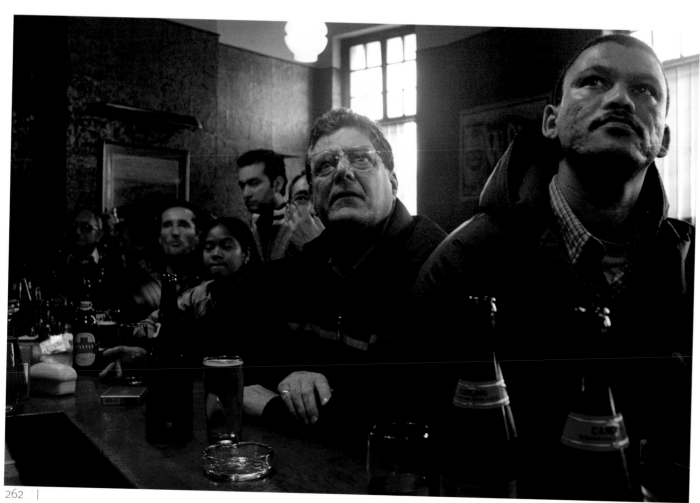

Rugby fans watch the Springboks lose against New Zealand in the bar of the Locomotive Hotel, Wooodstock, Cape Town. [ Mike Hutchings / Reuters ]

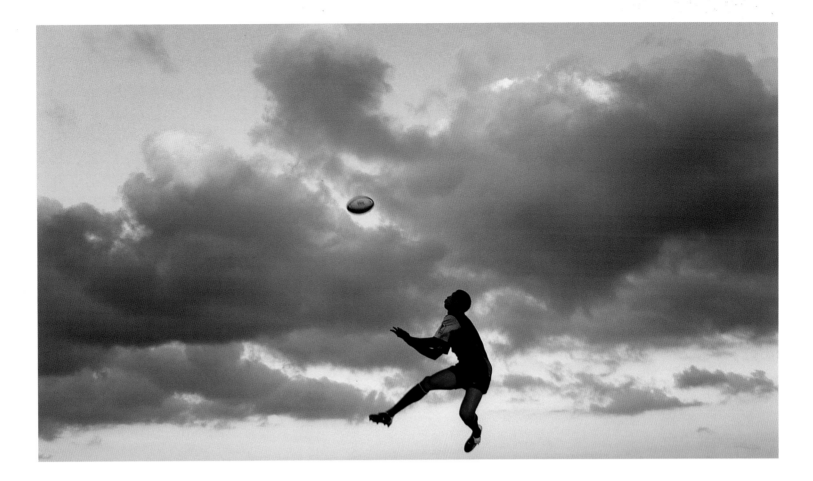

Wing Ashwin Willemse takes a high ball during a training session for the Rugby World Cup in Brisbane, Australia. October 2003. [ **Mike Hutchings** / Reuters ]

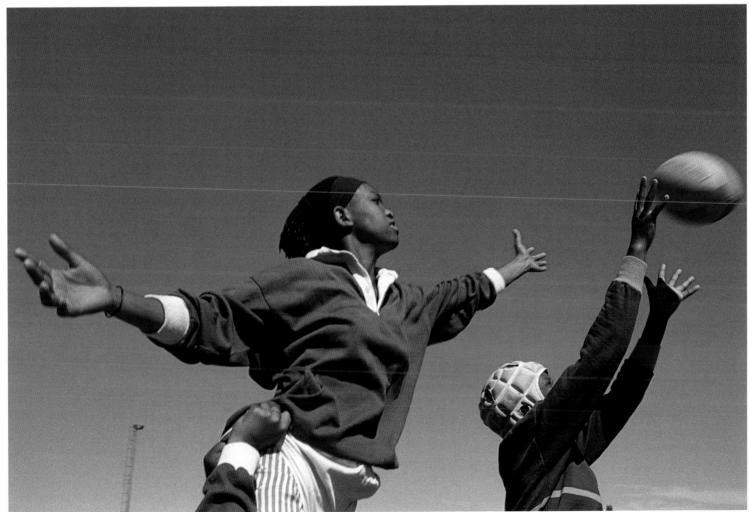

A member of the Purple Hearts, a female rugby team from Welkom in the Free State, jumps for the ball during a line-out in a match against a team from Meloding, a township outside Virginia. [ **Graeme Williams** / South Photographs ]

263

Bafana Bafana, the national soccer team, take the field for their game against France, Marseilles, 1998. [ **John Hogg** ]

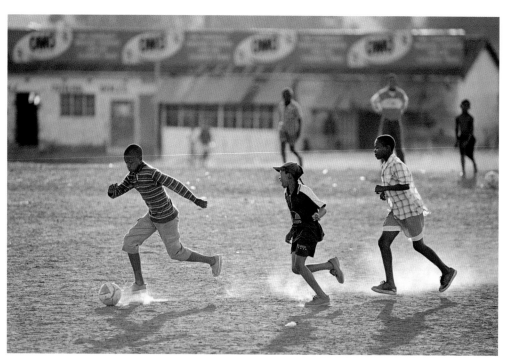

Soccer game, Soweto. [ **Lori Waselchuk** ]

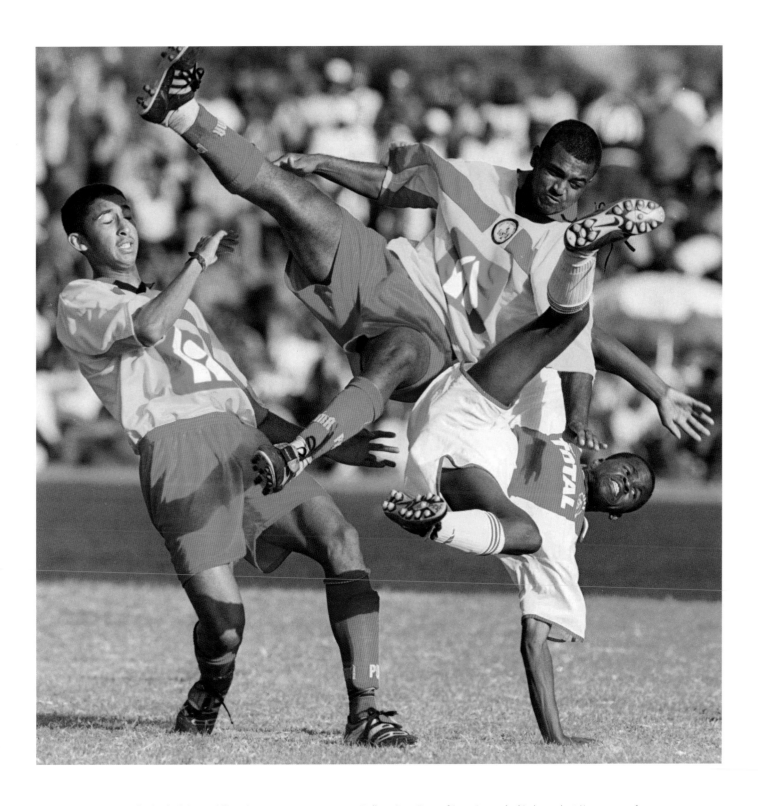

Santos versus Ajax in the final of the Bayhill under-19 soccer tournament, Belhar, Cape Town.  [ **Leon** Lestrade / Independent Newspapers ]

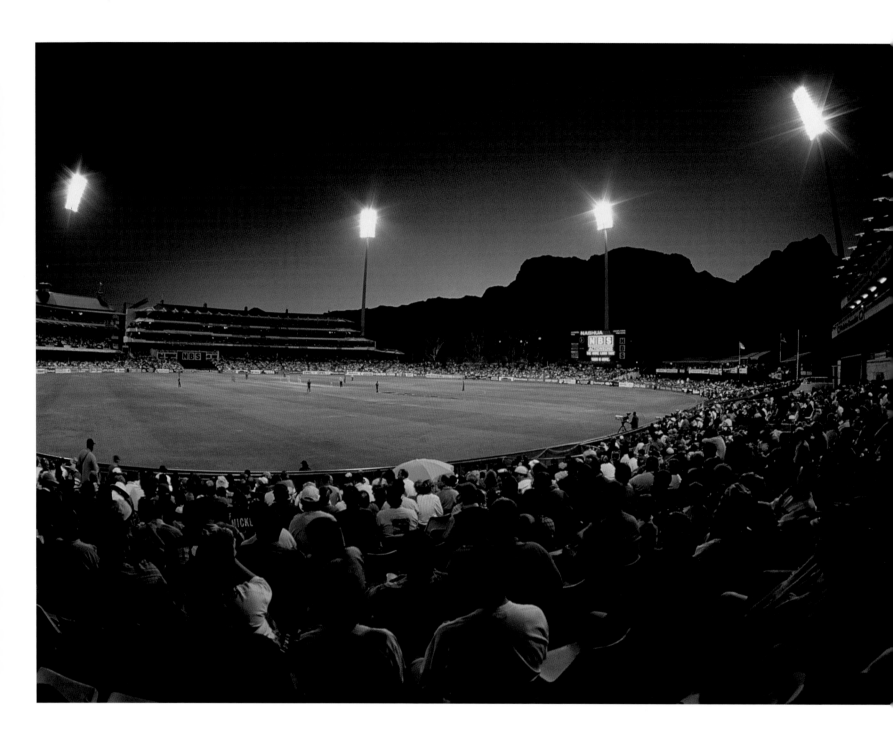

Night cricket, Newlands.  [ **Jeremy** Jow

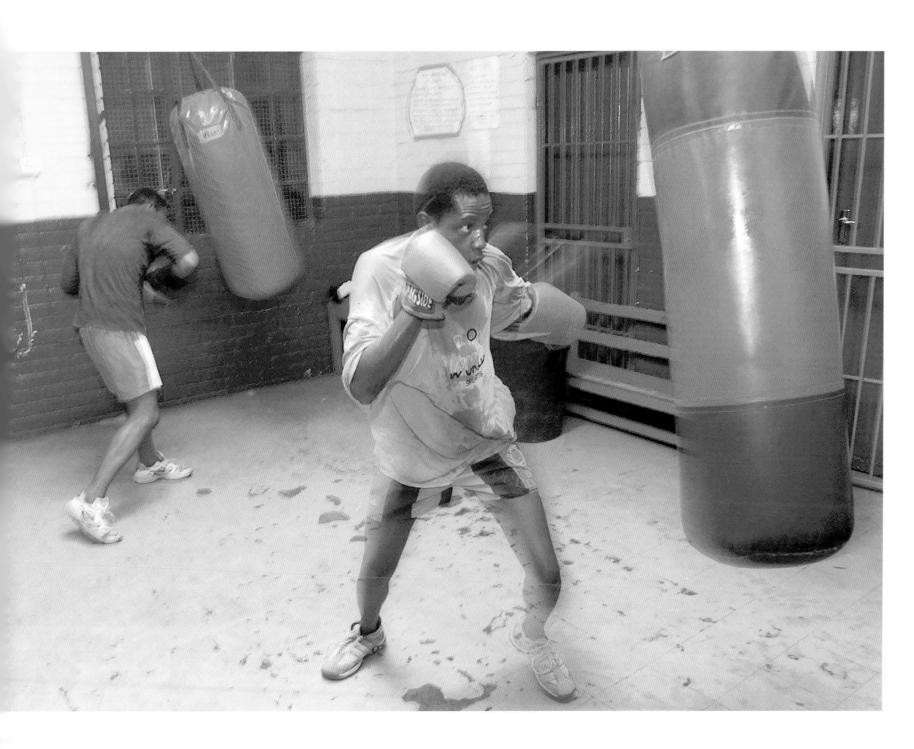

Amateur boxer in training, Dube, Soweto.  [ **Mike** Hutchings / Reuters ]

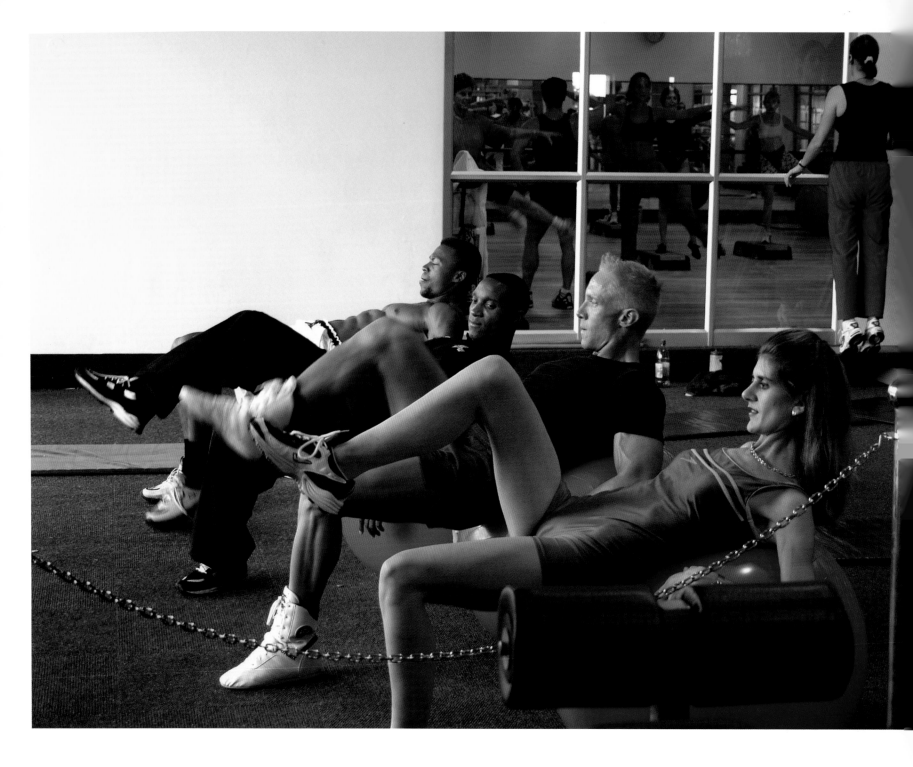

Clients and their personal trainers work out in the Virgin Active gym in Houghton, Johannesburg.  [ **Louise** Gubb / Trace Images ]

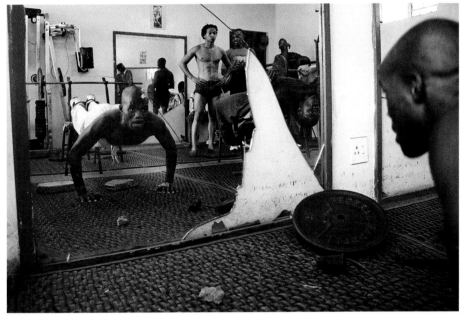

Township gym, Crossroads, Cape Town. [ **Brenton** Geach / Independent Newspapers ]

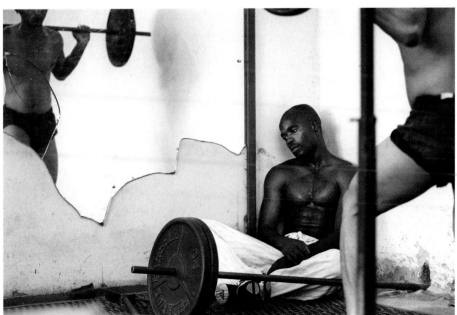

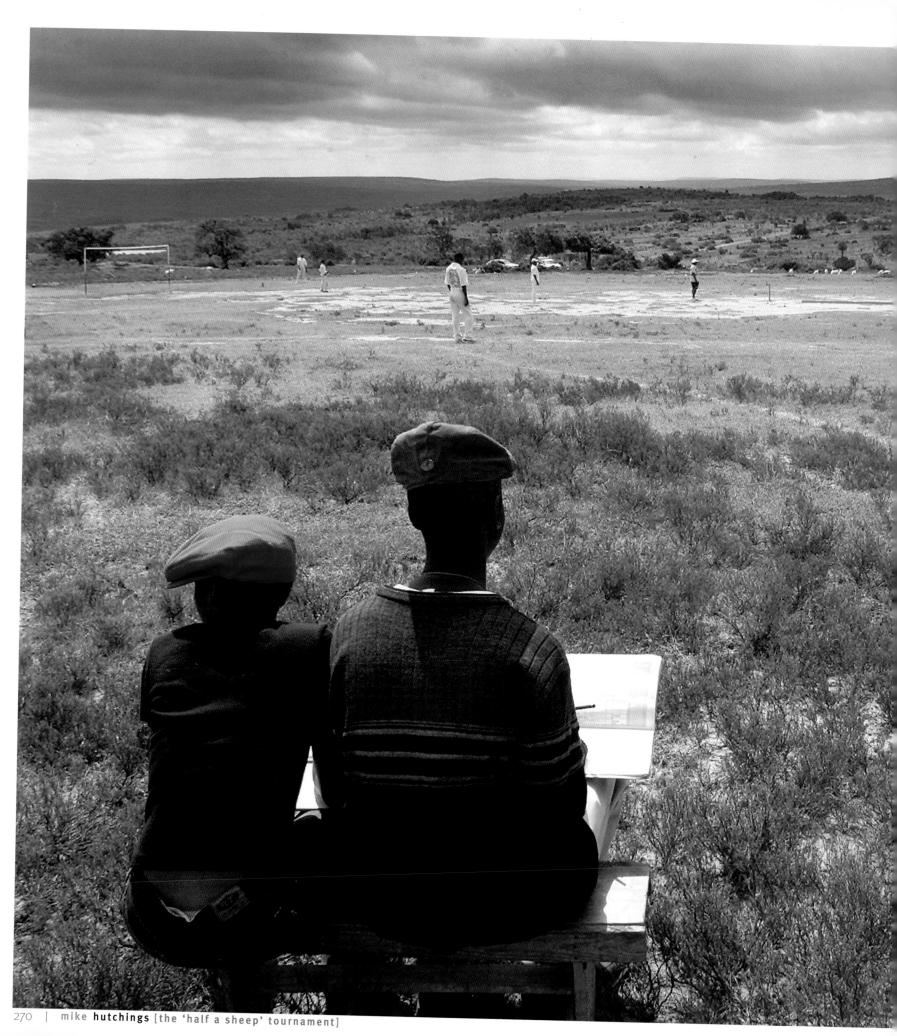

## mike **hutchings**
## [the 'half a sheep' tournament]

Cricket passions run high in the rural eastern Cape during the
*Ama cal'egusha* (half a sheep – the original trophy) village cricket
tournament. While, in South Africa, the game is widely regarded as
a white-dominated sport, the tournament has been played in the
region since the 1920s. It is traditionally held at the end of the year,
to coincide with the return of migrant workers to the villages. A lack
of facilities does not dampen enthusiasm for the game. Patches of
white-clad figures dot the hillsides on rudimentary pitches, and
youngsters set up 'sideshow' games. Cattle, ever present, are
jokingly referred to as the 'lawnmowers' of often overgrown playing
arenas, and show little respect for boundary lines. The
tournament's original ovine prize has, however, been replaced with
a more conventional trophy. King William's Town, December 2002.

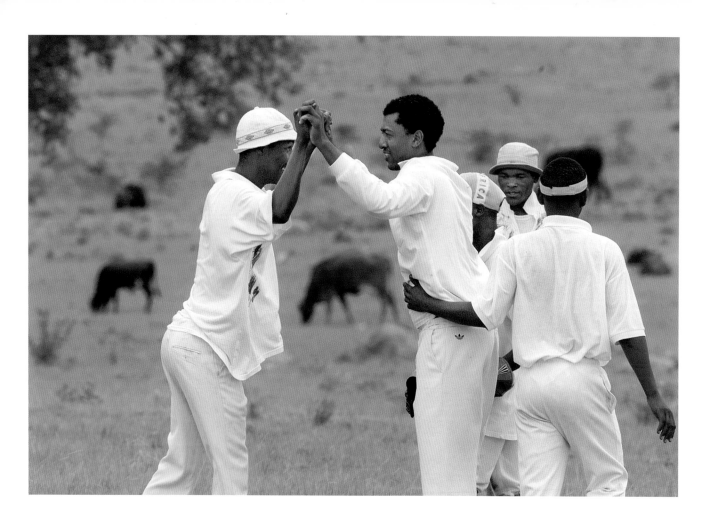

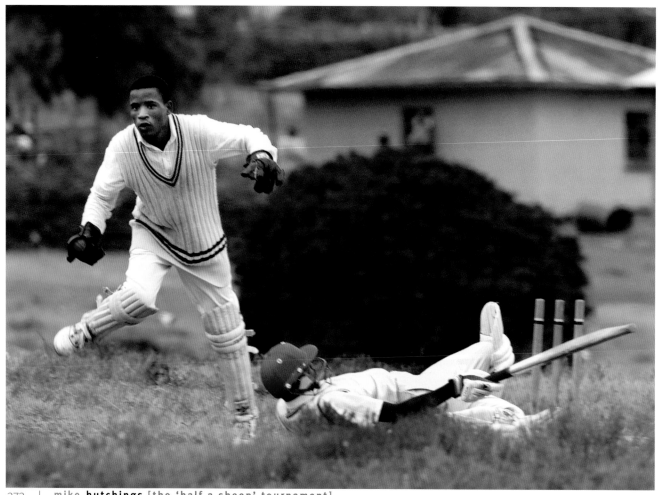

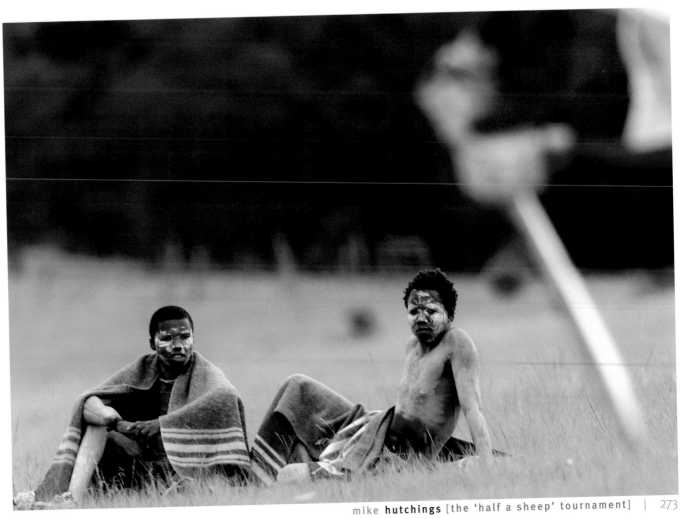

]

# about the contributors

**GEORGE HALLETT** became fascinated with photography while growing up in the fishing village of Hout Bay on the Cape Peninsula. After taking a British correspondence course in photography, he started working in Cape Town as a freelance photographer. During that time he photographed District Six before its destruction under apartheid. From 1970 onwards he lived and worked in London, Paris, and Amsterdam, where he formed close ties with South African exiles. He also briefly worked in Zimbabwe after that country's independence. In 1995 he returned to Cape Town, where he continues his photographic activities.

Hallett's work has been widely exhibited, both in South Africa and abroad, and is held in public collections in the United States, South Africa, and Europe. He has contributed to three books, and won numerous international and South African awards.

He is strongly committed to passing on his skills to younger people, and has taught photography at various American, British, European, and South African institutions.

**MANDLA LANGA** is a journalist, author, and a prominent figure in South African media organisations.

Langa grew up in KwaMashu township in Durban, and studied at the University of Fort Hare, where he became politically active. After being arrested in 1976 he went into exile, living in several African and European countries. While he participated in arts programmes and conferences, and won prizes for creative writing, he also underwent training in UmKhonto weSizwe, the military arm of the African National Congress. He held various ANC posts abroad.

After returning to South Africa, Langa convened the task group on government communications whose findings led to the establishment of the Government Information and Communication System (GCIS). He also served as programme director for SABC Television, and served on the SABC board.

He currently chairs the council of the Independent Communications Authority of South Africa (ICASA). He has published four novels and volumes of short stories, and written an opera.

**PAUL ALBERTS** is a freelance photographer, based in Brandfort in the Free State. He started his career as a photojournalist for various newspapers, but has worked independently since 1975, focusing on social-documentary subjects. His photographs have been published in seven books, and have been widely exhibited. He has received a medal of honour from the South African Academy of Science and Arts.

**JODI BIEBER** is a South African photographer now based in Paris. Her work has been published in numerous international magazines, including the *New York Times Magazine*, *US News and World Report*, *Geo*, and *L'Express*. She has also undertaken special projects for non-profit organisations such as Doctors without Borders and Positive Lives. She has won seven World Press Photo and numerous other awards. Her work has been extensively exhibited.

**RODGER BOSCH** is a freelance documentary and commercial photographer based in Cape Town. He started photography as a hobby, but then began to take photographs full-time. He later studied photography at Rhodes University in Grahamstown. His clients include overseas magazines and newspapers, NGOs, and corporations.

**JOHANNES DREYER** is a commercial photographer based in Johannesburg. He studied photography at the Vaal Triangle Technikon. His work was first published in 1994, and he has worked as a professional photographer since then. He specialises in fashion and portraiture.

**DUIF DU TOIT** is a staff photographer for Touchline Photo, an international photo agency that provides sports photographs to newspapers and magazines. A self-taught photographer, he previously worked for the *Sunday Star* and *The Star*. He has won several local awards.

**BRENTON GEACH** is senior photojournalist who has worked for Cape Town newspapers for the past 17 years. He has won 14 South African Fuji/Ilford Press Photo awards and numerous other awards, especially for sports photography.

**DAVID GOLDBLATT** is a photographer and consultant on photography and design, based in Johannesburg. He has done professional work for magazines, corporations, advertising agencies, and other institutions in South Africa and overseas. He has created a major body of personal work, comprising a series of critical explorations of South African society, which has been widely exhibited and published. His photographs have appeared in eight books, published in South Africa and elsewhere. They have been exhibited in the United States, Europe, Australia, and South Africa, and form part of several permanent collections. A retrospective exhibition of his work has toured the United States and Europe, and will travel to South Africa. He founded The Market Photography Workshop in Johannesburg. He has been awarded an honorary doctorate in fine arts by the University of Cape Town.

**LOUISE GUBB** is a photojournalist based in Johannesburg. She has photographed South African events since 1985, notably covering the struggle against apartheid and the advent of democracy. Her photographs have appeared in two books on Nelson Mandela, and have been exhibited in New York. They have also been published in numerous overseas magazines, including *Life*, *Time*, *Newsweek*, *Stern*, *Paris Match*, and *National Geographic*. She was the assignments editor of the 2002 book and travelling exhibition 'A day in the life of Africa', whose profits were donated to the fight against AIDS in Africa.

**OSCAR GUTIERREZ** was born in Guatemala, grew up in the United States, and has worked in Africa as a photojournalist since 1994. He divides his time between South Africa and Mozambique.

**ANDREW INGRAM** is chief photographer of the *Weekend Argus*. Besides shooting hard news, he specialises in nature and the environment. He has won numerous local and international awards.

**THEMBA HADEBE** is a photographer for Associated Press, based in Johannesburg. He attended the Market Photography Workshop, joined the *Mail & Guardian* as a trainee, and then moved to *The Star* before joining AP in 1999. His work has been widely published, and he has won a World Press Photo award.

**SHAUN HARRIS** is a documentary and portrait photographer based in Johannesburg. Born in Jamaica, he came to South Africa in January 1994 to cover the first democratic elections, and immigrated in 1995. He runs Afrika Moves, a photo agency that supplies images to print, electronic, and film media, both domestically and abroad. He also trains aspirant photographers from disadvantaged backgrounds.

**JOHN HOGG** is photographic editor of *This Day*. A largely self-taught photographer, he has worked in the South African media since 1984,

notably for the *Sunday Independent* from 1995 to end 2003. While he has covered a broad spectrum of events for newspapers and magazines, he specialises in the arts, particularly dance and music. He won a World Press Photo award in 2000.

**MIKE HUTCHINGS** is a photographer for the Reuters news agency, and is based in Cape Town. He studied anthropology at the University of Cape Town, but became a photographer instead. He has worked in Africa and in Asia on a variety of news, feature, and sports stories. He has twice won the Abdul Sharif award, which forms part of the South African Fuji Press Photo competition. His work has been exhibited in South Africa and Europe.

**NADINE HUTTON** is chief photographer of the *Mail & Guardian*, which she joined after studying journalism at the University of South Africa (UNISA) and Rhodes University in Grahamstown. Besides her newspaper work, she undertakes private feature projects. Her photographs have been exhibited locally and overseas.

**FANIE JASON** is a freelance photojournalist based in Cape Town. His career began in the early 1980s when he worked for *Drum* and *Pace* magazines in Cape Town. His photographs have appeared in numerous South African newspapers and magazines, as well as international publications. He has travelled extensively, covering events on several continents. He has participated in national and international exhibitions. He has won several South African Fuji Press Photo awards, including the Abdul Sharif Award, and has been highly commended in international competitions.

**JEREMY JOWELL** is a freelance photographer and travel writer, based in Cape Town. He regularly contributes to various South African and international publications, and his photographs have appeared in several calendars and books. He has also held three solo exhibitions.

**STEVE LAWRENCE** is a senior photographer at *The Star*. He studied photography at the Peninsula Technikon in Cape Town. Besides his domestic work, he has done extensive feature work in other African countries, including Angola, Rwanda, and the DRC, and has covered many local and international sports events. His work has appeared in numerous international publications, including *Time* magazine. He has won several South African Fuji Press Photo awards.

**CHRIS LEDOCHOWSKI** studied photography at the University of Cape Town, and continues to work from that city as a freelance photographer. In the early 1980s he joined the photographic collective Afrapix. Besides ongoing work on township art and culture, he is engaged in long-term projects in Venda and Pondoland. He has participated in group projects, and contributed to national and international exhibitions. His work was exhibited at the Venice Biennale 2003, and has been published in *Cape Flats details – life and culture in the townships of Cape Town* (2003).

**T J LEMON** is chief photographer of the *Sunday Independent*. After studying photography at Rhodes University in Grahamstown, he started his career as a freelance press photographer in Johannesburg. He later joined the Independent Group. His work has been exhibited in Johannesburg and in the United Kingdom, and he has won a World Press Photo award and a CNN African Journalist of the Year award. He has trained aspirant photographers at The Market Photography Workshop in Johannesburg.

**LEON LESTRADE** has worked as a freelance photographer for numerous Cape newspapers. He is currently employed by *The Cape Argus*.

**RONNIE LEVITAN** is a freelance photogapher based in Cape Town. Trained as an architect, he switched to full-time photography in 1984. He was chief photographer for *ADA Magazine*, photographing buildings, interiors, and creative people.

**KIM LUDBROOK** is regional photo editor Africa of the agency EPA Photos, based in Johannesburg. Prior to that he was a senior photographer for *The Star*. He has travelled extensively, covering news events in Africa and, more recently, the fall of Saddam Hussein in Iraq. He has also covered major international sports events. His work has been published in *The Times*, *The Observer*, *South China Morning Post*, *Time Magazine*, *New York Times*, and *Newsweek*. He was among 100 photojournalists who contributed to the travelling exhibition and book 'A day in the life of Africa' (2002).

**DAVID LURIE** is a South African photographer based in London. He initially studied economics and philosophy, and worked as a consultant economist, but started photographing full-time in 1995. His work has been published and exhibited in the United States, Europe, Australia, and South Africa. He has won numerous awards, including the World Understanding Award at the 61st Annual Pictures of the Year International Competition for 'Cape Town Fringe: Manenberg Avenue is where it's happening', which will be published by Double Storey Books later this year.

**MOTHLALEFI MAHLABE** is senior arts photographer for *The Star Tonight*, and undertakes personal projects in his spare time. His work has appeared in many local and international publications,

and he was nominated for a World Press Photo award in 1996. He is a graduate of the Market Photography Workshop, where he now trains students on a part-time basis.

**GIDEON MENDEL** is a South African freelance photographer based in London. In the 1980s he worked for *The Star* and Agence France-Presse, and then became a Magnum nominee. He has worked extensively in Africa. His work on HIV and AIDS has been widely exhibited and published. He has worked on assignment for many local and international magazines, as well as numerous international charities. He has won six World Press Photo awards and the Eugene Smith Award for Humanistic Photography.

**SIPHIWE MHLAMBI** is a commercial photogapher based in Johannesburg. His clients include advertising agencies, as well as government institutions and agencies.

**ERIC MILLER** is a freelance photojournalist based in Cape Town. He works on assignment in Africa for a range of international newspapers and magazines, as well as for local and international NGOs and corporations.

**PETER MOREY** is a Pretoria-based photographer specialising in corporate events, aerial photography, and media-related work. After spending 10 years with the *Pretoria News*, he launched Peter Morey Photographic in 1991.

**RUTH MOTAU** is a freelance photographer based in Johannesburg. After studying at the Market Photography Workshop, she joined the then *Weekly Mail* as an intern and rose to picture editor until her resignation to pursue a freelance career in 2001. Her work has appeared in numerous magazines and other publications, and has been exhibited locally and internationally, including at the Biennale in Brazil. She has trained aspirant women photographers in the southern hemisphere.

**SAFODIEN MUJAHID** is a photographer for *The Star*. He studied fine arts and graphic design at the Cape Town Technical college, and then worked as a freelance and staff photographer for several Cape Town newspapers and news agencies before joining his current employer in Johannesburg. He completes a major personal project every year. He has won a South African Fuji Press Photo award, and has been nominated several times for the World Press master class.

**LEON MULLER** is chief photogapher of *The Cape Argus*. A photojournalist for 20 years, he has won 12 South African Fuji/Ilford Press Photo awards.

**IVAN NAUDÉ** is a professional photographer specialising in magazine and advertising work, based in Johannesburg. He is the official photographer for *SA Fashion Week*, and has worked on varied assignments in different locations around the world.

**NEO NTSOMA** is a photogapher for *The Star*. Besides her press work, she also undertakes freelance projects. Her photographs have appeared in numerous publications, and have been locally exhibited. She has conducted gender imaging workshops in Zimbabwe, Tanzania, and India, and taught photography to women in Bangladesh. She has won several South African Fuji Press Photo awards.

**CEDRIC NUNN** is a freelance photographer based in Johannesburg. He has focused on documenting social change, and particularly rural issues. He has worked with a wide range of clients, including government institutions, corporations, and NGOs. His work has been exhibited both domestically and abroad.

**OBIE OBERHOLZER's** photographs of people and places have been published in six books, and he is working on a seventh. He has held 31 solo exhibitions, five of them in Europe. He studied photography at the University of Stellenbosch. He taught photography at the Natal Technikon for eight years, and at Rhodes University in Grahamstown for 19, retiring as associate professor at end 2002.

A number of his students have become prominent photographers.

**KARIN RETIEF**, chief photographer of the *Cape Times*, has worked as a photojournalist for 18 years. Her work has appeared in various domestic and international magazines and newspapers.

**JÜRGEN SCHADEBERG** has a collection of 100 000 negatives, spanning 53 years of documentary photography in Africa and Europe. His work on South Africa ranges from images of black social, political, and cultural life in the 1950s, including the early liberation struggle, to portrayals of life in contemporary South Africa.

**SIPHIWE SIBEKO** is a senior photographer at *The Star*, and does feature work in his spare time. His work has appeared in several books, including a manual on photojournalism used throughout Africa, as well as international magazines. He has won numerous South African Fuji Press Photo awards, the Mondi photographic competition, and the Mohammed Amin Photographic Award (CNN), and has been voted Vodacom journalist of the year (Johannesburg region). In 2003 he won the Commonwealth Photographic Award

for Africa. He has received the Steve Biko Scholarship from the Institute for the Advancement of Journalism (IAJ).

**GARTH STEAD** is a freelance photographer based in Cape Town. He began working as a news photographer while studying at the University of Natal. After a spell working as a photographer on cruise ships in the Mediterranean, he worked for the *Cape Times* as staff photographer for several years. During this time he won two South African Fuji Press Photo awards, and ran the One City, Many Cultures photojournalism project. His clients include newspapers, wire services, magazines, filmmakers, and corporations.

**CAROLINE SUZMAN** studied photography at Rhodes University in Grahamstown, and now works from Johannesburg as a freelance photographer. Her work has appeared in various local and international newspapers and magazines, including *The Guardian, Elle, The Star, Marie Claire*, and *The Boston Globe*. She has held two solo exhibitions, and has participated in several group exhibitions, including 'Lines of Sight' at the National Gallery in Cape Town, and 'Bonani Africa' at Museum Africa in Johannesburg. Her work has been included in permanent collections in South Africa and elsewhere.

**ANDREW TSHABANGU** is a freelance photographer based in Johannesburg. He studied photography at the Alexandra community art centre, and later worked for the Johannesburg-based newspaper *New Nation*. He is a founding member of the TWASA photographers' collective, and a participant in the Indian Ocean photographer's workshop. His work has been exhibited in South Africa and abroad.

**ANDREAS VLACHAKIS** is a freelance photographer based in Johannesburg. He studied photography at the Pretoria Technikon, and then joined *The Star*, rising to senior photographer in 1998. In 2000 he was runner-up to the South African Fuji press photographer of the year. He concentrates on editorial and commercial photography, and also undertakes personal photographic projects.

**ROGAN WARD** is a staff photagpher for Independent Newspapers in Cape Town, and also undertakes freelance projects. He studied photography at the Durban Technikon and in the United Kingdom, and started his career as press photographer in Natal. He specialises in social-documentary photography. His work has been included in several group exhibitions in South Africa.

**LORI WASELCHUK** is a freelance photojournalist and documentary photographer based in Johannesburg. Born in the United States, she moved to Johannesburg in 1996. Her work has been published in many leading newspapers and magazines, including *Time, Life, Newsweek, The New York Times, Der Spiegel, The Washington Post, The Los Angeles Times, The Independent, The Times,* and *The Telegraph*. In 1998 she was a finalist in the Alfred Eisenstaedt Awards for Magazine Photography. Her work has been exhibited in the United States, South America, and South Africa. She trains students and professionals at The Market Photography Workshop, the Institute for the Advancement of Journalism, and Rand Afrikaans University.

**PAUL WEINBERG** is a freelance photographer based in Durban. He has created a large body of work, much of it exploring the lives of indigenous people and their environments. He has worked for NGOs, magazines, and newspapers in southern Africa and abroad. He was a founder member of the photo agency Afrapix and its successor, South Photographs. His images have been widely exhibited, and he has published several books. He has won the Mother Jones International Documentary Documentary Award for his work on the people of Kosi Bay in KwaZulu-Natal.

**GRAEME WILLIAMS** is a freelance photographer based in Johannesburg, and manager of South Photographs. His work has featured in many publications, both locally and abroad, including *The New York Times, Time,* and *Telegraph Magazines*, in solo and collective exhibitions, and in two books.

**GÍSÈLE WULFSOHN** is a Johannesburg-based freelance photographer specialising in portraiture and documentary work. Her special areas of interest are women, children, education, health, and HIV/AIDS. Her work regularly appears in local and international publications.

**DEBBIE YAZBEK** is chief photographer of the Johannesburg-based newspaper *The Star*. She was the South African Fuji press photographer of the year in 1998 and 2003, and remains the only woman to have won this award. In 2003 she received the Nat Nakasa award for courageous journalism.